Outdoor Monuments of Manhattan

Outdoor Monuments of Manhattan

A Historical Guide

Dianne Durante

NEW YORK UNIVERSITY PRESS

New York and London

NEW YORK UNIVERSITY PRESS

New York and London

www.nyupress.org

© 2007 by New York University

All rights reserved

New York University Press books are printed on acid-free paper,
and their binding materials are chosen for strength and durability.

Library of Congress Cataloging-in-Publication Data

Durante, Dianne L.

Outdoor monuments of Manhattan : a historical guide / Dianne Durante.

p. cm.

Includes bibliographical references and index.

ISBN-13: 978-0-8147-1986-2 (cloth : alk. paper)

ISBN-10: 0-8147-1986-4 (cloth : alk. paper)

ISBN-13: 978-0-8147-1987-9 (pbk. : alk. paper)

ISBN-10: 0-8147-1987-2 (pbk. : alk. paper)

1. Public sculpture--New York (State)--New York--Guidebooks. 2.
Outdoor sculpture--New York (State)--New York--Guidebooks. 3.
Statues--New York (State)--New York--Guidebooks. 4. Manhattan (New
York, N.Y.)--Buildings, structures, etc.--Guidebooks. 5. New York
(N.Y.)--Buildings, structures, etc.--Guidebooks. 6. New York (N.Y.)--
Guidebooks. I. Title.

NB235.N5D87 2007

730.9747′1--dc22 2006025427

Manufactured in the United States of America

c 10 9 8 7 6 5 4 3 2 1

p 10 9 8 7 6 5 4 3 2 1

Contents

Map of Manhattan viii

Introduction 1

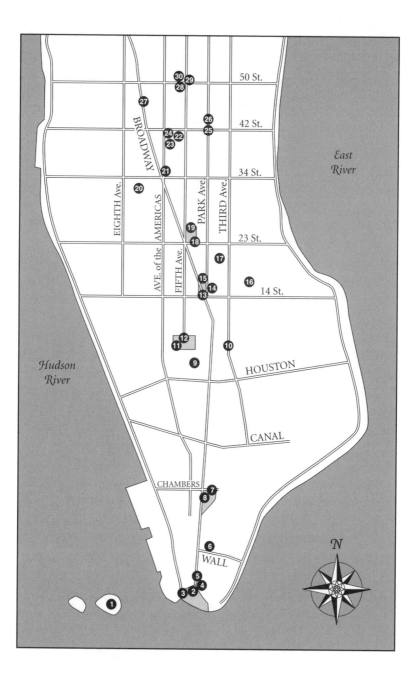

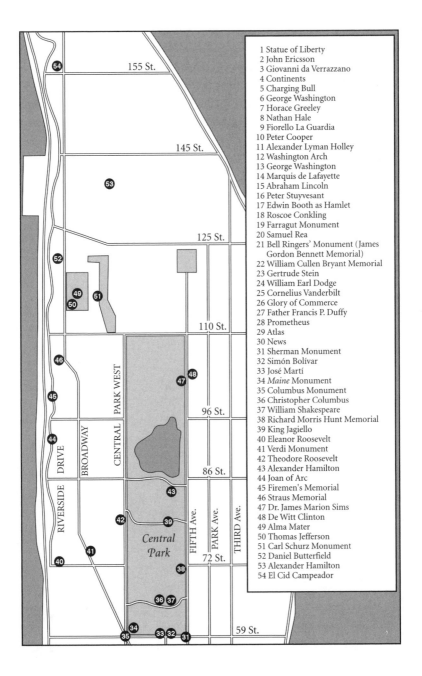

1 Statue of Liberty
2 John Ericsson
3 Giovanni da Verrazzano
4 Continents
5 Charging Bull
6 George Washington
7 Horace Greeley
8 Nathan Hale
9 Fiorello La Guardia
10 Peter Cooper
11 Alexander Lyman Holley
12 Washington Arch
13 George Washington
14 Marquis de Lafayette
15 Abraham Lincoln
16 Peter Stuyvesant
17 Edwin Booth as Hamlet
18 Roscoe Conkling
19 Farragut Monument
20 Samuel Rea
21 Bell Ringers' Monument (James
 Gordon Bennett Memorial)
22 William Cullen Bryant Memorial
23 Gertrude Stein
24 William Earl Dodge
25 Cornelius Vanderbilt
26 Glory of Commerce
27 Father Francis P. Duffy
28 Prometheus
29 Atlas
30 News
31 Sherman Monument
32 Simón Bolívar
33 José Martí
34 *Maine* Monument
35 Columbus Monument
36 Christopher Columbus
37 William Shakespeare
38 Richard Morris Hunt Memorial
39 King Jagiello
40 Eleanor Roosevelt
41 Verdi Monument
42 Theodore Roosevelt
43 Alexander Hamilton
44 Joan of Arc
45 Firemen's Memorial
46 Straus Memorial
47 Dr. James Marion Sims
48 De Witt Clinton
49 Alma Mater
50 Thomas Jefferson
51 Carl Schurz Monument
52 Daniel Butterfield
53 Alexander Hamilton
54 El Cid Campeador

Introduction

The summer after I graduated from high school I discovered that art wasn't merely a way to fill a blank wall. "I think you'll enjoy this," said my high-school art teacher, Mrs. Hartman, as she handed me what looked like the largest, thickest book in Catawissa, Pennsylvania. To eyes accustomed to garden gnomes and rock-star posters, the pictures in H. W. Janson's *History of Art* shone outrageously, extravagantly beautiful. More than that, I realized that when studying the art of the Renaissance, for instance, I could see what Europeans of that time considered important. Because art expresses ideas, I began to see how it related to history, science, technology, politics, philosophy. My greatest regret in reading Janson was that I couldn't travel the world to view all those artworks. What would I find if I moved around the side of Bernini's *David*? What colors were used in Rubens's *Landscape with the Chateau of Steen*, which Janson printed in black and white?[1]

After I moved to New York City, the Metropolitan Museum, the Frick Collection, and other institutions helped satisfy my curiosity. Then I noticed there were literally hundreds of sculptures in the city that I could study from any angle, at my leisure: the memorials and portrait sculptures erected in Manhattan over the past century and a half.[2] Most New Yorkers pass these sculptures so often that they don't even look at them. Tourists give them a brief, puzzled glance because guidebooks usually ignore them. Once you meet them, however, these "Forgotten Delights" become reliable friends. They can make you stop, look, and think when you'd swear your brain was too tired to function. They can provoke you or make you laugh aloud. They can invigorate you when you're tired or exasperated. The achievements and the virtues of the people represented in these statues can help supply the emotional fuel—the psychological energy—that keeps you going.

1

Sculptures Included in This Book

The works in *Outdoor Monuments of Manhattan* are either of high quality artistically or have intriguing subjects, or both. Among the fifty-four sculptures are conspicuous landmarks such as the *Firemen's Memorial*, the *Maine Monument*, *Prometheus* and *Atlas* at Rockefeller Center, and *Charging Bull*. Aside from a few allegorical or symbolic figures, most of the remaining works are portraits: explorers, an inventor, an architect, a musician, an engineer, businessmen, newspaper moguls.[3] Some are famous: George Washington, Alexander Hamilton, William Tecumseh Sherman, Fiorello La Guardia. Others have fallen into obscurity: J. Marion Sims (the "Father of Gynecology"), Daniel Butterfield (composer of "Taps"), and David Farragut ("Damn the torpedoes!"). And who would expect to find, in twenty-first-century Manhattan, statues of an eleventh-century Spanish hero, a medieval king of Poland, or a South American revolutionary?

Organization of the Essays

Each essay begins with the title, artist, date of dedication, medium, size, and location.[4] A sidebar offers a quotation by or related to the sculpture's subject.

The About the Sculpture section suggests what to look for in the sculpture. What does that gesture mean? What's the significance of the setting? (For more on this, see Appendix A: How to Read a Sculpture.) Occasionally this section tackles more abstract aesthetic questions: To what does a viewer react in a work of art? Can art be evaluated objectively? What's the point of portrait sculpture? What is art, what purpose does it fulfill, and how does it accomplish it? Why bother studying a work in detail, rather than enjoying it for a few seconds and moving on? I base these discussions on my understanding of Ayn Rand's work on aesthetics, particularly her definition of art.[5]

The About the Subject section discusses either the event commemorated, or an important episode or achievement in the life of the person represented. When a figure is well known, I've deliberately chosen a facet

of his or her life that will be unfamiliar to most readers. Sherman doesn't march through Georgia, he court-martials a journalist. Lincoln doesn't issue the Emancipation Proclamation, he deals with a vociferous Confederate sympathizer from Ohio. Richard Morris Hunt doesn't design a Beaux-Arts museum, he designs a skyscraper.[6] About the Subject comes after About the Sculpture because knowing biographical details about the subject tends to influence how you see the sculpture (see #18). I prefer that you look at the sculpture without preconceptions.

The sculptures are listed in chronological order by date of dedication in Appendix B. Appendix C offers additional information on the artists.

Visiting the Sculptures

The essays are arranged for a walking tour from the southern end of Manhattan northward. No single photograph reveals every detail of a three-dimensional object. To get the full impact, you must visit the work. Since it's difficult to get close to some of the sculptures, I recommend taking binoculars or a camera with an optical zoom lens. (Enlarging digital photos on a computer monitor is particularly helpful.) My favorite viewing time is an overcast day after the leaves have fallen, when shadows and glare are at a minimum.

You would think a multi-ton inanimate object would remain in one place. Not so: sculptures are moved, sometimes for cleaning, sometimes because the owners decide they would show to better advantage elsewhere. I verified all locations in late 2005. If you cannot find a city-owned sculpture in the location given, ask a Parks Department employee for information or try the Parks Department's Web site (http://www.nyc-govparks.org/index.php). If the sculpture is privately owned, the nearest doorman often knows where the work has decamped to.

Acknowledgments

The research for this book could not have been completed—or even begun—without the magnificent resources of the New York Public Library and the New-York Historical Society Library. The writing could not have

been completed without the blissful silence of the New York Society Library. Thanks also to the staffs of the New York City Department of Parks and Recreation, the Art Commission of the City of New York, and the National Sculpture Society for helping me track down obscure pieces, elusive sculptors and photographs of sculptures as they once were.

Heartfelt thanks to my agent, Rita Rosenkranz, to whose business sense and common sense this book owes its inception. The editorial suggestions of Steve Maikowski at New York University Press greatly improved the text, and the staff of the Press deftly handled a multitude of archaic foreign names and a complex layout. I am grateful to John McNulty and Sylvia Bokor, who read and commented on parts of this book before publication. John Haralabopoulos did exemplary research for the *Verdi Monument* (#41).

If a picture equals a thousand words, I would have to insert ten graphics here to thank my family. My husband, Sal, has been unfailingly supportive while I wrote this book, always straightening out my priorities when I worried that perhaps I should devote a week or two or three to cleaning the house. He has also spent hours looking at sculptures, commenting on drafts, and discussing art. My thanks also to my daughter, Allegra, whose constant search for knowledge and relentless refusal to accept any assertion she doesn't understand inspired the methodology for looking at art that is set forth in the About the Sculpture and How to Read a Sculpture sections. My debt to both of you is monumental.

And thanks, Mrs. Hartman. I really, really enjoyed the book.

NOTES

1. I read the third edition (1974). Later editions focus on individual artists' works and biographies rather than on integrating art with the philosophy and history of the time. The illustrations, however, have greatly improved.

2. If you're not in New York, photos at www.ForgottenDelights.com offer additional views.

3. My earlier book, *Forgotten Delights: The Producers* (New York: Forgotten Delights, 2003), covered twenty sculptures of businessmen, inventors, explorers, engineers,

and workers. Ten of the sculptures from that volume are included in this one, although in most cases the essays have been substantially revised.

4. Usually only the height is indicated. For a few very large ensembles, the width is given as well. The Smithsonian Institution's Inventory of American Sculpture (www.siris.si.edu) supplies detailed information on dimensions, foundry marks, inscriptions, and provenance. The Smithsonian Institution Research Information System (SIRIS) is a great resource for finding sculptures of your favorite Founding Father, every work of Augustus Saint Gaudens, or all the sculptures in Catawissa, Pennsylvania.

5. See #30 and the Afterword. For Ayn Rand's aesthetics, see especially *The Romantic Manifesto: A Philosophy of Literature* (New York: New American Library/Signet, 1975), and Leonard Peikoff, *Objectivism: The Philosophy of Ayn Rand* (New York: Penguin, 1993), Chapter 12.

6. To learn more about the lives of most individuals in this volume, the best source is the *American National Biography* (*ANB*), available in print or online at major libraries. The *ANB* presents a scholarly biography followed by an indispensable annotated bibliography for thousands upon thousands of Americans, as well as foreigners such as Christopher Columbus who played important roles in American history.

Statue of Liberty

Sculptor: Frédéric-Auguste Bartholdi. **Engineer**: Gustave Eiffel. **Pedestal**: Richard Morris Hunt.
Dedicated: 1886.
Medium and size: Hammered sheet copper over iron skeleton (151 feet), granite pedestal (155 feet).
Location: Liberty Island, New York Harbor.
Subway: 1, 4, or 5 to Battery Park, then Statue of Liberty Ferry.

Statue of Liberty, Bartholdi

Bartholdi's Inspiration for *Liberty*

At the view of the harbor of New York the definite plan was first clear to my eyes. The picture that is presented to the view when one arrives at New York is marvelous: when, after some days of voyaging, in the pearly radiance of a beautiful morning is revealed the magnificent spectacle of those immense cities, of those rivers extending as far as the eye can reach, festooned with masts and flags; when one awakes, so to speak, in the midst of that interior sea covered with vessels, some giants in size, some dwarfs, which swarm about, puffing, whistling, swinging the great arms of their uncovered walking-beams, moving to and fro like a crowd upon a public place. It is thrilling. It is, indeed, the New World, which appears in its majestic expanse, with the ardor of its glowing life. Was it not wholly natural that the artist was inspired by this spectacle? Yes, in this very place shall be raised the Statue of Liberty, grand as the idea which it embodies, radiant upon the two worlds.

— "The Statue of Liberty Enlightening the World," 1885

About the Sculpture

If she weren't so familiar, she'd seem outlandish: swathed neck to ankle in a bed sheet, wearing a spiked hat and brandishing a torch. In 1871, when Bartholdi sailed into New York Harbor, normal women dressed like Scarlett O'Hara. But *Liberty* isn't a normal woman or a specific person; she represents an abstract concept.

What concept? Bartholdi gives several visual clues. The tablet in her left hand bears the date of the Declaration of Independence: July 4, 1776. By her feet is a set of broken shackles, representing the broken bonds of tyranny. Given that this statue was designed just a few years after the American Civil War, the shackles also recall the end of slavery. Her torch and the shining rays on her crown represent enlightenment: literally shedding light on a subject, hence the original title of the statue, *Liberty Enlightening the World*.

Bartholdi toyed with various ideas for the statue, finally settling on a design during his first visit to New York Harbor (see Sidebar). Yet the sheer size of the project—it's still the world's largest freestanding sculpture—presented unique problems. Those that involved engineering (winds, changing temperatures) were the domain of Gustave Eiffel, soon to be famous for the Paris tower that bears his name. The artistic problems were Bartholdi's concern. He described some of them in "The Statue of Liberty Enlightening the World," an 1885 fund-raising pamphlet:

[There ought to be] great simplicity in the movement and in the exterior lines. The gesture ought to be made plain by the profile to all the senses. The details of the lines ought not to arrest the eye. The breaks in the lines should be bold, and such as are suggested by the general design. Besides the work should be as far as possible filled out, and should not present black spots or exaggerated recesses. The surfaces should be broad and simple, defined by a bold and clear design, accentuated in the important places. The enlargement of the details or their multiplicity is to be feared.... The model, like the design, should have a summarized character, such as one would give to a rapid sketch. Only it is necessary that this character should be the product of volition and study, and that the artist, concentrating his knowledge, should find the form and the line in its greatest simplicity.

To make Bartholdi's colossal problem more apparent, imagine the statue of *Ericsson* (#2) enlarged from 8 to 151 feet, and set on an island a mile away. The details of *Ericsson's* face and clothing would be indistinct. The object he holds near his chest would be indistinguishable. By deliberately choosing an easy-to-read pose, distinctive crown, and simple drapery—all plain to see even in silhouette—Bartholdi made *Liberty* understandable on a tremendous scale and from a great distance. Bartholdi was present at the dinner party where the *Statue of Liberty* was conceived (see About the Subject) because he'd been commissioned to create a bust of the host. Funds for *Liberty* were raised by public subscription among the French people in 1875. Funds for her pedestal were raised largely through Joseph Pulitzer's 1876 appeal to readers of the *New York World*.

About the Subject

At Edouard-René Lefebvre de Laboulaye's dinner party in mid-1865, the distinguished guests were debating whether true and lasting friendship between nations could exist. Their host argued that at least Franco-American friendship, which dated back to America's Revolutionary War, was enduring. He even suggested that it would be appropriate for France to join the United States in erecting a centennial monument to American independence. His idea languished, however, until American relief efforts for France during the Franco-Prussian War (1870–1871) led Bartholdi to broach the idea again with Laboulaye and his friends.

Why were these French intellectuals so eager to raise an expensive monument to liberty with private funds? The issue was not art but politics. Since 1776, the United States had defeated the British, one of the world's superpowers; had conceived, written, and abided by a novel Constitution; and had emerged wounded but stronger from a fratricidal civil war. It had expanded across a continent and was becoming one of the wealthiest and most powerful industrial nations on earth.

Frenchmen, on the other hand, had rebelled against royal authority in 1789 and established a republic, only to suffer through the Reign of Terror followed by Napoleon's bloody dictatorship. After Bonaparte's exile in 1814, the monarchy was reinstated. Although rebellions against royal authority were common (Hugo's *Les Misérables* describes one in 1832), the Second Republic was not established until 1848. A scant four years later, Napoleon III overthrew it. In 1865, Laboulaye and his liberal guests were still chafing under the repressive Second Empire. They regarded the United States as a shining example of the sort of republican government they wished to see instituted in France and around the world.

At a time when it was common to use art for didactic purposes (see *Bryant*, #22), the *Statue of Liberty* was a propaganda piece: an advertisement and a plea for the spread of liberty and self-government. (Note that *Liberty* isn't standing still, but striding forward—advancing.) Two decades after Laboulaye's dinner party, when the statue and the pedestal were finally ready for dedication, France was under the unbeloved but enduring Third Republic, whose establishment had been made possible

largely by the German capture of Emperor Napoleon III and 100,000 of his troops during the Franco-Prussian War.

At *Liberty's* dedication on October 28, 1886, speakers barely mentioned *Liberty's* welcome to immigrants. The recurring themes of the speeches were a celebration of liberty and of the Franco-American alliance. New York senator William M. Evarts said that the statue "speaks today, and will speak forever, the thoughts, the feelings, the friendships of these two populous, powerful, and free republics, knit together in their pride and joy at their own established freedom and in their hope and purpose that the glad light of Liberty shall enlighten the world." Noted orator Chauncey Depew mentioned immigrants, but with a warning as well as a welcome:

> The rays from this beacon, lighting this gateway to the continent, will welcome the poor and the persecuted with the hope and promise of homes and citizenship. It will teach them that there is room and brotherhood for all who will support our institutions and aid in our development, but that those who come to disturb our peace and dethrone our laws are aliens and enemies forever.

Emma Lazarus's "New Colossus," with its emphasis on welcoming immigrants ("Give me your poor, your tired, your huddled masses yearning to breathe free"), was composed in 1883 as part of the fund-raising efforts for *Liberty's* pedestal. Only in 1903 was it cast in bronze and affixed to the pedestal.

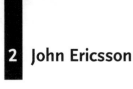

2 John Ericsson

Sculptor: Jonathan Scott Hartley.

Dedicated: 1903.

Medium and size: Bronze (10 feet), granite pedestal (11 feet) with four bronze reliefs (each 12 x 27.5 inches).

Location: Battery Park, between Castle Clinton and Battery Place.

Subway: 1, 4, or 5 to Bowling Green.

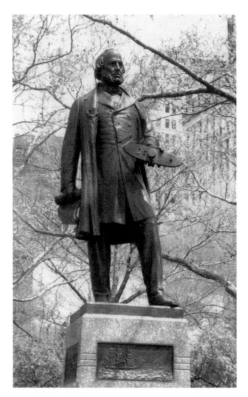

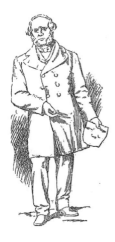

New York Times, April 15, 1893

Ericsson, Hartley

> **Marine Demon to Attack New York**
> Sunday came the ... disastrous tidings that the *Merrimac* was on the rampage among our frigates in Hampton Roads, smiting them down like a mailed robber-baron among naked peasants. General dismay. What next? Why should not this invulnerable marine demon breach the walls of Fortress Monroe, raise the blockade, and destroy New York and Boston? And are we yet quite sure that she cannot? The nonfeasance of the Navy Department and of Congress in leaving us unprotected by ships of the same class, after ample time and abundant warning, is denounced by everyone.
>
> —George Templeton Strong, *Diary*, February 27, 1862

About the Sculpture

When *Ericsson* was unveiled in 1893 to a twenty-one-gun salute and a lengthy parade, New Yorkers saw a man standing languidly, gesturing with a compass in his right hand to a small square of paper in his left. It didn't look like the gruff old man who for decades had been a familiar figure in New York, and whose ironclad *Monitor* had saved New Yorkers, they believed, from a Confederate naval attack.

The sculptor, Hartley, was so dissatisfied with this statue that he had a revised one cast at his own expense. Rededicated with another twenty-one-gun salute in 1903, *Ericsson* now stands tall and confident, with stern mouth and frowning brow. In one hand is a roll of blueprints, in the other a model of the *Monitor*.

Reliefs on the pedestal commemorate several of Ericsson's inventions. On the front is the USS *Princeton*, America's first screw-propelled vessel of war, still bearing the masts and rigging of a sailing vessel. On *Ericsson's* left the *Monitor* battles the *Merrimac*. Behind him is a rotary gun carriage. To his right, firemen battle a raging blaze using the steam-driven fire engine for which Ericsson won a prize in 1840, an era when flames sometimes destroyed hundreds of New York City buildings within a few hours. (See *Firemen's Memorial*, #45.)

Portraits are meant to remind us of great deeds and great minds—of what the best among us have accomplished and of the heights to which each of us can aspire. To achieve this purpose, a portraitist must be selective. The statue must convey a strong physical resemblance, but must also show the sitter in a characteristic attitude, one that evokes the sitter's personality and accomplishments. This second version of *Ericsson* fulfills that requirement. The first did not.

About the Subject

On January 30, 1862, the day of the *Monitor's* launch, New Yorkers crowded the shores of the East River to witness a disaster. The ship was constructed mostly of iron: how could she possibly float? Thomas Rowland, one of Ericsson's builders, recalled:

> It was the opinion of most shipbuilders that she would "throw pitch pole"—that is to say, her stern would go immediately down into the mud at the bottom of the river and she would turn a somersault. But her peculiarities I had provided for by putting air tanks under her stern and by an automatic device allowing the air to escape and the water to run into those tanks just in proportion as the vessel should be immersed in the water while leaving the ways. She was enabled thereby to slide into the water as quietly as a duck going into a pond to swim.

Why was this floating tin can built? The nineteenth century had seen rapid innovations in naval warfare. In the 1810s came the introduction of steam-powered ships—much faster and more maneuverable than sailing ships. Soon afterwards came artillery shells that could destroy a steamboat's paddlewheel and leave her dead in the water.

Ericsson (1803–1889), a Swedish-born engineer working in England, was invited to the United States in the 1840s to design and oversee the building of a screw-propelled warship, whose underwater propulsion system would be a much more difficult target. During trials, the screw propellers of the USS *Princeton* functioned perfectly, but a gun designed

by a colleague exploded, killing the secretary of the navy, the secretary of state, and President Tyler's prospective father-in-law. Ericsson's relations with the navy were arctic for the next twenty years, and might have remained so had the Civil War not intervened.

In late 1861, the North learned that a Confederate ironclad would soon be ready to devastate the Union's port cities. The Confederacy had raised the frigate *Merrimac* from Norfolk harbor, christened it the CSS *Virginia*, and iron-plated the charred hulk. Although it sailed lopsidedly and had barely functional engines, the *Virginia* was among the most powerful warships afloat because it could withstand shelling indefinitely while mercilessly bombarding its opponents.

The navy urgently invited proposals for a Union ironclad. Ericsson submitted a design for a radically different type of warship: small and maneuverable, with two powerful guns in a rotating turret, a low, stable design, and propeller and engines tucked below the waterline. After an exchange of acerbic comments with the Navy Board, he won the contract. Returning to New York, he oversaw the building of the *Monitor* in a hundred days flat—in the dead of winter, at a time when no bridges or tunnels existed for rapid transportation between the shipyards in Manhattan and in Greenpoint, Brooklyn.

In late February, 1862, as the *Monitor* wallowed southward through heavy seas, the telegraph flashed the news to New York and Washington that the *Merrimac*, on its maiden run from Norfolk, had rammed and sunk a fifty-gun Union frigate, set another on fire, and run a third aground. In a single day's battle, the Confederacy suddenly had the chance to break the Union blockade and become an international sea power. Terrified New Yorkers instructed the Common Council to appropriate the enormous sum of $500,000 for harbor defenses, "at any sacrifice and at every hazard."

The Battle of the Ironclads on March 9, 1862, is one of the most familiar stories of the Civil War. Although both ships steamed away largely unscathed after a four-hour battle, in the long term the Union won. The blockade remained intact, and the *Merrimac* was bottled up at Hampton Roads. Although Ericsson's *Monitor* went down in a storm off Cape Hatteras later in 1862, its effect on naval warfare was profound. The British

navy—the most formidable in the world—canceled all outstanding orders for wooden sailing ships. Iron plating, rotating turrets, steam power, and screw propellers were to be characteristic of the warships of the future.

3 Giovanni da Verrazzano

Sculptor: Ettore Ximenes.
Dedicated: 1909.
Medium and size: Overall about 22 feet. Bronze bust (5 feet), bronze allegorical figure (9 feet). Later granite base.
Location: Battery Park (in storage during park renovation).
Subway: 1, 4, or 5 to Bowling Green.

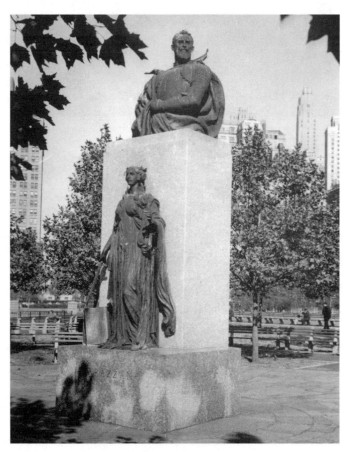

Giovanni da Verrazzano, Ximenes. New York City Parks Photo Archive.

First Impressions of New York Harbor
We found a very pleasant place, situated amongst certain little steep hills; from amidst the which hills there ran down into the sea a great stream of water, which within the mouth was very deep, and from the sea to the mouth of same, with the tide, which we found to rise 8 foot, any great vessel laden may pass up.... The people are almost like unto the others, and clad with feathers of fowls of divers colors. They came towards us very cheerfully, making great shouts of admiration, showing us where we might come to land most safely with our boat.... A contrary flaw of the wind coming from the sea, we were enforced to return to our ship, leaving this land, to our great discontentment for the great commodity and pleasantness thereof, which we suppose is not without some riches, all the hills showing mineral matters in them.

—Giovanni da Verrazzano, 1524

About the Sculpture

Verrazzano (also spelled Verrazano, as in the bridge) has a swashbuckling, arrogant appeal. Of heroic size (the bust is 5 feet tall), he holds his right arm akimbo while his left hand grips the cape sweeping down from his armor. His face, turned alertly to one side, displays the features recorded in contemporary portraits of Verrazzano: Roman nose (the sort that goes from forehead to tip without a dent at eye level), heavy but well-groomed beard and mustache. The lower edge of the cape, which originally curved around the base and linked him more closely to the allegorical figure below, was lopped off when the statue's crumbling pedestal was replaced in 1951.

In front of the bust stands another allegorical figure. This one is more difficult to interpret than the *Statue of Liberty*, because the symbols used are not as familiar and also because it's been vandalized. Her upraised left hand once held a torch, representing knowledge or enlightenment, as in *Liberty*. Propped against her leg is a book bearing the dates 1524 and

1909, a reminder of history—the year Verrazzano sailed into the harbor, and the year the statue was dedicated. The sword with which she pierces the book represents the sharp wits needed to see history clearly. (The same symbolism appears on a relief on Ward's *Pilgrim* in Central Park.) Combine these elements and this woman seems intended to represent the true facts of history: a recognition of what really happened so many centuries ago.

The inscriptions on the pedestal support that interpretation, although since they're in Italian, it's a rare viewer who understands them. On the west side, the inscription translates as, "In 1909, America and Italy remember Giovanni da Verrazzano, Florentine, who was the first European—preceding the fortunate sailor [Hudson] after whom they were named—to navigate these waters, whose shores were destined to become one of the leading cities of the world." On the east side, the inscription translates as, "For the sake of historical truth and justice, this monument was erected by Il Progresso Italo-Americano, edited by Carlo Barsotti, with the support of the Italians resident in New York, 6 October 1909."

Given this combination of figures and inscriptions, the *Verrazzano* is not merely a sculpture. It's a polemic. The literal subject is Verrazzano and his allegorical sidekick, but the theme—the message the artist is conveying to us, as viewers—is that Verrazzano deserves the credit for the discovery of New York Harbor. (For more on the theme or meaning of a sculpture, see *Charging Bull, #5*.)

Why was that even an issue? In 1909 New York was honoring Henry Hudson, the Englishman in Dutch pay who in 1609 became the first European to sail up the Hudson River. New York's substantial Italian-American community was offended that the celebrations ignored Verrazzano, the first European to sail into New York Harbor and to see the Hudson River. The editor of a prominent Italian newspaper led the drive to raise money for this statue to commemorate Verrazzano's voyage.

About the Subject

The first European sighting of New York Harbor was made by an explorer seeking profit for his backers. Fittingly, New York rose to greatness not as

a center of government or a religious haven, but as a thriving commercial hub.

Why was an Italian-born navigator working for the King of France sailing these waters? In 1522 the tattered remnant of Magellan's fleet (one of his five ships, and 18 of his crew of 239) reached Lisbon's harbor. The published report of this first voyage around the world inspired an intense rivalry among European monarchs to discover a route to Asia that would bypass the treacherous South American strait bearing Magellan's name. In the thirty years between Columbus's first voyage and Magellan's circumnavigation, much of the coast of Central and South America had been explored. Farther north, the area around Newfoundland was thoroughly familiar to fishermen. In seeking a passage through the American continent, therefore, Verrazzano set out for the Atlantic coast of what is today the United States.

Francis I of France, who had a high regard for Italians (Leonardo da Vinci and Benevenuto Cellini were honored guests at his court), provided Verrazzano with the caravel *Dauphine*. Italian merchants based in France funded the voyage, hoping Verrazzano would find a route to Asia that would reduce silk importation costs. After sailing as far as South Carolina, Verrazzano headed north, too far off shore to see either the Chesapeake or Delaware Bay. But he did espy New York Harbor, and on April 17, 1524, he described it as "a very pleasant place, situated amongst certain little steep hills" (see Sidebar). Anchoring at the site of the Verrazano-Narrows Bridge, he was warmly greeted by Indians and was disappointed when a sudden squall forced him to move on. The area, which he dubbed "Angoulême" after one of the estates of the French king, clearly made a better impression than southern Maine—labeled on the expedition's map "Terra onde he mala gente" (Land of the Bad People).

 Continents

Sculptor: Daniel Chester French.

Dedicated: 1907.

Medium and size: Marble (ranging from 9.5 to 11 feet), each pedestal about 9 feet.

Location: In front of the United States Customs House, facing Bowling Green between State and Whitehall Streets.

Subway: 1, 4, or 5 to Bowling Green.

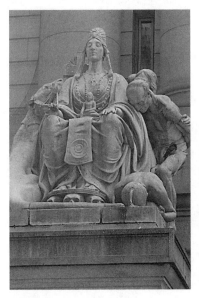

Asia, French

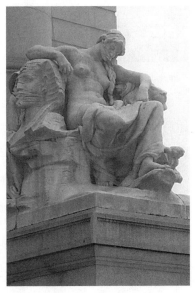

Africa, French

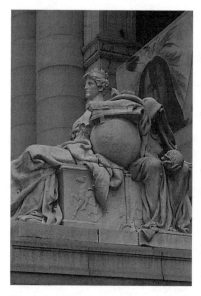

Europe, French

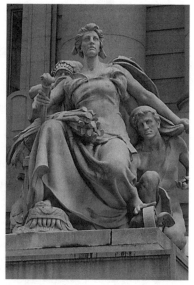

America, French

Daniel Chester French on Creating Art

[French] was especially happy in his work. He never agonized over it and it was seldom drudgery to him. Each statue as it came along was an exciting challenge, each difficulty met with in the mechanics of his trade was an absorbing problem to be overcome.

Daniel looked forward to doing the Custom House groups with more enthusiasm than he had felt for anything in a long while. Then he realized that he really felt almost the same enthusiasm in practically everything he did. Each new commission was a separate experiment, a widely differing challenge.

—Margaret French Cresson, *The Life of Daniel Chester French: Journey into Fame,* 1947

About the Sculpture

An important part of learning to enjoy art is learning to focus on it for a substantial amount of time, and figure out the effect of the details. Let's practice on the *Continents*—one of the most complex ensembles in Manhattan. Visit these if you can: one photograph of each is not enough to show all the details.

Asia

At the far left of the Customs House facade sits *Asia*, eyes closed. Is she sleeping? No, because her back is erect and her chin is up. Yet she's willfully not looking at the world around her. Her clothing seems almost too heavy to allow movement and conceals the lines of her body. Her left hand rests on her lap, unmoving, next to a small statue of the Buddha. Held loosely within her right hand, almost like a scepter, is a poppy flower, source of narcotic drugs that deaden the mind. Up its stem slithers a snake. While snakes have positive associations in some cultures, in the Judeo-Christian tradition that predominates in the United States snakes are the embodiment of evil. All is not well with this sedate figure, as becomes obvious when we look at what's around her.

Asia's footstool is supported by human skulls. On the left is a tiger, strong, wild, and bloodthirsty. Significantly, he seems to be looking to the woman for orders, rather than wondering which part of her to eat first—his teeth and claws are not bared. To our right of *Asia* are three men, almost naked, emaciated, bent, eyes closed. One has his hands tied behind his back: clearly he's not a willing follower. Another is rolled into a ball with his face on the ground, in abject submission.

Behind *Asia's* shoulder is a radiant cross. Does she know it's there? Is it meant as a symbol of hope, or to generalize the negative statement of the statue from Eastern religions to all religions? French leaves this ambiguous: he includes the cross, but doesn't give it a prominent size or position.

Asia includes details representing misery, tyranny, oppression, bloodthirstiness, drugged stupor, refusal to look at reality, and evil. Could that be an accidental juxtaposition? Only if you believe French had a magic modeling tool that carved without his control. In fact, every detail in the

Asia group had to be consciously selected by the sculptor. Because French presented these elements in this combination, we can assume that he believes there's a relationship between religion (at least some kinds of religion), force, and human suffering.

Africa

At the far right side of the Customs House is *Africa*. Her partial nudity suggests heat so oppressive that action is unthinkable. Although she's not emaciated like the men beside *Asia*, she's sprawled in an exhausted sleep, too tired even to lie down. Her arm rests on a lion—a powerful beast, but also sound asleep. To either side of her are reproductions of Ancient Egyptian monuments. On our right is a solar disk, the symbol of the god Horus; on our left is a sphinx, symbol of the pharaohs. Their decrepit appearance isn't due to New York pollution. French carved them to look as if they are crumbling and decaying. Behind *Africa*, to our left, sits a woman swathed in heavy robes. She's not asleep—she's upright, and holding her cloak across her face with one hand—but, like *Asia*, she has closed her eyes and withdrawn from the world.

What does the *Africa* group say? Both the woman and the lion have great potential, but both sleep exhausted amid the decay of once-great monuments. This figure did great deeds in the distant past, but has no energy to do anything now—not even to enjoy the memory of past greatness.

Europe

Europe, by contrast, sits proudly relaxed, looking outward. One hand is positioned as if to help her rise. She's dressed regally, with a battlemented crown (it looks like a medieval fortress) and a breastplate reminiscent of the Greek goddess Athena's aegis. "Embroidered" around the hem of her gown are the arms of European royal families. The ropes of pearls twined into her hair indicate great wealth.

The items surrounding *Europe* recall her impressive history. The reliefs on her throne are copies of those on the Parthenon. At her shoulder sits the imperial Roman eagle. Behind her, on our left, are the prows of Viking ships: a reminder that Europeans had been exploring the world and trading for centuries.

Moving around to the right, we see that the woman's arm rests on a huge book, which symbolizes the transmission of knowledge. (Note that neither *Asia* nor *Africa* has any books.) The book rests on a large globe—the world that Europeans explored and then dominated for centuries.

Behind *Europe* a cloaked figure, aged and gaunt, hunches over a book and a laurel-wreathed skull. Laurels often represent victory and fame, but here the wreath encircles the skull of a man long dead. The combination suggests that *Europe* tends to dwell on past glory. The difference between *Europe's* and *Africa's* ancient glories is that *Europe* is still aware enough to recall her discoveries, learning, and trade. She's rightfully proud of her accomplishments, even though she is now serenely sedate.

America

Finally there's *America*. What's different about her? She's actually moving, with one leg shifted back to take her weight as she rises. The flowing dress outlines her torso, emphasizing her twisting movement. Her hair is looser and more natural than that of either *Asia* or *Europe*.

In *America's* lap are stalks of corn, symbol of agricultural produce. The nopal cactus on our left, a distinctively American plant, produces prickly pears and serves as food for the cochineal insect, which in turn produces an expensive red dye. America, French tells us, is a country that creates goods as much as monuments.

America's right hand holds a torch, a symbol of enlightenment (as in the *Statue of Liberty* and the *Verrazzano*). Her left arm protectively encircles the man at her side, and she draws her cape forward to shelter him. This man is a startling contrast to those who accompany *Asia*. He's strong, healthy, energetic, alert. The chisel in his left hand and the paper in his lap imply that he has a plan for action. With his other hand he pushes a "wheel of progress." The symbolism's a bit obscure (although the same object appears on the spandrels above the windows in the Grand Central concourse), but it's clear this man is going somewhere: wheels are for motion. Of all the figures accompanying the *Continents*, this man is the only one who's healthy, alert, and cooperating with the main figure.

America is surrounded by Native American motifs. Her footstool is an ancient Aztec carving. Her throne bears Mayan glyphs. Behind her is the top of

a totem pole from the Pacific Northwest and, below it, ceramic pots that look vaguely Southwestern. Judging from his feathered headdress, the watchful figure peering over *America's* right shoulder is a Plains Indian. Why did French incorporate so many Native American motifs? Perhaps to emphasize how different America's history is from that of Europe, Asia, or Africa.

The Continents as a Group

Consider the *Continents* not as representatives of the people who live on each continent, but as illustrations of states of mind and their results. *Asia* represents the type of person who focuses on an unseen, supernatural world; with this come misery, bloodshed, and countless human deaths. *America* is alert, productive, and energetic, able to put natural resources to practical use; the humans and animals around her are peaceful and healthy. *Europe* is intelligent and proud, but living in her glorious past. *Africa* is exhausted amid the ruins of long-decayed greatness. The mere fact that French placed *Asia* and *Africa* at the outer edges of the building, and *America* and *Europe* at the center, flanking the building's main entrance, makes it clear which states of mind French considers more important and admirable.

You'll notice even more about these sculptures by comparing them with one another. For example, *Europe* and *Africa* both have reminders of the past, and both have a cloaked figure seated behind—but note the differences in the details, and in the message. Both *Asia* and *America* have nearly naked figures to one side, animals on the other side, and footstools: the similarity of these basic items makes the differences between them even more noticeable. Both *Europe* and *America* have eagles on the left, but one is the heraldic Roman eagle, stiffly posed, while the other is so tame it nibbles on *America's* sheaf of corn.

Cornice Sculptures

In keeping with the building's trade-related function (see About the Subject), the sculptures along the Customs House cornice commemorate nations engaged in international trade through the ages. From left to center, they are *Greece* and *Rome* (both by Frank Edwin Elwell), *Phoenicia*

(Frederick Wellington Ruckstull), *Genoa* (Augustus Lukeman, who also did the *Straus Memorial*, #46), *Venice* and *Spain* (Mary Lawrence Tonetti). From the center to the right side are *Holland* and *Portugal* (by Louis Saint Gaudens, younger brother of Augustus Saint Gaudens), *Denmark* (Johannes Gelert), *Belgium* (Albert Jaegers), *France* and *England* (Charles Grafly). The figure of *Belgium* was *Germany* until World War I, when anti-German sentiment became so intense that the statue was reworked.

At the center of the cornice, above the main entrance, Karl Bitter's cartouche with the seal of the United States is surmounted by an eagle, and flanked by the allegorical figures *Peace* and *Strength*.

About the Subject

Why is the Customs House so huge and elaborate? Money, money, money. Until the Sixteenth Amendment instituted the income tax in 1913, most federal revenue came from customs duties collected at American ports. About 75 percent of foreign commerce passed through the Port of New York. In 1905, while the Customs House was under construction, the federal budget was about $500 million. It collected $183 million of that through customs duties at New York.

No wonder, then, that one of the country's outstanding architects, Cass Gilbert, was chosen to design the new home for New York's customs officials. No wonder Gilbert was allotted $4.5 million for the project, including funds for a lavish decorative program. As the *New York Times* chirpily put it in 1906:

> When all the world comes to the Port of New York to be taxed, although they may grumble at some of Uncle Sam's tariffs, they will at least enjoy the privilege of paying tribute in a building fronting on Bowling Green whose palatial dimensions and architectural adornments have not been equaled or attempted in any other Custom House in the world. Whether this privilege will act as a palliative to the foreign pilgrim when he comes in practical contact with the complications of our tariff is not altogether certain.

5 Charging Bull

Sculptor: Arturo Di Modica.
Dedicated: 1989.
Medium and size: Bronze (16 feet long).
Location: North end of Bowling Green, Broadway near Beaver Street.
Subway: 1, 4, or 5 to Bowling Green.

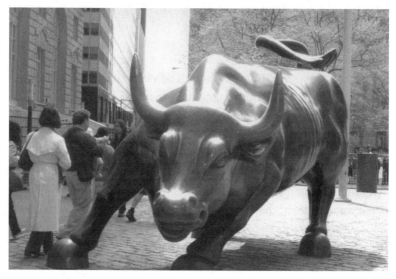

Charging Bull, Di Modica

Bulls and Bears

People who live far from Wall Street attach a mysterious and sometimes an awful signification to the terms "bulls" and "bears," which figure in the reports of the doings in that naughty place—the Stock Exchange. It is only the knowing ones who understand that both are speculators, often gamblers; the bulls buyers of stocks in the hope they will rise, and the bears sellers for future delivery, hoping that they will fall. Both of course "talk the market" to suit their operations. A bull sees every thing prosperous around him, and serene in the future; to a bear the future is pregnant with gloom, and trouble, and ruin.... The world is, in fact, full of bulls and bears; we are all of us either one or the other.

—*Harper's Weekly*, September 8, 1860

About the Sculpture

The subject of a sculpture is the figure or scene it literally represents. In this case, it's a charging bull; in the case of the *Statue of Liberty* (#1), a woman holding a torch; in the *Continents* (#4), four women in exotic garb with assorted accompanying figures. The literal subject, however, is only the top layer in a work of art. The deeper meaning is the message or theme the sculpture conveys about human beings and the world we live in. To determine the theme requires studying the details of the sculpture: not just what's represented, but how. The theme of that statue in the harbor, with its book bearing the date July 4, 1776, its symbolic torch and crown, is "Liberty Enlightening the World." The *Continents* show different states of mind and their consequences. For portrait sculptures, such as *Ericsson* (#2), the theme is often simply: "This person had such-and-such admirable qualities or characteristics."

What is the theme of *Charging Bull*? The *Bull's* head is lowered, its nostrils flare, and its wickedly long, sharp horns are ready to gore: it's an angry, dangerous beast. The muscular body twists to one side, and the tail is curved like a lash: the *Bull* is also energetic and in motion.

The sculpture's attributes (glossy texture, gleaming bronze color) have a crucial impact on the theme. Imagine this bull, in precisely the same pose, carved out of white marble and textured to show the hairs on its hide. The effect would be softer and gentler, even if the shape were identical.

Now step back and look at the whole sculpture. The *Bull* was designed so that viewers could walk all around him. That also suggests that his own movement is unrestricted. Given the twisting motion of his body, he could move any which way. *Charging Bull,* then, shows an aggressive or even belligerent force on the move, but unpredictably. Given its location in the Financial District, and the association of the bull with rising markets, it's not far-fetched to say the theme is the energy, strength, and unpredictability of the stock market.

So what? Why do we need to know that, as opposed to simply knowing it's a sculpture of a bull?

Identifying the theme is essential to understanding the meaning of the work of art. By definition, it *is* the meaning—the abstract, fundamental meaning—of the work. If you only go as far as saying "This is a sculpture of a bull," you haven't understood it. Understanding it means figuring out what the artist thinks about the bull (positive or negative), and whether he means it to symbolize something of wider significance than a farm animal. Knowing the theme, you can decide whether a sculpture is good or bad as a work of art. (See *Lincoln, #15.*) Knowing the theme, you can decide if the work presents a viewpoint that's valid according to your standards. (See *E. Roosevelt, #40.*) Knowing the theme, you can even understand your own emotional reaction better. (See *Booth* and *Conkling, #17, 18.*) In sum: you can't get farther than discussing random details unless you try to determine what the artist is saying—that is, what the work's theme is. Read more on the process of identifying the theme in *Lafayette, #14,* and in Appendix A, How to Read a Sculpture.

About the Subject

Ironically, no one paid a cent for *Charging Bull,* Manhattan's most popular symbol of a rising, profit-making stock market. On the night of De-

cember 15, 1989, sculptor Arturo Di Modica and friends drove a flatbed to the 60-foot tall Christmas tree in front of the New York Stock Exchange, where they unloaded a seven-thousand-pound gift. Workers arriving in the Financial District the next day were confronted with a sleek, 16-foot-long bronze bull, poised to charge up Broad Street. In a flyer distributed that day, Di Modica stated that he created the sculpture after the 1987 stock market crash as a symbol of the "strength, power and hope of the American people for the future."

The New York Police Department rebuked the *Bull* for obstructing traffic without a permit. New York Stock Exchange officials hired a truck to have it hauled away that very afternoon. But so great was the outcry that within a few days, Parks Department commissioner Henry J. Stern arranged for the *Bull* to be given a temporary stomping ground at Bowling Green. Seventeen years later it remains a "temporary" exhibit on city property.

6 George Washington

Sculptor: John Quincy Adams Ward. Granite pedestal by Richard Morris Hunt.

Dedicated: 1883.

Medium and size: Bronze (12 feet), granite pedestal (approximately 11.5 feet at front).

Location: Wall and Nassau Streets, Federal Hall National Memorial.

Subway: 4 or 5 to Wall Street.

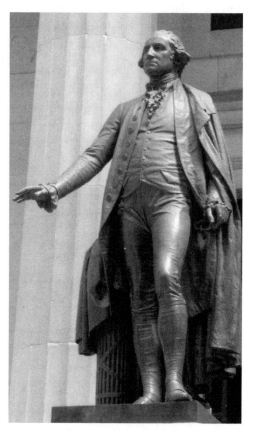

Washington, Ward

Washington's First Inauguration

Inexperienced in the duties of civil administration, he was to inaugurate a new and untried system of government composed of States and people, as yet a mere experiment, to which some looked forward with buoyant confidence, many with doubt and apprehension.

He had moreover a high-spirited people to manage, in whom a jealous passion for freedom and independence had been strengthened by war and who might bear with impatience even the restraints of self-imposed government....

[The country] presented to the Atlantic a front of fifteen hundred miles divided into individual States differing in the forms of their local governments, differing from each other in interests, in territorial magnitudes, in amount of population, in manners, soils, climates and productions, and the characteristics of their several peoples. Beyond the Alleghenies extended regions almost boundless, as yet for the most part wild and uncultivated, the asylum of roving Indians and restless, discontented white men.

—Washington Irving, *Life of George Washington*, 1855–1859

About the Sculpture

Washington took the oath of office, kissed the Bible, and then (the moment shown here) turned to acknowledge cheering onlookers. You can and should consider the significance of the position of his head (tilted up? down? level?), the direction of his gaze (what if he were looking down his nose?), the expression of his mouth (picture him with a big grin—I dare you), and the gesture of his hand. But right now, look at the pillar behind *Washington* on which the Bible rests. The bundle of rods tied together with bands is a fasces, a symbol carried by escorts of Roman magistrates from at least the fifth century B.C. as a reminder of the magistrates' power to punish. (Omitted in this sculpture is the axe for decapitating lawbreakers that protruded from the bundle's center.) In this

statue Washington wears a cape whose lush folds recall a Roman toga. Why are two ancient Roman elements included so prominently in Ward's sculpture of an American president? Why do similar ancient elements also appear in the *Statue of Liberty,* the *Washington Arch* (#1, 12), and other Manhattan sculptures?

Back in A.D. 800, more than three centuries after the Roman Empire in the West collapsed, Charlemagne had himself crowned Holy Roman Emperor. The territory he ruled was mostly in France and Germany, but the mere use of the title "Roman Emperor" linked Charlemagne to one of the world's most powerful and longest-enduring civilizations. Whenever a medieval or Renaissance ruler wanted to enhance his prestige, he turned to the classical style: the imagery of the Romans and of the Greeks, from whom the Romans adapted much of their art. In France, where the *Statue of Liberty* was made, a revival of the classical style had begun in the late 1700s. Nineteenth-century American sculptors trained in Europe brought the neoclassical style to the United States. We'll see its influence in several sculptures in this book.

The fasces and the toga/cloak don't give Washington dignity: that comes from his posture, expression, and gesture. The classical elements do, by association, give him an extra ounce of authority, and make him one of a long line of distinguished rulers, rather than the first elected executive of a nation barely a dozen years old.

About the Subject

For over a century, history has usually been presented as an inevitable, predetermined march of events. Event A happened, and because of that Event B, and then of course Event C. Individuals are viewed as irrelevant in this inexorable progression.

But history comes alive only if we remember that the individuals of a given period had their own values, purposes, and goals, and had no knowledge whatsoever of what was to come. To revive history, we have only to ask: What was important to those people? What events within their lifetimes colored the way they thought? Why did they make the choices they did, and what other possibilities did they reject?

Looked at from this perspective, even the unadorned American-made suit Washington wore at his first inauguration (which Ward has reproduced in this sculpture) is significant.

On April 30, 1789, most of those crowding the streets and rooftops to watch Washington take the oath as first president of the United States had lived through seven grueling years of war against one of the world's superpowers. They had suffered under the weak government established by the Articles of Confederation. Then, during five months of bitter wrangling in 1787, forty-three delegates in Philadelphia had hammered out a document setting forth the principles on which the government of the United States would operate. (See #12 on Washington's role.)

Even with brilliant promotion by Hamilton, Jay, and Madison in the *Federalist Papers*, it was nine months before the Constitution gained enough votes to become binding. Five states signed only on condition that a Bill of Rights be added, which had not been done by April 1789. The day Washington took the oath, Vermont, Rhode Island, and North Carolina had not even ratified the Constitution.

The difficulties faced by the new nation were obvious. The United States' large territory held a diverse and notoriously independent population (see Sidebar). The new government was deeply in debt, with no established source of income. (See *Hamilton*, #53.)

Washington himself—America's greatest Revolutionary War hero—was potentially a problem. No other man was even conceivable as the first president; he was unanimously chosen by the Electoral College. Yet Washington's every action was scrutinized for evidence of a lurking desire to become a monarch or dictator. For the spectators who watched Washington as he stood on the second-floor balcony in Federal Hall, at Wall and Broad Streets, on that spring morning, it was no minor matter that Washington wore a plain coat of American make. Had he worn velvet, silk, and jewels, like European royalty, it would have confirmed some viewers' worst suspicions, and even Washington's reputation might not have been enough to hold the country together through his term as president.

7 Horace Greeley

Sculptor: John Quincy Adams Ward. Pedestal: Richard Morris Hunt.
Dedicated: 1890.
Medium and size: Bronze (6.5 feet), granite pedestal (6.5 feet).
Location: City Hall Park, near the City Hall subway entrance.
Subway: 4, 5, 6 to Brooklyn Bridge–City Hall, or J, M, Z to Chambers
Street.

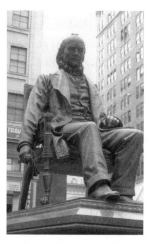

Greeley, Doyle

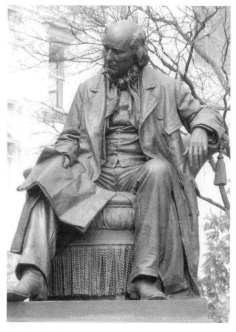

Greeley, Ward

Journalist Greeley on Relying on One's Own Judgment

You have been pleased on several occasions to take me to task for differing from you, as though such differences were an evidence not merely of weakness on my part but of some black ingratitude or heartless treachery. I cannot realize that there have been any series of obligations between us which render it proper in you to assume so complete a mastery over my opinions and actions. I have given you and I have been ever ready to give you any service in my power, but my understanding, my judgment, my consciousness of conviction, of duty and public good—them I can surrender to no man. You wrong yourself in asking. However deep my obligations I cannot pay in these. I am ever ready to defer to your superior experience and judgment—only convince me, but do not assume to dictate or lecture me. Do not ask me to forget that I, too, am a man—that I must breathe free air or be stifled.... I owe what little chance for usefulness that I may have to the impression that I do no man's bidding but speak my own thoughts.

—Letter to Thurlow Weed, 1842

About the Sculpture

When this statue was placed in a niche on the new Tribune Building in 1890, eighteen years after the death of Horace Greeley, the longtime editor of the *Tribune,* Greeley's face was still as familiar to many New Yorkers as Abraham Lincoln's. Passers-by often paused to say, "I once heard the old fellow lecture back home," or "My Dad read Greeley's paper as he did his Bible." Ward captured the editor's round face, bald head with a ragged fringe of hair, and habitually rumpled clothing, but that's not all he captured. The easiest way to see Ward's skill at portraiture is by comparing his *Greeley* to the one sculpted by Alexander Doyle two years later, which stands at Sixth Avenue and West 32nd Street.

The two figures are recognizably the same man, and both are seated in elaborate chairs, holding newspapers. It's the small details that are different—and so are their effects.

First, there's the pose. Doyle's figure sits straight in his chair, head slightly bowed. In his right hand, which hangs down by the arm of the chair, he holds a newspaper. It's not clear what he's doing: thinking about an article in the paper? Listening to someone talk?

Ward's figure, on the other hand, twists slightly in his betasselled chair. His torso is turned sideways, with one elbow resting on the back of the chair. His head is tilted down toward the newspaper he holds in his right hand. The squinting wrinkles around his eyes suggest that he is reading the paper, and the angle of his head that he is thinking carefully about what he's read. Contemporary accounts describe Greeley riding the trolley, so absorbed in the paper that he barely noticed where he was.

The clothes on the two statues also have small but significant differences. In the Ward statue, Greeley's waistcoat is stretched slightly across his abdomen so that it gapes open between the buttons. At his neck is a sloppy bow, so large it looks like a handkerchief rather than gentleman's neckwear. Likewise, the coat he wears isn't a proper nineteenth-century gentleman's frock coat: it's baggy, with a casual patch pocket and a rough, almost homespun texture. Compare the conventional coat worn by Doyle's *Greeley*, or the natty outfit worn by contemporary *Roscoe Conkling* in Madison Square Park (#18). Here's a man, we think, who's more concerned with the news than with fashion or personal appearance.

Ward was one of America's best sculptors, and it's the conception and execution of telling details such as *Greeley's* pose and costume that earned Ward high esteem. Looking at Ward's *Greeley*, we feel as if we know not only what Greeley looked like, but how he moved and how he thought. Given that the function of a portrait statue is to show the character as well as the physical appearance of the subject (see *Ericsson, #2*), *Greeley* ranks among Manhattan's best portrait statues.

About the Subject

"Galvanize a large New England squash," snapped James Gordon Bennett of the *New York Herald* (#21), "and it would make as capable an editor as Horace."

Greeley's *Tribune*, founded in 1841, was one of New York's great newspapers. By 1860 it had a circulation of nearly 300,000 and was the political Bible for the Republican Party that Greeley (1811–1872) had helped establish. While Greeley expressed his own opinions strongly on the editorial page (see his comments in the Sidebar), the *Tribune* was no mere soapbox. The news pages focused on high-quality, comprehensive reporting. In his *Recollections of a Busy Life* (1868), Greeley explained the philosophy behind the paper:

> No *one* person is expected to take such an interest in the rise and fall of stocks, the markets for cotton, cattle, grain and goods, the proceedings of Congress, Legislatures, and Courts, the politics of Europe, and the ever-shifting phases of Spanish-American anarchy, etc., etc., as would incite him to a daily perusal of the entire contents of a metropolitan city journal of the first rank. The idea is rather to embody in a single sheet the information daily required by all those who aim to keep "posted" on every important occurrence; so that the lawyer, the merchant, the banker, the forwarder, the economist, the author, the politician, etc., may find here whatever he needs to see, and be spared the trouble of looking elsewhere.

Greeley was a good businessman and opinionated editor, but he was full of inconsistencies. The Civil War brought some of these into sharp relief. A fervent abolitionist, he was willing in 1860 to let Southern states secede. Once Fort Sumter had been fired upon the following year, however, Greeley bitterly denounced the Confederates and demanded that Lincoln immediately emancipate the slaves. (Lincoln replied with the famous statement that his aim was to preserve the Union, with or without slavery.) Yet to the disgust of many fellow New

York businessmen, Greeley was one of a handful of Northerners who put up bail money for Confederate president Jefferson Davis after the war ended.

Prompted by his vehement opinions, Greeley ran often but unsuccessfully for political office. Of his failed bid for the presidency in 1872, reformer George William Curtis commented, "If there is one quality which is indispensable to a President it is sound Judgment. If there is one public man who is totally destitute of it, it is Horace Greeley."

Nathan Hale

Sculptor: Frederick MacMonnies. Pedestal: Stanford White.
Dedicated: 1890.
Medium and size: Bronze (6.5 feet), granite pedestal (5 feet).
Location: Facing City Hall, at the north end of City Hall Park.
Subway: 4, 5, or 6 to Brooklyn Bridge–City Hall.

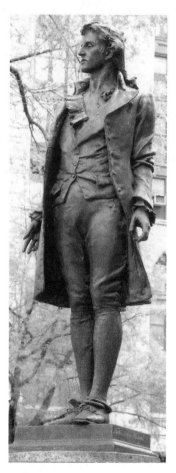

Hale, MacMonnies

"Invictus"
Out of the night that covers me,
Black as the Pit from pole to pole,
I thank whatever gods may be
For my unconquerable soul.

In the fell clutch of circumstance
I have not winced nor cried aloud.
Under the bludgeonings of chance
My head is bloody, but unbowed....

It matters not how strait the gate,
How charged with punishments the scroll,
I am the master of my fate;
I am the captain of my soul.

—William Ernest Henley, 1875

About the Sculpture

Commissioned to portray American patriot Nathan Hale, of whom no likeness survives, MacMonnies resolved: "I wanted to make something that would set the bootblacks and little clerks around here thinking, something that would make them want to be somebody and find life worth living." How did he do it? By a combination of posture, expression, and costume.

Hale stands tall, shoulders back: proud, but also tense. The long, vertical lines of his coat and the snugness of his vest and pants emphasize his slender frame. His hands gesture—he has just finished speaking the famous line, "I only regret that I have but one life to lose for my country," which appears on the sculpture's pedestal. His chin is lifted, another indication of pride. But he frowns slightly and turns his head aside, eyelids lowered as if in disdain.

Why? Look closer. No eighteenth-century gentleman would willingly have appeared in public in such disarray. Hale's shirt has been torn, leaving his neck exposed and vulnerable—a vulnerability emphasized by the high coat collar that frames his neck. Ropes unobtrusively circle his ankles. Walking around the statue, we see that his elbows are bound by a rope that stretches behind his back. Nathan Hale is a captive, about to be hanged. The disdain is for his captors and his fate:

Under the bludgeonings of chance
My head is bloody, but unbowed. (See Sidebar.)

How does one achieve such courage, such disdain for imminent death? From the certainty that one is fighting for the right, even if one is not winning. No one merely doing his duty, rather than defending what he believed in, could have the posture and expression of this *Nathan Hale.*

Sculptures of Hale have been done that lack the disdain, emphasizing instead Hale's captive status. But defiance made Nathan Hale famous— not the mere fact of his death. This *Hale* became an inspiration to the bootblacks and the clerks and the rest of us not because MacMonnies showed the specific values Hale fought for (life, liberty, the pursuit of happiness), but because MacMonnies showed the *way* in which Hale fought for those values: steadfastly, courageously, defiantly. That makes *Hale* a model not only for those who shared his values, but for all those who aspire to difficult goals.

A model, however, is not the same as a lecture on what to believe or how to behave. A personal example: in September 2001, it was difficult to get through a day in New York City without anger or fear or tears. I managed with the help of a pop song I'd heard the previous summer, whose refrain (translated from Spanish) was, "I will live, I will live, I will never give up, no one will stop me."

This two-minute song gave me no useful concrete information. It didn't tell me who masterminded the 9/11 attacks, or what should be done in response. It didn't explain why Americans don't deserve to be blown to pieces. It simply said "I won't give up" in a short, memorable way that encapsulated my will to survive a horrific event and get on with my life.

That's what art is for: to summarize an attitude toward the world, a sense of life, in a form so memorable that you can call it up in a split second when you need to reaffirm what you stand for. It's not a substitute for observing the world. It's not a substitute for thinking. It doesn't tell you what principles to live by or for. A work whose sense of life agrees with yours, however, visually reminds you of what you consider important about humankind and the world. It helps you remember what you want to focus on, amid the innumerable impressions that assault your senses every minute of every day. This connection between art and ideas explains why humans were creating art tens of thousands of years before they had written language, and why art created a hundred years ago (like *Hale*), or even thousands of years ago, can still have such powerful emotional impact.

About the Subject

On the night of September 21, 1776, a catastrophic fire swept through New York. Starting at Whitehall, it reduced Trinity Church to rubble and finally burned itself out in the empty lots north of St. Paul's (Broadway and Fulton Street). The British, who had just occupied New York after Washington's retreat, blamed the loss of a quarter of the city's dwellings on arson by American rebels.

In their sweep for suspects they arrested Nathan Hale. Hale, a native of Connecticut, earned his degree from Yale in 1773 and taught school until the Battles of Lexington and Concord occurred in April 1775. He promptly volunteered for the army. In September 1776, already promoted to the rank of captain, he volunteered to gather information on British activities in Manhattan and Long Island. The British captured him in civilian clothes, posing as a Loyalist schoolteacher, with incriminating notes (in Latin!) on troop movements and fortifications. General Howe had no compunction about ordering him hanged the following day. Hale's famous last words: "I only regret that I have but one life to lose for my country." Although barely twenty-one, he became one of the heroes of the American Revolution.

9 Fiorello La Guardia

Sculptor: Neil Estern.
Dedicated: 1994.
Medium and size: Bronze (life-size), granite pedestal (approximately 2.75 feet).
Location: East side of La Guardia Place, north of Bleecker Street.
Subway: A, B, C, D, E, F, or V to West 4th Street.

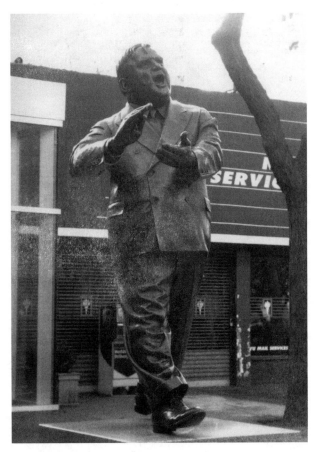

La Guardia, Estern. © Neil Estern, Sculptor.

La Guardia on Stage

In his opening campaign speech little Fiorello tossed away his pre-pared manuscript, grabbed off his horn rimmed glasses and used them alternately as a cutlass, a rapier, a back scratcher, a wand.... He touched his toes imitating a football player's kickoff, spat on an imaginary apple and polished it on his sleeve.... He ridiculed critics who complain of his Washington visits: "I saw the city needed this.... The bankers wanted to charge me 6%, but I could get the money in Washington for 3%. So wham!" (He ducked his head, took a track runner's on-your-mark position, dashed madly across the stage, pulled up puffing, but triumphant.) "So, away to Washington I go again."

—*Time*, October 27, 1942

About the Sculpture

La Guardia, a roly-poly five-foot-two, is the only mayor of New York City to have been represented as a giant balloon in the Macy's Thanksgiving Day Parade. This striding, gesticulating, haranguing figure is one of the most charming and energetic portrait statues in Manhattan—completely unlike the restrained figures we've seen so far. It's a perfect illustration of *Time* magazine's vivid description of sixty-year-old La Guardia (see Sidebar).

After looking at this sculpture in person at least a dozen times, it struck me that the reason we know La Guardia is moving along so briskly is the pattern of ripples on his right pants leg. The fabric would only fly forward that way if he were striding rapidly. Should you feel daunted by the number of details I point out in these sculptures, remember that no one can observe all these details and consider their possible effects in a single visit. If you pass by a certain sculpture often, try to spot something new every time you see it. You'll be surprised how much you can find after that first look, and how your perceptions

sharpen over the course of a short time. For hints, see Appendix A, How to Read a Sculpture.

About the Subject

"Our Mayor is probably the most appealing person I know," said President Franklin Delano Roosevelt. "He comes to Washington and tells me a sad story. The tears run down my cheeks and the tears run down his cheeks and the first thing I know, he has wrangled another $50,000,000." This rapport with the president and the ability to wring funds out of him was one reason La Guardia (1882–1947), New York City's mayor from 1934 to 1945, was dubbed "The Father of Modern New York."

La Guardia took office with high energy and exalted aims: "I shall not rest until my native city is the first not only in population but also in wholesome housing; not only in commerce but also in public health; until it is not only out of debt but abounding in happiness.... What an opportunity lies before the new administration!"

La Guardia streamlined New York City's unwieldy government, but whatever savings this consolidation brought were more than offset by increased government activism. His twelve-year tenure as mayor saw the building of the Triborough Bridge, the Brooklyn Battery Tunnel, the West Side Highway, the East River Drive, and the airport now named after him. The subway system was taken under city control. The Parks Department expanded parks, beaches, zoos, and swimming pools. Major public housing projects were undertaken for the first time in American history. La Guardia authorized health centers, water mains, sewage treatment facilities, indoor markets, street paving. He subsidized the arts and provided funding to train artists and musicians. Much of this was done under the aegis of La Guardia appointee Robert Moses, who freely used eminent domain to confiscate private property. "No law, no regulation, no budget stops Bob Moses in his appointed task," said La Guardia.

Who would argue against an apartment building, a park, or a swimming pool? The problem was not the objects themselves, but the runaway

government spending that paid for them. La Guardia's New York became a showplace for FDR's New Deal, and ultimately money for its improvements was extracted from the pockets of taxpayers nationwide. When federal funding dried up, however, New York City was left with a massive infrastructure that it had no funds to maintain, and which deteriorated steadily over the following decades.

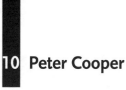

10 Peter Cooper

Sculptor: Augustus Saint Gaudens. Pedestal: Stanford White.
Dedicated: 1894.
Medium and size: Overall 20 feet; bronze figure (approximately 6 feet), granite pedestal and canopy, pink marble columns.
Location: Cooper Square south of the Cooper Union, where the Bowery splits into Third and Fourth Avenues.
Subway: 6 to Astor Place.

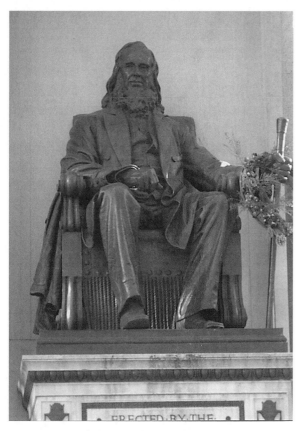

Cooper, Saint Gaudens

First Run of the "Tom Thumb"
After a great deal of trouble and difficulty in accomplishing the work, the stockholders came, and thirty-six men were taken into a car, and, with six men on the locomotive, which carried its own fuel and water, and having to go up hill eighteen feet to a mile, and turn all the short turns around the points of rocks, we succeeded in making the thirteen miles, on the first passage out, in one hour and twelve minutes; and we returned from Ellicott's Mills to Baltimore in fifty-seven minutes.

This locomotive was built to demonstrate that cars could be drawn around short curves, beyond anything believed at that time to be possible. The success of this locomotive also answered the question of the possibility of building railroads in a country scarce of capital, and with immense stretches of very rough country to pass, in order to connect commercial centers, without the deep cuts, the tunneling, and leveling which short curves might avoid. My contrivance saved this road from bankruptcy.

—Cooper, *Sketch of the Early Days of Peter Cooper*, 1877

About the Sculpture

Drawl "Go ahead, make my day," and you summon the image of Dirty Harry, a cop who broke all the rules but always put the crooks out of action. Compare a colleague to Howard Roark and you evoke the intransigent independence of the *Fountainhead's* hero. So strong are the associations of certain names and phrases that the mere mention of them evokes complete characters or situations. In sculpture, an artist can achieve the same result by "quoting" the pose or expression of a famous work of art.

Cooper has the lined face and full beard of an Old Testament prophet—Michelangelo's *Moses* and Donatello's *St. John the Evangelist* come to mind. His seated pose recalls such prophets, as well as representations of medieval kings. The cane he holds suggests a scepter. This as-

sociation with prophets and kings gives *Cooper* authority and grandeur. The same figure in the same chair but in *Greeley's* casual pose (#7) would convey a very different character.

Not only the pose but the setting makes *Cooper* impressive. Saint Gaudens and architect Stanford White designed an elaborate granite-and-marble "frame" against which the bronze sculpture vividly stands out. The style of letters and numerals on the pedestal's inscription evokes the grandeur and dignity of the Romans—a technique favored by neoclassical artists of the nineteenth century. (See *Washington,* #6.) As the final touch, *Cooper* is placed so that as we approach, he's set against his most enduring contribution to New York: the home of the Cooper Union. (See About the Subject.) "One does not 'happen upon' this statue of the great philanthropist," wrote Lorado Taft in his *History of American Sculpture;* "one approaches it and is conscious of the approach."

Yet *Cooper* is not a forbidding, regal presence. Why? In portraits of medieval kings, the figures are rigidly symmetrical. *Cooper* is not—in fact, one foot is slightly in front of the other, as if he's about to stand up. Kings are portrayed with lavish robes, crowns, and scepters. *Cooper* wears the frock coat of a well-to-do nineteenth-century gentleman, and his cane is elegant but simple. End result: *Cooper* looks like Moses, if Moses were a Victorian-era grandfather.

About the Subject

As the Industrial Revolution gathered momentum in America during the early years of the nineteenth century, Peter Cooper (1791–1883) demonstrated the innovation and flexibility that made him one of the wealthiest businessmen of his time. In 1828 he was duped into purchasing a three-mile stretch of Baltimore waterfront. Struggling to compete commercially with Boston, Philadelphia, and New York, the citizens of Baltimore planned to build a railroad to connect their harbor with Ohio, on the American frontier. Cooper's land, rich in iron ore and at the terminus of the Baltimore and Ohio Railroad (yes, the one on the Monopoly board), would be extremely valuable once the B&O was operating.

Alas, the B&O was not. Designed for horse-drawn carriages, the tracks wound in tight curves through the rolling hills of Maryland. When George Stephenson introduced the steam locomotive in England in the late 1820s, the B&O wanted to purchase one for its own use, but Stephenson's locomotive could not negotiate the curves laid down in Maryland. The engineers were stumped. The investors refused to provide more funds. By 1830 the B&O Railroad faced bankruptcy, and Cooper faced a precipitous drop in the value of his Baltimore property.

Cooper, an inveterate tinkerer, cobbled together a locomotive with a shorter wheelbase and smaller wheels than Stephenson's model. The engine, later nicknamed "Tom Thumb," first ran on the B&O's convoluted tracks in 1830 (see Sidebar). Although it was so slow that it once lost a race to a horse, it was the first successful steam locomotive built in America. As Cooper points out, the "Tom Thumb" made the future development of railroads in the United States feasible by demonstrating that railroad tracks could be built over rough terrain without great expense.

Railroads were crucial to America's expansion. They moved passengers and freight rapidly and inexpensively across terrain where canals such as "Clinton's Ditch" (#48) would have been impossible to construct. They lowered costs and spurred heavy industry and large-scale manufacturing. They spawned new methods of corporate financing. "No invention in history had so swift and decisive an effect upon the world economy as did the railroad," asserts Gordon in *The Great Game*. "Indeed, it might almost be said that the railroad created the world economy out of a myriad of local ones."

Although Cooper's successes and innovations ranged from the I-beam and the "Tom Thumb" to powdered gelatin (hello, Jell-o!), as a child Cooper only attended school for fifty-two days. He felt strongly that had he been better educated, he would have wasted less time trying to implement ideas that were physically impossible. So when Cooper was in his sixties, he established and endowed the Cooper Union for the Advancement of Science and Art. The Union offered free evening courses to thousands of working-class New Yorkers. Augustus Saint Gaudens, who sculpted the *Cooper*, was one of the Union's earliest and most illustrious pupils (class of 1864), studying drawing there while he worked as a

cameo-cutter. The Cooper Union's home was New York's first fireproof building, and at seven stories its tallest. Its Great Hall was the scene of speeches by Ulysses S. Grant, Theodore Roosevelt, Susan B. Anthony, and Frederick Douglass, as well as the "Right Makes Might" speech of February 27, 1860, that established Abraham Lincoln's antislavery platform.

11 Alexander Lyman Holley

Sculptor: John Quincy Adams Ward. Pedestal: Thomas Hastings.
Dedicated: 1890.
Medium and size: Bronze bust (approximately 3.25 feet), limestone
 pedestal (approximately 10.25 feet).
Location: Washington Square, west of the central fountain.
Subway: A, B, C, D, E, F, or V to West 4th Street.

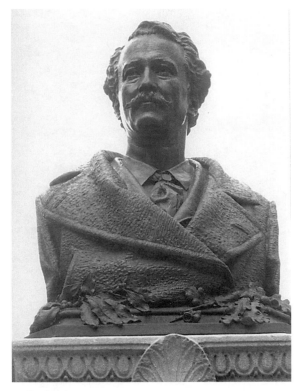

Holley, Ward

Holley on Making Steel

A million balls of melted iron tearing away from the liquid mass, surging from side to side and plunging down again, only to be blown out more hot and angry than before. Column upon column of air, squeezed solid like rods of glass by the power of 500 horses, piercing and shattering the iron at every point, chasing it up and down, robbing it of its treasures, only to be itself decomposed and hurled out into the night in a roaring blaze. As the combustion progresses the surging mass grows hotter, throwing its flashes of liquid slag. And the discharge from its mouth changes from sparks and streaks of red and yellow gas to thick full white dazzling flame.... The converter is then turned upon its side, the blast shut off, and the carburizer run in. Then for a moment the war of the elements rages again—the mass boils and flames with higher intensity and with a rapidity of chemical reaction, sometimes throwing it violently out of the converter's mouth. Then all is quiet, and the product is steel, liquid, milky steel that pours out into the ladle from under its roof of slag, smooth, shiny, and almost transparent.

—Holley, ca. 1870–1880 (quoted in Elting E. Morison, *Men, Machines and Modern Times*)

About the Sculpture

With his direct gaze and upright carriage, Holley appears to be intelligent, levelheaded and self-controlled—desirable characteristics in a man who routinely built and operated the plants for the steel-making process he describes in the Sidebar. His curly hair and the nubbly texture of his overcoat nicely set off his handsome, strong-featured, unlined face with its broad forehead and cavalry mustache. At the right, a twig of oak leaves alludes to the honor being paid to him.

Doubtless Holley slept, laughed at jokes, and tied his shoes, but this bust presents a stripped-down Holley: the features and expression that show

him as the type of person who understood dangerous industrial procedures and complex machinery, and confidently relied on his own judgment to control them. Those characteristics, and of course his detailed knowledge of the Bessemer process (see About the Subject), made him invaluable to the American steel industry in the late nineteenth century.

Twenty years after Holley introduced the Bessemer process to the United States, when Americans were as blasé about rolled steel as today's ten-year-olds are about the Internet, the *New York Times* derided the idea of setting Holley's bust up in a public place: "The time is coming ... when sites for statues in the Park will be too scarce to be assigned to effigies from which the general public will derive its first knowledge that the originals of them have existed" (April 24, 1890). But like those who donated funds for *Dodge* and *Sims* (#24, 47), Holley's colleagues thought he deserved to be honored:

> Our heroes are not alone those who have repelled invasion, suppressed rebellion, or broadened our boundaries by conquests of the sword or pen, but in a better sense those who have made the great forces of nature subservient to our purposes, and placed at the command of industry and enterprise the means which have rendered possible a national development that commands the admiration of the world. [James C. Bayles at the dedication of the Holley bust, *New York Times*, October 3, 1890]

Art's most important purpose is to help you reaffirm your own view of the world. (See *Hale*, #8.) The right art can remind you of the sort of person you want to be: a brilliant inventor like John Ericsson, a courageous patriot like Nathan Hale, a dignified leader like Washington (#2, 8, 6). For Holley's colleagues and for anyone familiar with Holley's lifework, this sculpture is a reminder of how much one individual can accomplish through diligent thought and hard work.

About the Subject

After the B&O Railroad's success in 1830 (see *Cooper*, #10), railroad tracks snaked across the United States. A thousand miles were laid by

1835, 30,000 by 1860. But under the enormous weight of locomotives and freight, iron rails often lasted barely two years. When the next great age of railroad expansion occurred, immediately after the Civil War, the life of rails was closer to fifteen years, because they were made largely of Bessemer steel—a material whose use in America was brought about almost single-handedly by Alexander Lyman Holley (1832–1882).

During a Civil War trip to Europe to study weaponry, Holley observed Henry Bessemer's new process for making steel. Steel was more resilient than iron and could be poured or rolled directly into any desired shape. The major advantage of Bessemer's process, however, was its speed.

Before Bessemer's time, producing even small quantities of steel required weeks of intensive labor. Bessemer perfected a method of blowing a tremendous blast of air through melted pig iron to remove all impurities, and then adding the desired amount of carbon while the metal was still molten. (For Holley's description of this spectacular process, see Sidebar.) A Bessemer converter could produce two tons or more of steel in about twenty minutes. Because it was homogeneous and its carbon content precisely controlled, it was higher-grade steel than any produced previously.

Grasping that Bessemer's process could have a tremendous impact on American industry, Holley persuaded his employer to purchase the American rights to the process and to license its use to other American manufacturers. His designs were the basis for eleven of the twelve Bessemer plants eventually built in the United States. In just thirteen years annual production of Bessemer steel rose from 3,000 tons to well over a million. Most of it was used by the railroads, whose mileage nearly doubled in the six years after 1867, from 39,276 to over 70,000 miles.

The last American Bessemer plant was phased out in the 1970s. A hundred years earlier, however, Holley had already recognized the advantages of the Siemens brothers' open-hearth process of steel making. He convinced several clients of its value but died in 1882, at age fifty, before he could supervise construction of such plants.

Holley is a perfect example of the businessman acting as the link between the scientist's theoretical discoveries and the material goods such discoveries make possible. Although neither a technological nor a finan-

cial genius, Holley made a respectable living by spreading a new technology. In so doing, he brought radical and beneficial innovations not only to steel makers but to all American industry. The life of everyone who rode a train or used goods transported by rail—and that meant nearly all Americans—was immeasurably improved by Holley's dedication to doing his best in his chosen field.

12 Washington Arch

Sculptors: Hermon MacNeil (Washington as commander in chief) and Alexander Stirling Calder (Washington as civilian). Architect: Stanford White.

Dedicated: Arch 1895, MacNeil's *Washington* 1916, Calder's 1918.

Medium and size: Marble, overall 77 x 62 feet. Each *Washington* is 16 feet tall.

Location: Washington Square Park, Fifth Avenue at Washington Square North.

Subway: A, B, C, D, E, F, or V to West 4th Street.

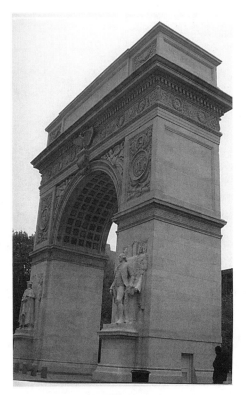

Washington Arch, MacNeil and Calder

George Washington, soldier

George Washington, civilian

Washington on the Proposed New Constitution
It is too probable that no plan we propose will be adopted. Perhaps another dreadful conflict is to be sustained. If, to please the people, we offer what we ourselves disapprove, how can we afterwards defend our work? Let us raise a standard to which the wise and the honest can repair. The event is in the hand of God.

—George Washington, 1787 (reported by Gouverneur Morris, 1799)

About the Sculpture

The symbolism of the *Washington Arch,* a marble version of one of four wooden triumphal arches erected in 1889 to celebrate the hundredth anniversary of George Washington's first inauguration (see #6), is nearly as complex as that of French's *Continents* (#4). As in the *Continents,* the elements add up to a theme more complex than any single figure could convey.

On the northeast side of the *Arch* stands Washington as commander in chief. The caped cloak, tricorn and gloves recall the brutal winter of 1777–1778 at Valley Forge. Yet Washington looks into the distance, upright and unmoving: feet parallel, weight evenly balanced, hands resting on the hilt of an unsheathed sword. He's prepared to fight, yet calm and commanding—two of the qualities his compatriots most admired in him, and that helped his soldiers endure grueling periods such as those at Valley Forge.

At Washington's feet are the business end of a cannon and a cannonball. Flanking him are two allegorical figures in low relief. The figure on our left, Fame, carries the palm branch that signifies peace or fame. She also holds a trumpet, the usual allegorical way of announcing fame (hence "blowing your own horn"). Valor, on our right, wears a helmet and carries a sword in his left hand, the hilt raised to his shoulder. Behind his head are oak leaves, symbolizing courage. Between the two allegorical figures is a blank shield encircled by a wreath, which frames and thus emphasizes Washington's head.

On the right side of the *Arch*, Washington as president wears an elegant coat, waistcoat, and knee breeches. He stands relaxed, weight on one leg, holding an open book and resting his hand on a lectern. It's the pose of a public figure rather than a scholar. To the left of this Washington stands Wisdom, represented as the helmeted Greek goddess Athena. In her right hand she raises an unidentified object. Her right arm presses a long scroll against her body. Behind Wisdom's head are clumps of pine needles, perhaps a reference to Washington's Southern heritage or his enduring reputation.

On Washington's other side stands the muscular figure of Justice, wearing a battlemented crown and holding the traditional scales and sword. Instead of wearing a blindfold, he has simply closed his eyes. Behind Justice is a curved ax head whose handle Wisdom's left hand grasps. Perhaps it refers to the execution of a sentence once Justice has decided the matter.

Behind Washington's head, carved on the pages of an open book that Justice grips with his right hand, is Washington's motto: *Exitus acta probat,* "The result (or outcome) justifies (or tests, or proves) the deed." In

its colloquial translation, "The end justifies the means," it's an unexpected motto for a man as principled as Washington. A better translation—buttressed here by its close relationship to Justice—might be, "Judge me by the results of my actions."

The two major sculptural groups on the *Arch* show two facets of Washington: as a renowned and courageous military leader, and as a wise and just civilian leader. The subsidiary decoration reinforces and elaborates those images. Above the keystones on the north and south side are fierce American eagles by Philip Martiny. Flanking them in the spandrels are winged figures by MacMonnies, sculptor of *Nathan Hale* (#8). Fame blows a trumpet; War brandishes a trident and a laurel wreath.

In the upper level of the *Arch* are four coats of arms. At the northeast side, above Washington as commander in chief, are the arms Washington adopted from his British ancestors, bearing three stars above two bars. (These may have been Betsy Ross's inspiration for the Stars and Stripes.) Below the shield on a banner is the same Latin motto that appears behind the figure of Washington as president. At the northwest, above Washington as president, is the Great Seal of the United States. On the southwest are the arms of New York City, and on the southeast, those of New York State.

The inscription at the top of the south side of the *Arch* reads, "Let us raise a standard to which the wise and the honest can repair. The event is in the hand of God.—Washington." This single brief quote summarizes the type of man Washington was, and the type of men he hoped to associate with and lead. (See Sidebar and About the Subject.) The message of the complex imagery on the *Arch* is more than the sum of its parts. It's a tribute to the Father of Our Country as a courageous military leader, a wise and just civilian leader, and a man of incorruptible integrity.

About the Subject

The statues on the north side of the *Washington Arch* show Washington as commander in chief and as president (compare #13, 6), but the *Arch's* only inscription refers to Washington's other important contribution to

the newly independent United States: his participation in the Constitutional Convention.

A mere five years after he had accepted General Cornwallis's surrender at Yorktown, Washington saw the United States disintegrating under the toothless Articles of Confederation. When mobs stormed Massachusetts courthouses during Shays' Rebellion (1786–87), Washington wrote to Henry Lee:

> I am mortified beyond expression when I view the clouds, that have spread over the brightest morn that ever dawned upon any country.... It is hardly to be supposed, that the great body of the people, though they will not act, can be so shortsighted or enveloped in darkness, as not to see rays of a distant sun through all this mist of intoxication and folly.... Let us have [a government] by which our lives, liberties, and properties will be secured, or let us know the worst at once.... If defective, let it [the Articles] be amended, but not suffered to be trampled upon whilst it has an existence.

Washington had hoped to retire to Mount Vernon, but in 1787 acquiesced when Virginia chose him as a delegate to the Constitutional Convention in Philadelphia. In the same room where the Declaration of Independence and the Articles had been signed, and where the Congress met that had been his titular superior during the Revolutionary War, Washington was unanimously elected president of the Convention.

He arrived punctually for every session, six days a week for over four months, but hardly ever spoke. Perhaps he feared his authority would have disproportionate influence on the debates. The statement attributed to him by Gouverneur Morris (see Sidebar) was probably made outside the official sessions. Yet Washington's mere presence among these men who had voted him commander in chief, served with him in the army, or visited him at Mount Vernon was enough to remind the delegates of the exacting thought and unbreached integrity that would be required to hammer out a practicable governing document for the United States.

13 George Washington

Sculptor: Henry Kirke Brown. Pedestal: Richard Upjohn.

Dedicated: 1856.

Medium and size: Bronze (approximately 9 feet), granite pedestal (approximately 9 feet).

Location: South side of Union Square, facing East 14th Street between University Place and Broadway.

Subway: 4, 5, 6, N, R, Q, W, or L to Union Square.

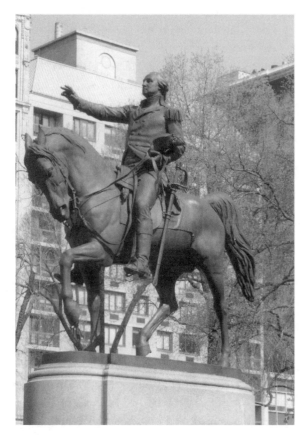

Washington, Brown

General Washington Returns to New York

We had been accustomed for a long time to military display in all the finish and finery of garrison life; the troops just leaving us were as if equipped for show, and with their scarlet uniforms and burnished arms, made a brilliant display; the troops that marched in, on the contrary, were ill-clad and weather beaten, and made a forlorn appearance; but then they were *our* troops, and as I looked at them and thought upon all they had done and suffered for us, my heart and my eyes were full, and I admired and gloried in them the more, because they were weather beaten and forlorn.

—Eyewitness at Evacuation Day, November 25, 1783 (reported in Washington Irving, *Life of George Washington*, 1855–1859)

About the Sculpture

Large as this sculpture is, it implies more than it includes. Let's find out what's going on. Is Washington riding into battle or riding in a parade? The measured pacing of his horse, the fact that *Washington* has his hat tucked under his arm and only one hand on the reins, and most of all the way his right arm is stretched out in front of him, all suggest that this is a ceremonial occasion. Is Washington greeting a single person or a group? The arm, outstretched horizontally, suggests a group. Seeing a friend, you'd raise your arm and wave, rather than extending it in that regal manner.

Does the crowd Washington greets respect him or hate him? Surely they respect him; he doesn't have the bearing of a man dodging tomatoes or replying to hecklers. In the equestrian states of the *Cid, Jagiello,* and *Joan of Arc* (#54, 39, 44) the riders are about to gallop into battle. Here the hero is returning in triumph to fellow citizens who honor him. (For the particular event commemorated, see About the Subject.)

The pose of Saint Gaudens's *Cooper* (#10) "quoted" representations of kings and prophets to give authority to a nineteenth-century philanthropist. In *Washington,* Henry Kirke Brown is also quoting. *Washington* bears

a remarkable resemblance to the equestrian statue of Marcus Aurelius, Rome's philosopher-emperor, that has stood in Rome since the second century A.D. Both figures are in military dress. (Roman military dress was a tunic, not the lavishly draped and suffocatingly hot toga.) Both figures have their right arms raised, palms down. Both ride well-mannered horses, and the position of the horses' feet and tails are very similar. The differences in pose are minor, notably that the emperor's head is bowed, as if he's deep in thought. *Washington* instead looks to the crowd around him.

Such strong resemblances can't be accidental. What did Brown achieve by making *Washington* so similar to *Marcus Aurelius?* He gave *Washington* status by association. George Washington, the Father of Our Country, is compared to one of the most renowned, and certainly the most intellectual, of the Roman emperors. Simply showing Washington on a horse would literally raise him above the crowd. Associating him with Marcus Aurelius elevates him metaphorically as well.

Of course, not everyone will recognize the resemblance between *Washington* and *Marcus Aurelius.* Does that mean the artist shouldn't have incorporated it? No. Viewers unfamiliar with the Roman statue can still easily recognize Washington's dignity and leadership, as well as the respect in which he's held by those he's greeting. Those who do recognize the resemblance will have an extra "layer" of understanding about *Washington.* Sculptors, like novelists, can layer their works so that viewers will continually discover new aspects to ponder.

About the Subject

Through the nineteenth century, the image was familiar: a sailor clambering up a flagpole to hoist the Stars and Stripes. The British, finally evacuating New York on November 25, 1783—two years after the last battle in the Revolutionary War—had left a mocking memento. They nailed the British flag to the pole at the Battery, cut the halyards, and greased the pole. To the cheers of a patriotic crowd, a sailor finally shimmied up the pole with the American flag. A thirteen-gun salute marked the raising of the flag after seven years of British occupation. Then, at last, General

Washington rode down Broadway to ceremonially reclaim the city for the Americans.

The devastation Washington saw on his way downtown must have dismayed even such a courageous man as the commander in chief. During the British occupation two catastrophic fires had swept through the city: charred ruins stretched for three-quarters of a mile. (See #8.) Fortifications disrupted street traffic. Public buildings, used as barracks or stables, were in shambles. The wharves and warehouses on which New York's thriving prewar trade had depended were disintegrating; the merchant fleet that had sustained them had fled or been destroyed. Every tree, fence, and ornamental shrub had been burned for fuel. Looking at the raw wound of Ground Zero 220 years later, it's heartening to recall that New York has been struck by disaster before, and New Yorkers— stubborn, creative, and commercially minded—have always rebuilt their city better than ever.

For over a hundred years Evacuation Day was celebrated in New York with a military parade and a school holiday. Today its only public memorial is *Washington* in Union Square, commemorating the moment and the spot where Washington met an official deputation sent to welcome him to the city. The statue itself testifies to the importance of Evacuation Day: this *Washington* was the first large-scale bronze erected in Manhattan in the three-quarters of a century following the Revolutionary War.

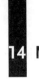

14 Marquis de Lafayette

Sculptor: Frédéric-Auguste Bartholdi. Pedestal: H. W. DeStuckle.
Dedicated: 1873.
Medium and size: Bronze (8 feet), granite pedestal (6.5 feet).
Location: Union Square at East 16th Street.
Subway: 4, 5, 6, N, R, Q, W, or L to Union Square.

Lafayette, Bartholdi

Lafayette on the Success of the French Revolution

Although warlike preparations are going on, it is very doubtful whether our neighbours will attempt to stifle so very catching a thing as liberty. The danger for us lies in our state of anarchy.... That liberty and equality will be preserved in France, there is no doubt; in case there were, you well know that I would not, if they fall, survive them. But you may be assured, that we shall emerge from this unpleasant situation, either by an honorable defence, or by internal improvements.... The success of our revolution cannot be questioned.

—Letter to George Washington, March 15, 1792

About the Sculpture

What makes this figure of Lafayette so unlike the Manhattan sculptures of Washington, Hamilton or Jefferson? Well, he looks ... aristocratically elegant, as we'd expect a nobleman to look. What makes us think so? To answer that, it's important not only to study the details of the sculpture, but to state what effect they have. Otherwise we'll end up with nothing but a laundry list of concrete observations.

Lafayette is stepping forward and turning at the same time. He could almost be dancing, which is partly why he seems so elegant. He's also slender, compared to Ward's *Washington* or Brown's *Lincoln* (#6, 15). That, too, adds to his debonair demeanor. *Lafayette's* sword is drawn, but instead of brandishing it as if in battle, he has raised it to his heart. Clasping a hand to one's heart is universally a sign of sincerity— schoolchildren do it while reciting the Pledge of Allegiance. Lafayette's right hand is extended to a figure we can't see. Since he was famous for offering his services to Washington, we can assume that's who *Lafayette* is looking at. In fact, Bartholdi's *Lafayette* was originally situated facing Brown's *Washington* (#13).

Looking at *Lafayette's* face, we see that the bone structure is sharply defined, not at all like Washington's broad features or Lincoln's rugged

ones. Surely not all French aristocrats had such features, but this is the stereotypical image of one. *Lafayette's* expression is solemn, in accord with the sincere gesture of offering his services and his sword to Washington.

Lafayette's aristocratic image is confirmed by a high-maintenance hairdo. Its complexity (curls over the ears, queue behind, perfect symmetry) implies that Lafayette has the time or the servants to be concerned with the most minute details of his appearance—or, at the very least, he has money and taste for an expensive wig.

His uniform confirms that he's wealthy: it's simple but exquisitely fitted. (When was the last time you had a pair of knee-high leather boots that fit so well?) The uniform also unobtrusively asserts his rank: one epaulet shows beneath the luxurious folds of his cape.

Now when asked why *Lafayette* seems so aristocratically elegant, we can cite specific details that create that impression: his almost-dancing pose, his slender proportions, the refined bone structure of his face, the high-maintenance hair, the simple yet expensive outfit. We can add that he's solemnly, sincerely offering his services to Washington.

Remember that on a first visit, you won't notice all the details of a sculpture, much less grasp all their implications. (See *La Guardia*, #9.) I'd seen the *Lafayette* many times before I noticed what his feet rest on. Can you tell what it is? Why do you suppose the sculptor included this detail? What aspect of Lafayette's life and character is it meant to remind you of? (Hint: read About the Subject.)

About the Subject

Lord Acton wrote that Lafayette taught his compatriots the American "theory of revolution, not their theory of government—their cutting, not their sewing." Gouverneur Morris told George Washington that Lafayette "left America, you know, when his education was but half-finished. What he learnt there he knows well, but he did not learn to be a government maker." What did these two astute political observers mean?

When he sailed to America in 1776, violating a direct order from his king, the nineteen-year-old Marquis de Lafayette was handsome, charis-

matic and extraordinarily wealthy. To the wife he left behind he explained, "The happiness of America is intimately connected with the happiness of all mankind; she is destined to become the safe and venerable asylum of virtue, of honesty, of tolerance, and of peaceful liberty."

Lafayette's bravery at the Battle of Brandywine made him a favorite of Washington. In an army where men still tended to think of themselves as residents of separate states rather than of a new nation, Lafayette became one of the few figures admired from New Hampshire all the way to Georgia: "Our Marquis," they called him. Benjamin Franklin gave Lafayette credit for persuading the French king to sign a treaty of alliance with the United States. The ammunition and troops that arrived because of that treaty were a definitive factor in the American victory. When Cornwallis surrendered at Yorktown in 1781, Lafayette stood in a well-earned position at Washington's side.

Back home in France, a hero to nobles and bourgeois alike, Lafayette eagerly set out to introduce American-style liberty to his native land. In July 1789 he proposed to the National Assembly the Declaration of the Rights of Man and Citizens, co-authored with his friend Thomas Jefferson. But when the Declaration was approved two months later, it had been substantially altered. Jefferson was strongly influenced by Locke, who emphasized individual rights. In France the favored political philosopher was Rousseau, who argued that the state, as the agent of the General Will, has the right and obligation to override individual rights if the public good demands it.

Without Locke's ideas as groundwork, a government on the American model was impossible. Lafayette knew how to lead an army to displace the old regime, but didn't know the principles necessary to set up a new, improved government. Hence, writing to Washington in March 1792, Lafayette admitted that the French constitution was not as good as the American one, but optimistically predicted that "the success of our revolution cannot be questioned." (See Sidebar.)

Even as he wrote, events were spinning out of control. Demagogues roused the Paris mobs. Heads rolled. Extremists in the National Assembly overthrew the monarchy, imprisoned the royal family, and charged thirty-five-year-old Lafayette with treason. He fled France—only to be

imprisoned as soon as he crossed the border to Belgium. Lafayette had offended his fellow revolutionaries, but he had horrified European monarchs, whose thrones were tottering in the shockwaves of France's Revolution. When he finally returned to France after five years in prison, Lafayette was so weak he could barely walk.

Yet he never gave up. In 1803, when Jefferson offered him the governorship of the newly purchased Louisiana Territory (#50), Lafayette sighed that he could not leave his homeland while he had "even the smallest hope" of bringing liberty to France.

15 Abraham Lincoln

Sculptor: Henry Kirke Brown.
Dedicated: 1870.
Medium and size: Bronze (11 feet), granite pedestal (approximately 14.5 feet).
Location: Union Square, on a line with East 16th Street.
Subway: 4, 5, 6, N, R, Q, W, or L to Union Square.

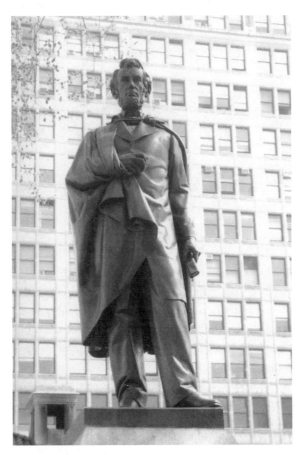

Lincoln, Brown

Lincoln on Suspension of *Habeas Corpus*

He who dissuades one man from volunteering, or induces one soldier to desert, weakens the Union cause as much as he who kills a Union soldier in battle. Yet this dissuasion or inducement may be so conducted as to be no defined crime of which any civil court would take cognizance.

Ours is a case of rebellion—so called by the resolutions before me—in fact, a clear, flagrant, and gigantic case of rebellion: and the provision of the Constitution that "the privilege of the writ of *habeas corpus* shall not be suspended, unless when, in cases of rebellion or invasion, the public safety may require it," is *the* provision which specially applies to our present case.

I can no more be persuaded that the Government can constitutionally take no strong measures in time of rebellion, because it can be shown that the same could not be lawfully taken in time of peace, than I can be persuaded that a particular drug is not good medicine for a sick man, because it can be shown not to be good food for a well one.

—Letter to the Albany Democratic Committee, June 12, 1863

About the Sculpture

Ask any critic to name the country's best statues of Abraham Lincoln, in purely artistic terms, and this statue won't even make the short list. In a moment I'll discuss which one would probably be chosen, but first: how can we judge the aesthetic quality of this or any sculpture? Is there a way to do it rationally and objectively, rather than just making arbitrary assertions?

Whether you admire or detest Lincoln's actions as president is irrelevant to a discussion of this sculpture in aesthetic terms. Evaluating art as art means evaluating the means rather than the content: the "how" rather than the "what." In turn, that requires knowing what art's function is—otherwise we can't say if it fulfills that function, or how well. The

function of art is to summarize a view of the world in a vivid, memorable image. (See *Hale*, #8.) That leads to two closely related requirements.

First, a work of art must be clear. We, as viewers, must be able to figure out what the piece is about and what the artist thinks about it. Michelangelo's *David* shows a young man armed with a sling who seems relaxed (the stance) but also alert for an approaching danger (the frown lines). The Hellenistic *Laocoon Group* shows a man and his sons fighting bravely but being defeated by monstrous snakes. We may disagree with the artist's point of view, but the message in both cases is perfectly clear.

Second, a work of art must be integrated. Every detail must help convey the message. None can lead the viewer off on a tangent by making him wonder what the devil it's doing there. Imagine *David* wearing only one sandal, or *Ericsson* (#2) carrying a model of the *Monitor* in one hand, a dozen roses in the other. For us as viewers, combining such disparate elements is like trying to fit the pieces of two different jigsaw puzzles together. As soon as we start worrying about why the artist included certain odd details, we stop seeing the work of art as a single, memorable image.

Now let's return to *Lincoln*. The critics' choice for best sculpture of *Lincoln* would probably be Saint Gaudens's *Standing Lincoln* in Chicago (1887). Brown's and Saint Gaudens's figures are both recognizable portraits of Lincoln. Both are dressed in appropriate period costume. Yet Saint Gaudens's effort is aesthetically superior, because it presents Lincoln's character more vividly.

How? The head of Saint Gaudens's *Lincoln* is bent, as if he's deep in thought; his furrowed brow confirms that. Brown's *Lincoln* gazes calmly into the distance rather than introspecting.

Saint Gaudens's *Lincoln* wears snugly fitting clothes that reveal his

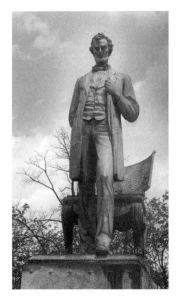

Saint Gaudens, *Lincoln*.
Photograph by David Finn.

lean, angular body. The gauntness combined with the bent head and furrowed brow suggest that this is a man whose concerns are so pressing that he doesn't have the time or the desire to eat. Brown's *Lincoln* wears looser garments that conceal his body. The cape looped over his arm, a neoclassical touch reminiscent of a Roman orator, gives *Lincoln* some time-honored associations and authority (see *Washington,* #6), but makes his figure even bulkier.

In pose and costume, Brown's *Lincoln* could be any late nineteenth-century notable. The eminent rank of Saint Gaudens's careworn *Lincoln* is indicated by the chair behind him, on which the American eagle spreads its wings. It's a seat proper only for a president.

In purely artistic terms, Saint Gaudens's *Lincoln* is undeniably better than Brown's, for the same reasons that Hartley's second *Ericsson* (#2) was better than the languid earlier version, and Ward's *Greeley* (#7) is better than Doyle's. Its details make the sitter's character more obvious, and that makes it aesthetically a better sculpture.

Note that how we react to a sculpture emotionally is a different matter from how we evaluate it aesthetically. On emotional evaluation, see *Booth* and *Conkling* (#17, 18).

About the Subject

In March 1863, after a series of devastating defeats, Union victory in the Civil War seemed more distant than ever. Congress had recently passed unpopular legislation to draft soldiers for the Union army. In early May, Clement Vallandigham told a crowd in Ohio that the war was "wicked, cruel and unnecessary—a war not being waged for the preservation of the Union, but for the purpose of crushing out liberty and establishing a despotism—a war for the freedom of the blacks and the enslaving of the whites."

Vallandigham was arrested a few days later on charges he had violated Union general Burnside's decree that "the habit of declaring sympathies for the enemy will no longer be tolerated in this Department." The arrest caused a pro-Vallandigham furor in Dayton, where telegraph lines were cut and the local newspaper office was torched. Vallandigham was court-

martialed, convicted, and sentenced to close confinement in (horrors!) Boston. His lawyer promptly requested a writ of habeas corpus, which would have required Vallandigham's appearance before a civil court to determine if he was being held illegally. Unfortunately for Vallandigham, Lincoln had suspended habeas corpus throughout the United States in September 1862 in an attempt to curb the spying and disinformation campaigns of Southern sympathizers. Vallandigham was one of 15,000 or so civilians detained without trial. In his case, a judge of the federal district court ruled that no civil court was competent to determine whether the arrest was justified for the government's self-preservation.

In the Vallandigham affair, Lincoln displayed a sense of humor as well as a canny political mind. He transmuted the sentence. Since Vallandigham was so sympathetic to the Confederates, said Lincoln, Vallandigham could spend the duration of the war in the South. But barely a month after he was sent there, Vallandigham slipped through the Union blockade and fled to Canada. A year later Vallandigham resumed his political life in the United States, without any interference from army or administration.

In the meantime, his case had inspired Edward Everett Hale's classic 1863 short story, "The Man without a Country." The protagonist, Philip Nolan, was enmeshed as a young army lieutenant in Aaron Burr's traitorous schemes. At his court-martial he petulantly desired never again to hear of the United States. The judge obligingly ordered Nolan's guards to ensure that he did not. Hale's narrator offers the story as "a warning to the young Nolans and Vallandighams and Tatnalls of to-day of what it is to throw away a country."

Although Vallandigham's role in the Civil War turned out to be minor, his arrest was a cause célèbre at the time and involved issues still controversial enough to raise voices and hackles at your next dinner party. Are there limits to free speech when a country is at war, rather than at peace? Do civilians ever fall under military jurisdiction?

16 Peter Stuyvesant

Sculptor: Gertrude Vanderbilt Whitney. Pedestal: Noel and Miller.
Dedicated: 1936.
Medium and size: Bronze (7.3 feet), granite pedestal (4 feet).
Location: Stuyvesant Square, between East 16th and East 17th Streets,
　　west of Second Avenue.
Subway: L to 1st Avenue.

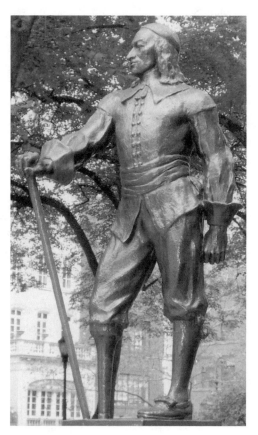

Stuyvesant, Whitney. Used with permission of the
artist's descendant.

Stuyvesant and His Times

He was a Dutchman of the old school called upon to deal with an entirely new spirit of political self-reliance which in turn was born out of that sense of economic independence which seems to be the hereditary right of those born in the New World....

When he accepted the post of Director of the New Netherlands, Stuyvesant had had full reason to expect that he would never be called upon to discuss the problem of "equal rights" with anybody. And now the incredible had happened. He was too ignorant of the inner qualities of the deeply hidden economic forces which were working all around him to understand how it ever could have happened....

Whatever the old Director lacked in tact was richly offset by his tenacity of will and by his personal courage. He could accomplish more with fewer soldiers and with less money than almost any man who ever tried to sit in a game of international poker and win the pot with nothing better than a busted flush.

—H. Van Loon, *Life and Times of Peter Stuyvesant,* 1928

About the Sculpture

The lift of the chin, the out-thrust hip and the tilt of the cane all suggest the authority and aggression that made Stuyvesant one of the most effective leaders of New Netherlands. (See About Subject.) The only feature that keeps this from being a fascinating sculpture is the surface finish. It's more or less the same all over—compare the face and the doublet, for example. It doesn't entice us to linger, studying the details and pondering this man's character and significance.

Why would an artist use such a texture? Whitney was strongly influenced by Rodin, who pioneered a shimmering, irregular, all-over surface pattern. (See *Jefferson,* #50.) While too much detail can be overwhelming (see *Shakespeare,* #37), too little discourages interest. Sculptors such as Saint Gaudens and Ward knew how to include precisely the right

amount of detail, so that the details add interest and information: consider Greeley's homespun coat and Sherman's stubble (#7, 31).

About the Subject

It's August 1664. You're Peter Stuyvesant, and you're in charge of the small Dutch outpost in North America known as New Amsterdam. What's your situation?

You've been employed by the Dutch West India Company for three decades—half your life. In 1644, as you attempted to capture the island of St. Martin for the company, a Spanish cannonball ripped off the lower part of your right leg.

A couple of years later the company named you director-general of New Netherlands. You're responsible for territory stretching from the English colonies at Hartford and New Haven south to the Delaware River. Mind you, it's not a densely populated area: the main settlements are a fortress and trading post on the Delaware, another at Fort Orange (modern Albany) on the Hudson River, assorted towns on Long Island, and your headquarters, New Amsterdam, which huddles behind a defensive wall at the southern tip of Manhattan.

Back home, your fellow Dutch have made up for their lack of land and resources by building a magnificent fleet that trades from Sumatra, Ceylon, and Africa to Brazil, Virginia, and Connecticut. The States-General has given the Dutch West India Company a monopoly on trade in the Americas, on the condition that the company maintain a fleet for trading and defense. As director-general, your job is to keep things running smoothly so that the company makes a profit.

The inhabitants of New Amsterdam are a conglomeration of races, religions, and languages that wouldn't be tolerated anywhere else in the seventeenth-century world except Amsterdam itself. You've kept your charges safe, negotiating a treaty with the English to the North and chasing Swedes away from the Delaware River. You've maintained largely peaceful relations with the neighboring Indians. After all, they're your trading partners, and the West India Company exists to trade. You've done all this despite the fact that the company habitually keeps you short

of soldiers and ammunition. Under your twenty-year leadership, New Netherlands is stable and beginning to prosper.

By the summer of 1664 you're grappling with two tasks: keeping your employer happy by maintaining trade, and quelling the residents of New Amsterdam and Long Island, who are clamoring for a greater voice in local government (see Sidebar). As always, you're also watching your northern and southern borders for attacks by New Englanders or the Indians.

The attack on New Amsterdam comes, unexpectedly, from the east. King Charles II decides that New England is too geographically isolated to become a North American trading center. The key to the interior, with its untapped wealth, is the waterways. New Amsterdam sits at the outlet of a major waterway, the Hudson River. On August 28, 1664, you and the residents of New Amsterdam watch four English men-of-war boldly sail into your harbor. In the name of Charles II, Colonel Richard Nicolls demands the town's surrender. You are a soldier; you detest the idea. But you're also a realist. On September 1, you write to the company:

> We have no soldiers, we have no gunpowder, we are short of food. Furthermore the citizens are completely disheartened. They cannot see that there is the slightest chance of relief in the case of a siege and if the island falls into the hands of the invaders, they fear for the lives of themselves and their wives and their children. It is clearly apparent that this town cannot possibly hope to hold out for more than a very few days.

Your letter never leaves New Amsterdam. No Dutch ship manages to evade the English men-of-war in the harbor.

On September 8, you sign a document turning control of New Netherlands over to the English. Despite your quarrels with the residents and the English, you find you have a fondness for the place. After explaining your actions to a Dutch board of inquiry, you live out your life at your Bouwerie (farm) on Manhattan, in the area now known as Stuyvesant Square.

17 Edwin Booth as Hamlet

Sculptor: Edmond T. Quinn. Pedestal: Edwin S. Dodge.
Dedicated: 1917.
Medium and size: Bronze (approximately 7 feet), granite pedestal (approximately 7 feet).
Location: Inside Gramercy Park, between East 20th and 21st Streets at Lexington Avenue.
Subway: 4, 5, 6, N, R, Q, W, or L to Union Square.

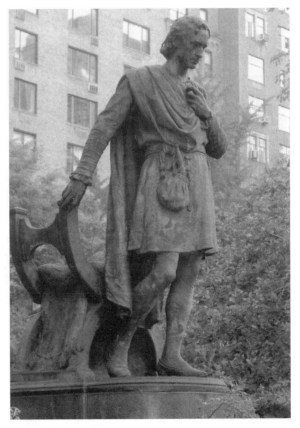

Booth, Quinn

Shakespeare ... Or Not

Now are our Brows bound with Victorious wreaths,
Our stern allarms are changed to Merry-meetings,
Our dreadfull marches to delightful measures.
Then since this Earth affords no joy to me,
But to Command, to Check, and to Orebear such,
As are of Happier Person than my self,
'Why then to me this restless World's but Hell,
Till this mishapen trunk's aspiring head
Be circled in a glorious Diadem.

—Colley Cibber's adaptation of *Richard III*, 1700

Now is the winter of our discontent
Made glorious summer by this sun of York;
And all the clouds that lowered upon our house
In the deep bosom of the ocean buried.
Now are our brows bound with victorious wreaths,
Our bruised arms hung up for monuments,
Our stern alarums changed to merry meetings,
Our dreadful marches to delightful measures.
And therefore, since I cannot prove a lover
To entertain these fair well-spoken days,
I am determined to prove a villain
And hate the idle pleasures of these days.

—Shakespeare's *Richard III*, ca. 1600

About the Sculpture

Why does the same statue bore some people while it thrills others? A few art historians get passionate about the use of gold leaf rather than a green patina, or the anatomy of a kneecap, but most of us become passionate about what we consider important—our own values, as reflected

in a particular work of art. An emotional reaction feels monolithic, but in fact it's made up of two parts. First you grasp the artist's message or theme. Then you evaluate it based on whether that message is good, bad, or indifferent according to your view of the world.

Consider the *George Washington* at Union Square and the *Cid* at the Hispanic Society (#13, 54). If you enjoy the sense of serene triumph that comes after a job well done, you'll probably like the *Washington*. If charging into battle or into a new project appeals more to you, you'll probably prefer the *Cid*.

Do you have the same favorite song today as you did ten years ago? Probably not. If your idea of what's important changes, your reaction to art will change, too. Ten years from now the *Washington* and the *Cid* will be the same, but your reaction may be radically different.

What does this have to do with *Booth?* I could barely force myself to draft an essay about *Booth*. The sculpture bored me. Why, I asked myself, does it bore me? It's not as much fun to analyze as the *Continents* (#4), or as historically important as *Farragut* (#19), but its subject is presented clearly, with interesting details—especially if you can see it close up.

The problem, I finally realized, is that *Booth* shows an actor playing Hamlet. While I appreciate the literary quality of *Hamlet,* I find its story and sense of life depressing. Looking at a statue of its main character makes me want to move right along. Of course, an actor or a Shakespeare aficionado might react very positively to this statue. We're each "right" in our emotional reaction, because we're each judging according to our values.

It is crucial not to confuse your emotional reaction with an evaluation of the aesthetic quality of a given work. You might react positively to a work that's mediocre because you associate it with the day you met your future spouse. You might react negatively to a work that's executed with impressive skill but reminds you of your sadistic tenth-grade trigonometry teacher. For more on aesthetic evaluation, see *Lincoln* (#15).

About the Subject

When Junius Booth, a well-known American actor, played Richard III in the early nineteenth century, his opening words were:

Now are our Brows bound with Victorious wreaths,
Our stern allarms are changed to Merry-meetings. (See Sidebar.)

These were not the opening lines of the performance: before them came a long scene in which Henry VI was told of his son's death in battle. Had you attended *Richard III* several decades later, with Junius's son Edwin Booth (1833–1893) in the title role, the curtain would have risen to these lines:

Now is the winter of our discontent
Made glorious summer by this sun of York.

Junius's lines are from Shakespeare as adapted by Colley Cibber (1671–1757), actor, theater manager, playwright, and poet laureate of England. For nearly two hundred years, Cibber's was the preferred acting version of *Richard III.* Edwin Booth is credited with reverting to Shakespeare's texts when performing *Richard III* and *King Lear.*

Booth was famous, however, for his Hamlet, and that's the role he's playing in this sculpture. In New York's Winter Garden Theater in 1864, he set a record of a hundred consecutive performances of *Hamlet.* The last performance of his career, in 1891 at the Brooklyn Academy of Music, was as Hamlet.

Booth was one of the most popular actors on the American stage, rivaled only by Edwin Forrest (1806–1872). Even the outrage following the May 1865 assassination of President Lincoln by Edwin's brother John Wilkes Booth was not enough to ruin Edwin's career. Declared the *New York Times* in his obituary: "No actor has spoken the words of Shakespeare more correctly or more eloquently ... [He had] a face of uncommon comeliness, a voice of ample range, great beauty of tone and rare flexibility, and a lithe, graceful figure." In their *History of the Theatre,* written half a century after Booth's final performance, Freedley and Reeves describe Booth as "probably America's greatest actor, if contemporary criticism can be believed together with the word of men and women still living who saw him play and who are competent to judge."

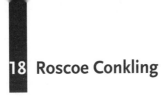

18 Roscoe Conkling

Sculptor: John Quincy Adams Ward.

Dedicated: 1893.

Medium and size: Bronze (5.8 feet), granite pedestal (6.5 feet).

Location: Southeast corner of Madison Square, near Madison Avenue and East 23rd Street.

Subway: 6, N, R, W to 23rd Street.

Conkling, Ward

Herald's Obituary on Conkling

The arts of modern leadership—tact, compromise, recognition of the limitations and weakness of devoted friendship—were unknown to his haughty spirit. He rather led the leaders of men.... Generations will come and go before the example of this extraordinary man, his eloquence and learning, his undaunted devotion to truth, his purity and courage, his uncompromising patriotism, his scorn of cant and deception, will be forgotten.

—*New York Herald,* April 18, 1888

About the Sculpture

Conkling (another top-notch creation by John Quincy Adams Ward) is handsome and well dressed. The turn of his head makes him seem alert, not stiffly posing. The way his left thumb hooks casually on his pocket makes him seem relaxed, but the movement of his right hand suggests that he's speaking, making a point. Overall he's livelier than either *Washington* or *Lincoln* (#6, 15).

What's your emotional reaction to this man? Jot down a couple of adjectives, positive or negative. If you met him at a party or a business meeting, would you admire him? Would you speak to him? Would you avoid him? What about his pose or expression makes you feel that way?

Here's a quote from Chidsey, one of Conkling's biographers: "A political boss, indeed; and one of the harshest, strictest, most narrow-minded of all political bosses. Possibly like Pooh Bah he was born sneering."

Look at the statue again. Has your reaction changed? How do you interpret the expression, gestures, and pose now?

Then again, noted orator Robert Green Ingersoll described Conkling thus:

He stood for independence, for courage, and above all for absolute integrity.... He not only acted without fear, but he had that forti-

tude of soul that bears the consequences of the course pursued without complaint. He was charged with being proud. The charge was true.... Vanity rests on the opinion of others—pride, on our own.

Look yet again at the sculpture: now how do you interpret the expression and pose?

Chances are you've changed your mind twice in as many minutes. That can happen with an emotional reaction to a work of art, because the reaction is a combination of the details and the theme of the sculpture, plus your own values. (See *Booth*, #17.) The concretes of this sculpture haven't changed a bit in the last two minutes, but learning more about the figure represented has changed your interpretation of them. A glance that seemed friendly and inquiring suddenly looks disdainful. A gesture that appeared relaxed suddenly appears dismissive.

Let this be a warning if you're inclined to judge people based on their reaction to paintings, sculptures, songs, movies, or other arts where ideas are implied rather than stated explicitly. Particularly if you're discussing art with a friend, you should have the courtesy and the curiosity to find out what element of the work your friend is reacting to, before condemning the friend. Works of art are not and should not be philosophical litmus tests.

About the Subject

Was Conkling (1829–1888) a political boss or a man of impeccable integrity? The evidence I've seen could go either way. President Ulysses S. Grant said of his trusted adviser, "For the ability to seize and solve problems of State, Roscoe Conkling has had no equal in this country." Despite his close association with Grant's scandal-ridden administration, Conkling's *New York Times* obituary noted that "from his youth until death claimed him he stood in the glare of publicity. In all that time no breath touched his integrity." Yet he resigned from Congress over a dispute about political patronage with President Garfield: how does that fit this picture?

As a scholar, I can think of many avenues to investigate. Go through the Congressional Record to see what legislation Conkling promoted, and with whom. See what else President Grant said about Conkling. From the biographies cited in Conkling's entry in the *American National Biography*, put together a list of Conkling's friends, colleagues, and opponents and see what they wrote about him. Search the *New York Times* and other New York newspapers for references to his speeches and actions. Look at the cartoons of Thomas Nast, who frequently lampooned Conkling: what characteristic or action of Conkling roused Nast's wrath? Evaluate all these sources based on reliability in other matters and on party loyalty. Set them all in the context of New York State and United States politics in the decades just after the Civil War.

This amount of research and analysis would be enough to justify a doctoral dissertation. Switching abruptly from scholarly researcher to writer with a deadline, I'm afraid I'll have to leave you not with a definitive analysis of Conkling's character, but with these tantalizing questions.

19 Farragut Monument

Sculptor: Augustus Saint Gaudens. Original bluestone pedestal by Saint Gaudens and Stanford White; granite copy by Works Progress Administration artists, 1935.

Dedicated: 1880.

Medium and size: Bronze (7.5 feet), granite pedestal (8.75 feet).

Location: North end of Madison Square (near Fifth Avenue and East 26th Street).

Subway: 6, N, R, or W to 23rd Street.

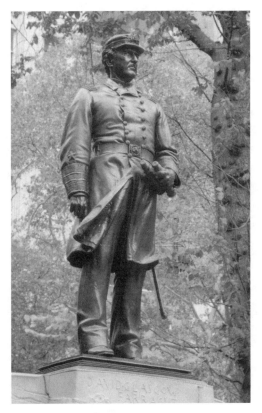

Farragut, Saint Gaudens

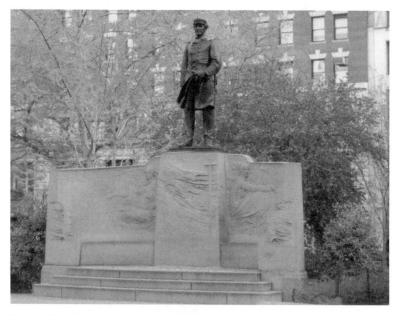

Farragut, Saint Gaudens

A Painter's Thoughts on *Farragut*

When I went over to see your statue this morning, and saw the whole thing there before me, it fairly took my breath away, and brought my heart into my mouth. It is perfectly magnificent. I haven't felt so about anything for years. The sight of such a thing renews one's youth, and makes one think that life is worth living after all. I felt as I have only done about a few things in my life ... I was surprised to see how the rabble about the statue spoke of it, and how they seemed to be touched by it. It is a revelation to them, and what is more, I feel that they are ready and longing for better art. It cheers one to think it.

—Maitland Armstrong to Saint Gaudens, 1880 (quoted in Saint Gaudens's *Reminiscences*)

About the Sculpture

Few works have altered the course of American sculpture: this is one of them. For most of the nineteenth century, the neoclassical style dominated American sculpture. Ward's *Washington,* Brown's *Lincoln* (#6, 15), and Pickett's *Samuel F. B. Morse* (Central Park at East 72nd Street) have capes that might almost be togas. The *Statue of Liberty* is dressed like a Greek. Symbols of the Roman Republic, such as the fasces, appear frequently (*Washington, Washington Arch,* #6, 12). In an extreme instance that startled even his contemporaries, Horatio Greenough portrayed Washington in 1841 as an Olympian Zeus, bare to the waist and seated on a throne.

Farragut, by contrast, wears the uniform of a Civil War naval officer, accurately depicted right down to the eagles on the buttons. He carries binoculars in one hand and lifts his head to scan the distance, bracing his feet as if on a heaving deck. The front of his knee-length coat blows open with the wind of his ship's motion.

These details add up to a major difference from earlier portraits. *Farragut* looks as if he were doing his job—commanding a fleet—rather than posing for a portrait. "He is so quiet," commented Lorado Taft, "that he seems to move." It was an extraordinary innovation, but not the only one Saint Gaudens incorporated into this memorial.

Pedestals of portrait statues were typically simple and rectangular with a few inscribed lines, intended only to raise the figure above the passing throng. Typical are the *Lafayette* and *Washington* at Union Square (#14, 13)—both familiar to Saint Gaudens. Departing from this norm, Saint Gaudens requested the assistance of his friend architect Stanford White to create a pedestal that adds to the viewer's knowledge of Farragut's character and actions. For the broad stone base, Saint Gaudens designed figures in relief of Loyalty (on the left) and Courage (on the right, wearing a breastplate). A lengthy inscription in elegant lettering describes Farragut's achievements. The background is an irregular series of waves, the terminals leaping fish. Since the original stone had a bluish tint, the whole pedestal recalled the sea.

Although the pedestal is considerably larger than *Farragut,* it's calculated to draw attention to him. The top edge slants gently up toward the center, where two vertical lines draw our gaze up to the figure. The upward movement is continued by the vertical lines of Farragut's legs and sword and the double line of buttons. Without conscious effort, our eyes finish on *Farragut's* face—a relatively small part of the composition. The pedestal is also designed to draw us near. Its ends curve forward, so we can't read the complete inscription unless we mount the steps. Doing so, we find a charming detail: a bronze crab bearing the names of Saint Gaudens and Stanford White set into the pebble-strewn concrete.

The *Farragut Monument* was a turning point for American sculpture because it not only conveyed the subject's physical appearance but revealed that he was a farsighted, courageous naval leader, all the while encouraging us to linger, look at the details, and think about the importance of Farragut the man. Even today, it remains a remarkable achievement.

About the Subject

Ironclads are "cowardly things," said David Glasgow Farragut (1801–1870), the first officer in the United States Navy to be promoted to the rank of admiral. Ericsson's *Monitor* (#2) had beaten the Confederate ironclad *Merrimac* at Hampton Roads in 1862, and dozens of monitor-style ships were being built. But Farragut didn't consider them a magic bullet, favoring "iron hearts and wooden ships."

Having served in the War of 1812 and the Mexican-American War (1846–1848), Farragut was one of the most experienced Civil War naval commanders. He led the forces that captured New Orleans in 1862, putting nearly all of the Mississippi River into Union hands and splitting the South in half. In 1864 he was ordered to capture Mobile Bay, the South's best remaining port on the Gulf of Mexico and a haven for ships running the Union blockade.

Mobile Bay's first line of defense was a string of "torpedoes," floating barrels filled with gunpowder and rigged to explode if a passing ship touched a fuse. A narrow channel east of the torpedoes was guarded by

the guns of Fort Morgan. Beyond, the bay was defended by the South's most formidable ironclad, the *Tennessee*.

On August 5, 1864, Farragut arrayed his eighteen ships for battle. Four ironclads at the head of the line were to bear the brunt of Fort Morgan's attack, and chase the *Tennessee* if she retreated into shallow water. Wooden screw-propelled vessels followed, lashed to small side-wheel steamers. As the ships entered the bay, the overly eager captain of the leading ironclad turned too quickly. His ship's unarmored belly was ripped open by a mine. In minutes she went down, with over a hundred hands.

The remaining ships milled about under the murderous guns of Fort Morgan. Informed of the crisis, Farragut, who had clambered up the shrouds of his flagship in order to see above the guns' smoke, shouted, "Damn the torpedoes! Full speed ahead!" Moving his flagship to the head of the line, he led the fleet into the bay. Although the breathless crews heard mines rubbing against their boats' hulls, no others detonated. Within three hours the *Tennessee* surrendered and the last major port on the Gulf coast fell into Union hands.

20 Samuel Rea

Sculptor: Adolph A. Weinman.

Dedicated: 1930.

Medium and size: Bronze (10 feet), pedestal (approximately 3 feet).

Location: Entrance to 2 Penn Plaza, Seventh Avenue at West 32nd Street. Standing at the top of the Seventh Avenue stairs to Penn Station, turn right and go up six steps. Bear left to the front of the building that rises over Penn Station.

Subway: 1, 2, or 3 to 34 Street–Penn Station.

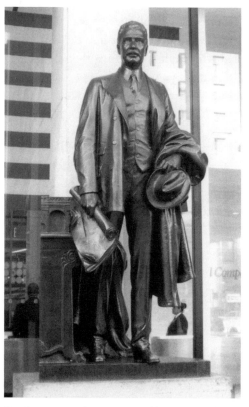

Rea, Weinman. With permission of the Weinman family.

> **"The Thinker"**
> Back of the beating hammer by which the steel is wrought,
> Back of the workshop's clamor, the seeker may find the thought.
> The thought that is ever master of iron and steam and steel,
> That rises above disaster and tramples it under heel.
> The drudge may fret and tinker, or labor with lusty blows,
> But back of him stands the Thinker, the clear-eyed man who
> knows....
>
> —Berton Braley, 1948

About the Sculpture

Seventy-five years after this statue was cast, *Rea* would still look appropriate at a Wall Street conference table. From his well-groomed hair and mustache to his three-piece double-breasted suit, overcoat, and hat, he is impeccably turned out. His upright posture, level gaze, and unlined brow mark him as calm, confident and ready to deal with major projects or sudden crises. "Mr. Rea's appearance was that of a man of great strength and power," recalled the *New York Times* (March 29, 1929). "He was more than six feet in height, and his strong, rugged face was surmounted by a shock of iron-gray hair. He would deal with tremendous problems and immense figures almost as with trifles, and while his associates often were struggling with a problem he would snap out his decision and the problem would be ended."

Rea was president of the Pennsylvania Railroad for over a decade. After his death in 1925, this sculpture honoring him was set in a niche high in the wall of the original Pennsylvania Station. The model next to him and the roll of plans in his hand are for the station, whose construction he supervised (see below).

About the Subject

"The station ... is the largest and handsomest in the world," declared the *New York Times* in 1910. "Any idea of it formed from description and

pictures falls short of the impression it makes upon the eye." Commissioned in 1902, begun in 1904, completed in 1910, Pennsylvania Station was a magnificent building, from the steel and glass vaults of the concourse, to the coffered ceiling and arched windows of the waiting room (as large as the nave of St. Peter's in Rome), to the pediments and 35-foot columns of its exterior. The General Post Office at Eighth Avenue and West 34th Street, designed a decade later by the same architects, gives some idea of the monumental facade. "No half-way solution should be attempted by the Pennsylvania Railroad Company," asserted Rea (1855–1929), who was in charge of the project to link the PRR's Jersey City terminal with Manhattan. "It should ultimately go into New York in such a manner as to answer the needs of the Company for the next half century at least, and on an equality with, if not on a more elaborate scale, than the New York Central and Hudson River Railroad Company."

Like Cooper, Ericsson and Holley (#10, 2, 11), Rea, who worked his way up from the lowliest ranks of the PRR, was the sort of man who knew how to persuade nature and his employees do his will:

The drudge may fret and tinker, or labor with lusty blows,
But back of him stands the Thinker, the clear-eyed man who
 knows. (See Sidebar.)

The Penn Station project was much more than the building at Seventh Avenue and West 33rd Street. A set of railroad tubes under the Hudson (the first such built in the Americas) brought trains from New Jersey to Manhattan. Another set of tubes sent trains under Midtown and the East River to the sprawling railroad yards in Sunnyside, Queens, where cars were serviced, cleaned, and assembled into outgoing trains. The complexity of this project was matched only by Grand Central Terminal, under construction at the same time, a few blocks away, by the heirs of Cornelius Vanderbilt (#25, 26).

The tubes still carry trains under the Hudson and East Rivers. The Sunnyside Yards still service trains. But barely fifty years after its much-lauded completion, Pennsylvania Station was torn down by the very company that built it. What happened?

The Pennsylvania Railroad was the most efficient and aggressive competitor of Vanderbilt's New York Central, but for over forty years, PRR trains reaching New Jersey had to transfer passengers and freight to ferries in order to cross the Hudson River. The PRR did not have legislative permission to build a railroad into Manhattan. By the late 1800s, when the PRR was finally granted permission to run such a line, the commercial center of the city had shifted north to the mid-40s. The price of land forced the PRR to settle for a site on the less developed west side of Midtown.

In 1906, while Pennsylvania Station was under construction, the Interstate Commerce Commission (ICC) was authorized to set "just and reasonable" rates for railroad freight and passengers. From 1900 to 1915, under new laws favoring unionization, wages of railroad workers increased 50 percent. Real prices increased 35 percent. Taxes paid by railroads increased 200 percent. During the same period, the ICC permitted one rate increase for the railroads, of 5 percent.

By the 1950s, the PRR's major competitors—automobiles, buses, airplanes—had use of publicly financed and operated roads and terminals, including the interstate highway system, the Port Authority Bus Terminal, and Idlewild and La Guardia Airports. Railroad travel during the 1950s fell to less than 25 percent of its peak during World War II. By the early 1960s, the PRR was deeply in debt and losing another $1.5 million every year. The multimillion-dollar upkeep and operating expenses of Penn Station came out of the pocket of the PRR, which also paid over a million dollars a year in New York real-estate taxes. With no relief in sight for its steeply declining revenues, the PRR decided to reduce present and future losses by going into partnership with Madison Square Garden to build a smaller, underground railroad station beneath a sports arena and office tower. The elegant home of the Chattanooga Choo-Choo ("You leave the Pennsylvania Station 'bout a quarter to four / Read a magazine and then you're in Baltimore") was demolished in the 1960s amid cries of horror that insensitive capitalists were destroying a historic building of tremendous architectural beauty and importance. But who destroyed Penn Station: the PRR, which paid for its demolition as well as its construction, or the local, state, and federal officials who hampered and harassed the PRR until it could no longer afford to maintain Penn Station?

21 Bell Ringers' Monument (James Gordon Bennett Memorial)

Sculptor: Antonin Jean Paul Carles. Architect: Aymar Embury II.
Dedicated: 1895.
Medium and size: Bronze (approximately 10 feet), later granite niche (approximately 30 feet).
Location: Herald Square, intersection of Sixth Avenue and Broadway between West 34th and 35th Streets.
Subway: B, D, F, N, Q, R, V, or W to 34 Street–Herald Square.

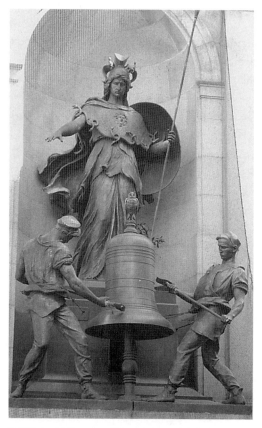

Bell Ringers' Monument / Bennett Memorial, Carles

The Night Owls' Newspaper

Architecturally, the new home of the *Herald* is a rebuke to the utilitarianism of the American metropolis, an appeal for something better than sky-scraping ugliness.... The fascinating rush and whir of men and machinery late at night, when the place is ablaze with electric light, and the entire mechanical force is straining to get the paper printed in time for the early trains, will be one of the notable sights of New York, while around the edge of the roof a row of twenty gilded owls will wink electric eyes at regular intervals by a mechanical device connected with the clock.... The presence of the owls is explained by the fact that the owl is a jolly fetich of Mr. Bennett's, and is to be seen in every part of his private establishment—stuffed owls, bronze owls, painted owls, iron owls—on his yachts, his carriages, his note-paper, his coaches in various parts of France, and in his many residences. The bird that is awake and alert when all else is asleep is not a bad emblem for the *Herald*.

—*Harper's Weekly*, September 2, 1893

About the Sculpture

In 1895, when pocket- and wristwatches were still luxury items, the clock atop the new two-story Renaissance-style Herald Building at West 35th and Broadway rang the hours for workers in the neighborhood. Under the Greek goddess Athena's imperious gaze, Stuff and Guff (also known as Gog and Magog) swing a mallet at a bell, atop which sits an owl.

Step back and look at the arrangement of this group: the composition. It's roughly triangular, with Athena's head at the apex. Usually that's a very stable shape, but here it's not static because the individual figures are so lively. Athena gestures commandingly with one hand, holding a slanting spear with the other. Stuff and Guff have stances so unbalanced that we read them as being in mid-motion. Compared to the compact, closed outlines of *Ericsson* or *Farragut* (#2, 19), the *Bell Ringers' Monument* is very animated.

Athena was chosen for the *Herald's* clock not because she signifies wisdom or war, but because she's often accompanied by an owl. The younger James Gordon Bennett adored owls, as *Harper's Weekly* noted (see Sidebar). Even the *Herald's* masthead sported an owl. The cornice of the Herald Building was ringed with owls whose eyes blinked an eerie green through the New York nights. After the Herald Building was demolished in 1921 and a new architectural setting was created for Athena and her henchmen, some of the owls were positioned on pillars near the *Memorial*.

Bennett's most extravagant owlish scheme was a 125-foot sculpture on a 75-foot base that he intended to commission from architect Stanford White. The owl was to be perched in Washington Heights, where it would tower over the tomb of Ulysses S. Grant, whom Bennett despised. A winding staircase inside the owl would have allowed visitors to gaze downtown through the owl's eyes. Bennett's coffin was to be suspended from chains in the owl's head. Unfortunately for those of us who enjoy eccentric monuments and panoramic views, Bennett interpreted Stanford White's 1906 murder as an evil omen, and abandoned the project.

About the Subject

In 1835, when most newspapers were sold to the wealthy by yearly subscription, James Gordon Bennett (1795–1872) sent newsboys on the street to sell the *New York Herald* at a penny a copy. Bennett soon discovered that sensational stories sold papers. The *Herald* gave prime space to crime, suicide, catastrophes, and violence, but it also aimed to be first with the news, utilizing foreign correspondents and the telegraph. By 1860 the *Herald* had a wider circulation than any other daily in the United States, and its techniques had influenced every other New York newspaper.

The editorship of the paper passed in 1867 to James Gordon Bennett, Jr. (1841–1918). His coverage of Wall Street's first "Black Friday," the gold crash of September 24, 1869 (see *Butterfield, #52*), is a good specimen of the *Herald's* approach to news reporting.

New York Times coverage of Black Friday focused on the schemes of Jay Gould and Jim Fisk to influence the Grant administration's sale of gold. It labeled their efforts the "climax of folly and effrontery," and noted severely that the two "failed most contemptibly, most ignominiously, and with the bitter reflection that they are without sympathy in their fall."

The *Evening Post,* founded by Alexander Hamilton (#43, 53) and in 1869 under the editorship of poet/pundit William Cullen Bryant (#22), mentioned the distress of some Wall Street brokers. The strain was "beyond the power of nerves and brains to endure long," it reported. But the report focused on the disruption of routine: "The 'Gold Room' has slept upon its fury of yesterday, whether its individual members could sleep or not, and has come to the sensible conclusion to do no business today." Horace Greeley's *Tribune* (#7) also emphasized the disruption of affairs and the disastrous results for many brokers: "as furious a financial battle as was ever witnessed. It was the Bull Run of the stock campaign; the utter rout, wreck, and ruin of thousands."

Charles A. Dana's *Sun* (the only paper to run the story on the front page) paid even more attention to the effects on individuals. The Financial District was "strewn with wrecks. Every gold and stock broker wore a pallid face. Moneyed men rushed about the streets as if insane. Some of them were literally made insane."

The headlines on Bennett's *Herald* were by far the most emotionally charged: "The Bulls and Bears and Sharks and Sharpers Biting and Tearing Each Other. Bedlam in the Gold Room." Toward the end of the story the prose became lurid: "Beyond doubt the Revelations disclose nothing so hideous as the demoniacal yells and screams, the terrorism, fright and fearful scenes enacted yesterday. May it never come again." Given the *Herald's* preference for sensational headlines, one may doubt the sincerity of the reporter's wish.

22 William Cullen Bryant Memorial

Sculptor: Herbert Adams. Architect: Thomas Hastings.
Dedicated: 1911.
Medium and size: Overall about 50 feet wide; bronze figure (6 feet), marble canopy and pedestal flanked by urns and balustrades.
Location: Bryant Park behind the New York Public Library, between Fifth and Sixth Avenues and West 42nd and 41st Streets.
Subway: B, D, F, or V to 42nd Street–Bryant Park.

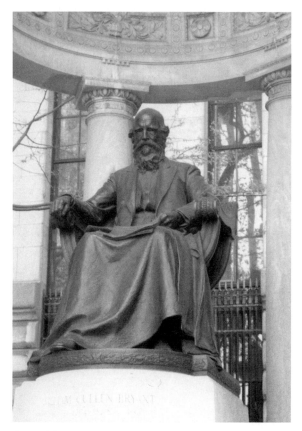

Bryant, Adams

"My Autumn Walk"
On woodlands ruddy with autumn
The amber sunshine lies;
I look on the beauty round me,
And tears come into my eyes.

For the wind that sweeps the meadows
Blows out of the far Southwest,
Where our gallant men are fighting,
And the gallant dead are at rest....

O for the fresh spring-season,
When the groves are in their prime,
And far away in the future
Is the frosty autumn-time!

O for that better season,
When the pride of the foe shall yield,
And the hosts of God and Freedom
March back from the well-won field;

And the matron shall clasp her first-born
With tears of joy and pride;
And the scarred and war-worn lover
Shall claim his promised bride!

The leaves are swept from the branches;
But the living buds are there,
With folded flower and foliage,
To sprout in kinder air.

—Bryant, October 1864

About the Sculpture

This is another great ensemble, like Saint Gaudens's *Cooper* (#10). Here the architectural frame is crucial for making the statue stand out against the huge blank wall of the New York Public Library. Thomas Hastings, architect of the *Bryant Memorial,* was also one of the architects of the library, which was completed the same year this sculpture was dedicated.

Bryant is memorialized as a grand old man of letters, with his trademark long beard. A rug covers his knees, making him look at first as if he's wearing a toga, and he holds a sheaf of papers on his lap. On the statue's pedestal is an inscription from "The Poet," one of Bryant's later works.

At first glance *Bryant* appears similar to Saint Gaudens's *Cooper,* dedicated seventeen years earlier. Both are authoritative, elderly men in conventional business suits. It's the seemingly minor differences that distinguish them. The position of *Cooper's* cane suggests that he may stand up at any moment, while the rug on *Bryant's* lap suggests he's a sedentary type, likely to retreat to his books and papers. *Cooper* sits on a fringed chair that's decidedly Victorian, while *Bryant* sits on a chair of ancient Greek style that recalls his love of the classics. *Bryant* is the bookish one, *Cooper* the man of action.

Both the *Cooper* and the *Bryant Memorial* are excellent examples of works produced during the City Beautiful movement. One of the spurs of that movement was the 1893 Columbian Exposition in Chicago (see *Columbus,* #36). Many of the Exposition's twenty million visitors vividly remembered the sights, smells, and ambiance of the "White City." It was clean, well-lit and safe—the opposite of American cities such as New York. Think Disney World versus the South Bronx.

The City Beautiful Movement, which lasted from the 1890s until World War I, was in part a drive to improve cities physically, but it also aimed to improve city residents morally and intellectually. Many of New York's grandest public buildings date to this era: the New York Public Library, the Customs House at Bowling Green, Pennsylvania Station, Grand Central Terminal (#4, 20, 26). The sculpture that decorated these buildings, or was erected during the same period in Central Park and

other public venues, was meant to edify passersby with illustrations of patriotism, good government, technological progress, civic harmony, culture, or simply beauty. Wealthy and sophisticated residents felt that the floods of immigrants (in 1900, 41 percent of New Yorkers were foreignborn) needed to be shown the values and virtues of American citizens.

The flaw in the City Beautiful movement was the idea that art could teach abstract ideas, rather than presenting vivid models and reminders (see *Hale*, #8). However mistaken the motive, the decades during which this view of art as a didactic instrument dominated saw the production of many of New York's most beautiful works of outdoor sculpture. See Appendix B for over two dozen works from this period described in this volume.

About the Subject

If you're of a certain age (ahem!), you'll remember these lines from highschool literature classes:

> To him who, in the love of Nature, holds
> Communion with her visible forms, she speaks
> A various language . . .

Later described by New York mayor William J. Gaynor as "the most melancholy poem that was ever written," "Thanatopsis" made twentyone-year-old William Cullen Bryant (1794–1878) a rising literary star— one of the first truly American poets. His reputation both benefited and suffered, as biographer William Aspenwall Bradley explains:

> After a period in which he suffered somewhat of an eclipse
> through the rise of new schools and new poets to contest with him
> the palm of supremacy, his great age, the traditions of an earlier
> day which he represented, his personality which so perfectly embodied the prophetic and seer-like aspect of the poetic ideal, and
> finally local pride in the possession of a poet whom New York
> could produce to oppose the claims of its rival, Boston, to literary

supremacy,—all these tended to create a regard for Bryant that was rather personal than literary. To-day the tendency ... is to regard him rather as a figure, a landmark in the literary history of America, than as a true and original poet.

Some consider Bryant long-winded; but then, some consider Bill Clinton eloquent. Depends on your style preferences and your breath control. I'm willing to forgive a great deal to a man who can compose a poem as poignant as "My Autumn Walk" (see Sidebar), written when three years of civil war had racked up half a million American casualties.

Although the emphasis in this sculpture is on Bryant as a poet, Bryant's widespread influence in New York was due as much to the logic and eloquence of his prose as to his verse. For over fifty years he was editor of the *New York Evening Post,* founded in 1801 by Alexander Hamilton (#53). "He had not the fiery, warlike temperament of Horace Greeley," said Bryant's *New York Times* obituary. "His fibre was too fine, his mind too pensive for those vigorous brutalities of the daily press in which Horace Greeley delighted." While Greeley's *Tribune* and Bennett's *Herald* (#7, 21) titillated readers with sensational stories, Bryant transformed the *Post* into the newspaper of choice for educated New Yorkers, forming American literary taste for half a century.

23 Gertrude Stein

Sculptor: Jo Davidson.

Dedicated: 1992; cast from an original of 1923.

Medium and size: Bronze (2.5 feet), concrete pedestal (4.5 feet).

Location: Bryant Park, between West 42nd and 41st Streets, and Fifth
and Sixth Avenues.

Subway: B, D, F, or V to 42nd Street–Bryant Park.

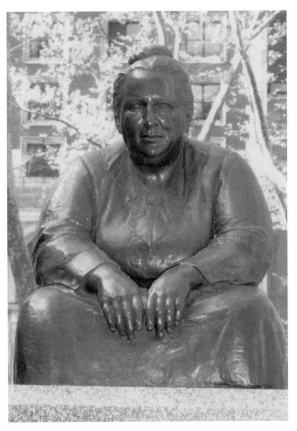

Stein, Davidson. © 2005 Artists Rights Society (ARS), New
York/VI$COPY, Australia.

Stein on the Evils of the Comma
And what does a comma do, a comma does nothing but make easy a thing that if you like it enough is easy enough without the comma. A long complicated sentence would force itself upon you, make you know yourself knowing it and the comma, well at the most a comma is a poor period that it lets you stop and take a breath but if you want to take a breath you ought to know yourself that you want to take a breath. It is not like stopping altogether which is what a period does stopping altogether has something to do with going on, but taking a breath well you are always taking a breath and why emphasize one breath rather than another breath.

—"Poetry and Grammar," 1935

About the Sculpture

This sculpture, one of ten casts of a work created in 1923 by Jo Davidson, is notable for its smooth surface and simplified details. Davidson made Stein (in his words) "a sort of modern Buddha," arranging her in a characteristic pose: leaning forward with hands on widespread knees. She holds a similar pose and wears a similar blouse and brooch in Picasso's 1906 portrait at the Metropolitan Museum of Art. Davidson sculpted her considerably less than life-size, perhaps to emphasize her down-to-earth, unheroic character.

About the Subject

During her lifetime Gertrude Stein (1874–1946) was more famous for her brilliant circle of friends than for her published work. Visitors to her Paris home included artists, writers, and musicians, among them Picasso and Hemingway. Stein's own reputation as a leader of avant-garde literature is based on experimental works that defied conventional grammar and syntax. For her thoughts on the evils of the comma, see the Sidebar.

"The extraordinary part of it was that, as she read, I never felt any sense of mystification," recalled sculptor Jo Davidson. "Gertrude did a portrait of me in prose. When she read it aloud, I thought it was wonderful. It was published in *Vanity Fair* with my portrait of her. But when I tried to read it out loud to some friends, or for that matter to myself, it didn't make very much sense." The *New York Times* tellingly subheaded her obituary, "First Book Intelligible. Two Biographies Also Written in Lucid Form" (July 28, 1946).

24 William Earl Dodge

Sculptor: John Quincy Adams Ward. Later pedestal; the original, by Richard Morris Hunt, has been destroyed.

Dedicated: 1885.

Medium and size: Bronze (7.5 feet), granite pedestal (6.5 feet).

Location: North side of Bryant Park, just south of West 42nd Street and east of Sixth Avenue.

Subway: B, D, F, or V to 42nd Street–Bryant Park.

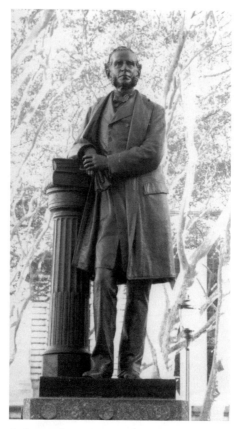

Dodge, Ward

New York's Mayor Explains the Need for Public Portrait Statues
It is the highest honor which can be paid to a citizen, that his memory and features shall be preserved in bronze or marble for the reverent homage of future generations. As a rule, the lapse of time and the favorable judgment of posterity should decide the claim for such eminent recognition. We have not yet erected statues to Fulton, who gave us steam navigation, or to Dewitt Clinton, who created [the Erie Canal,] the highway of commerce which has made New-York great and rich. All men will agree that too much honor cannot be paid to the memory of such public benefactors by the generations which have inherited their glory and profited by their genius....

Even with all his virtues fresh in our minds, and with the fruits of his long and well-spent life in our possession and enjoyment, we cannot venture to compare [Dodge's] unquestionable merits with the achievements of the great men who laid the foundations of our commercial supremacy. But there are men who can wait for recognition, and there are, on the other hand, characters which demand present recognition, if recognition is ever to be given.

—Abram S. Hewitt at the unveiling of *Dodge*, 1885

About the Sculpture

Although Dodge was a businessman, like Vanderbilt and Rea (#25, 20), his statue doesn't stand staunchly, confidently upright as theirs do. Instead, *Dodge* sways elegantly as he rests an elbow on a pile of books atop a column, gazing meditatively into the distance. If the pillar were removed, *Dodge* would fall over. That makes the pillar an important part of the sculpture, one we have to consider, in contrast with the much less obtrusive pillar behind *Washington* (#6).

What, then, does the combination of the pillar, the books, and *Dodge's* swaying pose tell us? That Dodge is to be remembered not only as a wealthy man, but as an elegant gentleman of learning and culture. A con-

temporary writer praised this sculpture for capturing Dodge's fine appearance and cordial manner as he delivered a speech, so perhaps the folded paper in his right hand contains notes. Given Dodge's incessant involvement in committees (see About the Subject), it would certainly be appropriate to represent him speaking publicly.

Dodge introduces an interesting point about commemorative sculpture in New York. While not everyone would admire Dodge's focus on charity, his fellow members of the Chamber of Commerce did. They paid for this statue in 1885 so that passersby who recognized Dodge's face or name could remember, admire, and emulate him. Dodge had lived the sort of life that many New York businessmen claimed to approve, even if they didn't follow Dodge's lead.

All the nineteenth-century portrait sculptures in this volume—from *Washington* to *Conkling,* from *Holley* to *Hunt* (#6, 18, 11, 38)—were erected with the aim of providing models. This, remember, is a prime function of art: to remind us of important values in an easy-to-grasp, visual form. (See #8, 30.)

About the Subject

William Earl Dodge (1805–1883) cofounded Phelps Dodge, still one of the world's foremost copper producers. From 1834 to 1860, while Dodge was its leading partner, Phelps Dodge expanded from importing metals to promoting American mining, including Pennsylvania iron and Lake Superior copper.

Dodge himself was nicknamed "the Christian Merchant." How did he reconcile business and religion? By splitting his efforts. He managed Phelps Dodge, but sat on dozens of charitable committees. He worked hard to become wealthy, but gave away untold thousands of dollars to charities, often anonymously. His own riches he justified on the grounds that "poverty is something to fly from. It stints the growth and usefulness of man. Christ bore it; but he bore it as he did other wretched conditions and surroundings of mortality—to show that it can be nobly endured. The poor man walks from hour to hour along the slippery edge of temptation, and is in momentary danger of falling into the bottomless pit."

Even his colleagues in the Chamber of Commerce, who admired Dodge's charitable efforts and contributed the funds for this statue, recognized that Dodge's widely dispersed efforts would make him far less memorable than men such as Clinton, Vanderbilt, or Cooper (#48, 25, 10). As Hewitt said at the statue's dedication, some characters "demand present recognition, if recognition is ever to be given" (see Sidebar).

25 Cornelius Vanderbilt

Sculptor: Ernst Plassmann.

Dedicated: 1869.

Medium and size: Bronze (8.5 feet), granite pedestal (approximately 9 feet).

Location: South facade of Grand Central Terminal, at the level of the Park Avenue viaduct. Pedestrians can enter the Hyatt Hotel (East 42nd Street just east of Grand Central), go up the stairs on the left to the reception level, go up the escalator to the left of the concierge's desk, then go through the revolving doors (ahead and to your right as you come off the escalator) to the sidewalk by the Park Avenue viaduct. Turn left on the sidewalk (toward East 42nd Street), and follow the sidewalk around to the south side of Grand Central. The sidewalk ends almost across from the Vanderbilt statue.

Subway: 4, 5, 6, 7, or S to Grand Central–42nd Street.

New York Times Eulogizes Vanderbilt

What he bought he bought to keep, to build up, and to make more productive.... It required skill, patience, and that mental quality which we call forethought, to conduct successfully such vast concerns as those which employed Vanderbilt's energies. Every movement of his will was perceptible in the fleets which covered the waters, or in the network of rails which enmeshed the land. By him, therefore, the movements of population, the currents of trade and travel, and the requirements of commerce, must have been clearly seen and understood. It was his business, in a large way, to anticipate and meet all these requirements and changes. He did this so well that he is now set down as a highly successful man.

—Obituary, January 5, 1877

About the Sculpture

Upright and alert, *Vanderbilt* surveys his domain: a wealthy, powerful, alert man whose presence you can't fail to notice. Well, you couldn't were he not placed where few pedestrians venture. Rightly proud of having worked his way up from poverty, he wears a bulky double-breasted coat with fur lapels and cuffs. As compared to the conventional business attire of *Rea* and *Dodge* (#20, 24), the coat suggests that he's a hands-on manager, not content to run his business from behind a desk.

Like *Ericsson*, *Farragut*, and *Rea* (#2, 19, 20), *Vanderbilt's* upright posture speaks of confidence. The gesture of his left hand suggests he's in the middle of an action—perhaps giving an order. For more on this gesture, see *Columbus* (#36).

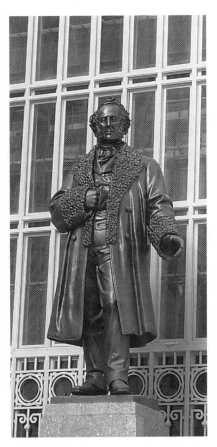

Vanderbilt, Plassmann

Like *Rea* in his Penn Station niche, *Vanderbilt* was designed for an architectural setting and meant to be seen only from the front. When dedicated in 1869, the sculpture was the centerpiece of a 150-foot-long, 31-foot-high pediment on Vanderbilt's Hudson River Railroad Freight Depot, just south of Canal Street. Bronze reliefs to either side showed sailboats, steamboats, and railroads: the transportation industries in which Vanderbilt made his millions. The fact that the sculpture appeared atop the third story of the depot explains the relatively simple pose, the

lack of small gestures and props, and even the bulky coat. To be viewed at that distance, the sculpture needed something of the monumental simplicity of the *Statue of Liberty* (#1).

About the Subject

Cornelius Vanderbilt (1794–1877), an uneducated farm boy, was worth about $100 million when he died—probably the wealthiest man in America. He earned his first million on the water, ferrying passengers by sailboat as a teenager, then switching to steam. So safe and efficient was the service Vanderbilt provided that a series of rivals either sold out to him or paid him to operate elsewhere. By age forty-five (1841), the "Commodore" owned or had an interest in more steamboats than anyone else in the country.

Meanwhile, after Peter Cooper designed the first American-made steam locomotive in 1830 (#10), the railroad industry boomed. Small wonder: the trip by rail from Buffalo to Albany took a mere thirty hours, while the trip by the twenty-year-old Erie Canal (#48) took ten days. With the advent of railroads the cost of shipping, and hence the cost of goods, plummeted. Privately financed and privately built railroads spread across the country.

Vanderbilt, in his sixties, astonished contemporaries by selling his prosperous steamboat line and applying his formidable energy to the acquisition of railroads. By 1857 he was a director of one New York railroad line, and by the early 1860s he owned a controlling interest in the only two railroads that ran into Manhattan.

Why only two? Because in the 1830s, New York politicians decreed who could build lines into Manhattan, how far south steam locomotives could run (at first to Canal Street, later only to East 42nd Street), and whether existing lines could merge. Such political control was often employed as a weapon by Vanderbilt's enemies, although seldom with success. On lines he controlled, Vanderbilt improved service and equipment by doubling tracks (for passengers and freight) and upgrading rolling stock and bridges. Curmudgeonly Horace Greeley of the *New York Tribune* (#7), a regular commuter on Vanderbilt's Harlem Railroad, commented

in 1867 that "we lived on this road when it was poor and feebly managed—with rotten cars and wheezy old engines that could not make schedule time; and the improvement since realized is gratifying. It is understood that the road now pays, and, if so, we are glad of it."

Under Vanderbilt's leadership, railroads linked New York to Albany in the 1850s and to Chicago by the early 1870s. So efficiently did he run his railroads that even in the depression of the 1870s, the lines paid dividends of 6 to 8 percent. Soon Vanderbilt was known as "The Railroad King" as well as "Commodore." Grand Central Depot, completed at East 42nd Street in 1871 as the New York terminal of Vanderbilt's railroads, was one of the largest enclosed spaces in the world. Within a few years, it became too small for its volume of traffic. (See *Commerce*, #26.)

The *New York Times* commented in Vanderbilt's obituary: "By him, therefore, the movements of population, the currents of trade and travel, and the requirements of commerce, must have been clearly seen and understood. It was his business, in a large way, to anticipate and meet all these requirements and changes" (see Sidebar). Often reviled as a "robber baron," Vanderbilt was in fact a trader who offered high-quality services to a public eager to buy them.

26 Glory of Commerce (Progress with Mental and Physical Force)

Sculptor: Jules-Felix Coutan.

Dedicated: 1914.

Medium and size: Limestone, overall 50 x 60 feet; Mercury is 28 feet.

Location: Grand Central Terminal, roof of south facade, East 42nd Street and Park Avenue.

Subway: 4, 5, 6, 7, or S to Grand Central–42nd Street.

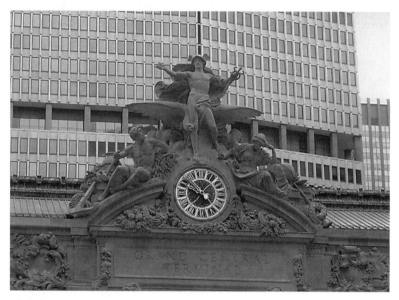

Glory of Commerce, Coutan

"Travel"
The railroad track is miles away,
 And the day is loud with voices speaking,
Yet there isn't a train goes by all day
 But I hear its whistles shrieking.

All night there isn't a train goes by,
 Though the night is still for sleep and dreaming
But I see its cinders red on the sky
 And hear its engine steaming.

My heart is warm with the friends I make,
 And better friends I'll not be knowing,
Yet there isn't a train I wouldn't take
 No matter where it's going.

—Edna St. Vincent Millay, 1921

About the Sculpture

Did you ever wonder what these figures are doing atop a twentieth-century railroad station? The figure at the center is Mercury (Hermes), recognizable by his winged hat and caduceus. From his role as messenger to the gods, he became identified with travel, commerce, business, and wealth.

Looking up at Mercury from our left is an older, muscular man—Hercules—stripped for action and grasping a hammer. Surrounding him are an anchor, a cogwheel, an anvil, and a beehive, representing the technology by which man has conquered the earth and seas. On Mercury's other side, an elegantly dressed woman—Minerva—is intent on a long scroll; she holds a quill pen in her right hand, as if about to take notes. Behind her is a globe. Minerva represents intellectual endeavors, as Hercules represents physical ones. We can say, therefore, that the sculpture as a whole represents business supported by physical and mental effort. So logical is

this idea that it's a shock to see, in Coutan's original proposal, that he had mirror images of Hercules and the mechanical devices on both left and right. Minerva didn't appear.

The sculptor not only shows that business requires both physical and mental effort; he seems to consider business in a positive light. Mercury is handsome, physically strong and healthy, and rising upward—not bowed by cares or hunched over, scheming like Scrooge. Hercules looks up to him; Minerva is relaxed in his presence. An American eagle nuzzles Mercury's knee, suggesting that business is compatible with patriotism and the nation's welfare. This complex message—that successful, thriving business requires physical and mental effort—is the sort of abstract theme that only top-notch allegorical figures seem able to convey.

About the Subject

Today far fewer travelers respond to Mercury's beckoning hand, but for some, no other mode of transportation inspires wanderlust as intensely as railroads:

> There isn't a train I wouldn't take
> No matter where it's going. (See Sidebar.)

Few places evoke the excitement of the great era of railroads as does Grand Central Terminal. Not only is it a beautiful space, it's a magnificent engineering accomplishment. Vanderbilt's 1871 Grand Central Depot (see #25) was a tangle of platforms and tracks through which commuters, long-distance travelers, freight, and mail swarmed helterskelter. Its successor, Grand Central Terminal, was by comparison a marvel of efficiency. Passengers could descend from the street to the lower levels via gentle ramps: no stairs or elevators required. Baggage was handled separately. Commuters were segregated from long-distance travelers. Convenient transfers to New York's new subway system were incorporated. Mail went directly to the neighboring Post Office, express freight by elevator to a separate building. Perhaps the most remarkable engineering feat was the fact that from 1903 to 1912, while the terminal

was being constructed on the site of the depot, trains continued to operate on regular schedules.

North of Grand Central, tracks that stretched from East 42nd to East 50th Street and from Madison across to Lexington Avenue were electrified and buried, making a huge area north of 42nd Street available for commercial and residential development. Income from "air rights" on this property was a significant source of revenue for the New York Central Railroad in the coming decades, as railroad traffic declined in the face of competition from automobiles and airplanes. In 1970, after the Pennsylvania Railroad had merged with the Central and gone spectacularly out of business in the largest corporate bankruptcy in United States history, the biggest asset remaining to the company was not its trains, tracks, or buildings, but the air rights north of Grand Central Terminal. That income was a major reason that Grand Central wasn't demolished as the original Pennsylvania Station was. (See *Rea*, #20.)

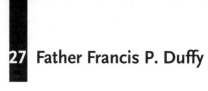

27 Father Francis P. Duffy

Sculptor: Charles Keck.

Dedicated: 1937.

Medium and size: Overall 17 feet; bronze figure (9 feet) in front of a granite cross (11 feet).

Location: Broadway and Seventh Avenue, between West 46th and West 47th Streets.

Subway: 1 to 50th Street.

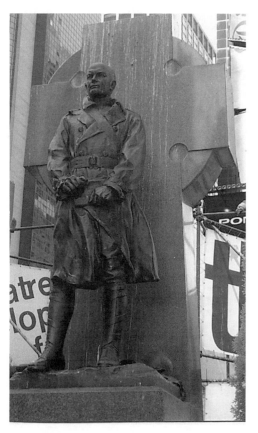

Duffy, Keck. © Charles Keck.

Mustard Gas and Mayhem

The men were prompt in putting on their masks as soon as the presence of gas was recognized, but it was found impossible to keep them on indefinitely and at the same time keep up the defense of the sector. By about midnight some of the men were sick as a result of the gas, and as the night wore on, one after another they began to feel its effects on their eyes, to cry, and gradually to go blind, so that by dawn a considerable number ... were sitting by the Luneville road, completely blinded, and waiting their turn at an ambulance.

—Duffy, *Father Duffy's Story*, 1919

About the Sculpture

What can we deduce about the man represented here, without reading a biography? Let's look in turn at the figure, the costume, and the props.

The man's face is what we notice first. (More on why that's so in a moment.) He seems serious, even worried, with lines between his brows and a frowning mouth. He stands upright, shoulders back, feet braced. In comparison, even *Vanderbilt* (#25) looks relaxed. In fact, the posture has a military aspect, very like *Farragut's* (#19).

Comparison with *Farragut* helps us see a few significant differences. *Duffy* wears a much later uniform, an officer's trench coat, and distinctive World War I puttees, strips of cloth wound knee to ankle. Although he's outdoors (the wind is blowing his coat open), his head is uncovered. His helmet lies at his feet. He bears no weapons, but his hands fiercely grip a small book. That grip plus the frowning face give a tension to the pose that even *Farragut* (who seems to be on the deck of his flagship) doesn't exhibit.

If we look closely at the book, we can see a cross inscribed on its cover: it's probably a Bible. On his collar are the letters "U.S." followed by a cross. These details tell us that Duffy was a chaplain rather than a soldier. His job was not to fight, but to offer the troops spiritual comfort

and advice. His obvious anxiety, his gaze fixed in the distance, and the fact that his trench coat blows in the wind all suggest that he's outdoors watching troops in battle.

Even before we saw the cross on his collar and the book in his hands, we should have suspected that this is no ordinary soldier from that eleven-foot cross looming behind him. Its sheer size indicates its importance in Duffy's life, yet the sculptor has managed not to allow it to overpower *Duffy's* figure. How? By giving it a simple outline and texture, and by carving it from material whose color and texture distinguish it from the bronze figure. This "Celtic Cross" is particularly appropriate for Duffy since his unit's nickname was the "Fighting Irish."

But the cross isn't just a backdrop. It's a vital part of the composition. The circle behind the crossing of the arms and the circular notches where the arms meet the upright post echo the shape of *Duffy's* nearly bald head. The circular shape is the only one repeated in the sculpture, and it thereby draws attention to *Duffy's* head, even though the head is a relatively small part of the sculpture.

This arrangement wasn't self-evident. In the model of *Duffy* submitted for the Municipal Art Commission's approval, Keck, the sculptor, showed *Duffy* wearing his helmet. The cross was so large in comparison to *Duffy* that the head was insignificant. By putting the helmet at *Duffy's* feet and reducing the cross's size, Keck made the priest more vulnerable, made his expression easier to read, and caused the circles on the cross to emphasize the head. By these and other details, he shows us that Duffy was a brave soldier but also a thoughtful clergyman—a rare combination.

After the Civil War numerous sculptures were erected in Manhattan to military leaders, among them *Sherman, Farragut*, and *Butterfield* (#31, 19, 52). Like statues of business leaders such as *Dodge* (#24), they were celebrations of hard-won achievements and well-earned pride, and reminders to passersby that such heroes can be emulated as well as respected and admired.

By the end of World War I, the message of military memorials had changed dramatically. Except for *Duffy*, which portrays a religious rather than a military leader, Manhattan's World War I memorials are to the anonymous men who fought and died in the trenches. Philip

Martiny sculpted the *Abingdon Square Memorial* (West 12th Street at Eighth Avenue) and the *Chelsea Park Memorial* (West 28th Street at Ninth Avenue). Gertrude Vanderbilt Whitney (*Stuyvesant, #6*) designed the *Washington Heights–Inwood War Memorial* (Broadway and St. Nicholas Avenue at West 168th Street). Burt W. Johnson produced the melancholy *Flanders Field Memorial* (Eleventh Avenue at West 53rd Street), and Karl Illava the *107th Infantry Monument* (Fifth Avenue at East 67th Street). In these sculptures, the soldiers shown are not only anonymous, but often wounded or dying. They remind us, grimly, of the horrors of war.

In time this shift from heroic leaders to anonymous soldiers is taken even farther. Mac Adams's *Korean War Memorial* (Battery Park) is a silhouette of a man with a rifle, cut out of a slab of granite. The *New York Vietnam Veterans Memorial* (Coenties Slip) is a wall of translucent glass blocks engraved with letters and dispatches. However thought-provoking and emotionally charged the words are, they're not visual art, and don't have the impact of representational sculpture. (See #30, 45.)

About the Subject

In late 1914, when he signed up as chaplain of the New-York based "Fighting Sixty-Ninth" Regiment, Duffy (1871–1932) could not have imagined a scene such as he described in the Sidebar. Until World War I, such scenes had never occurred. In his 1919 autobiography, Duffy recounted his experiences—sometimes charming, more often harrowing—in "the war to end all wars." He faced tanks and machine guns. He faced planes spewing bullets and dropping bombs. He watched men sicken or die by the hundreds and thousands of diseases every bit as deadly as the most innovative military hardware: influenza, mumps, measles, scarlet fever. In March 1918 the Sixty-Ninth first faced mustard gas, whose caustic fumes ate through any protective gear available at the time. Then it caused blindness, blistered skin, and slow suffocation. By the time the fighting in Europe ended in November 1918, only about 600 of the original 3,500 members of the Sixty-Ninth remained on active duty.

Although he was not a soldier and refused to carry weapons, Father Duffy was always in the thick of the action and sustained serious wounds. General Douglas MacArthur, commander of the Forty-Second (Rainbow) Division, was so impressed by Duffy's courage and cool head that he recommended Duffy for combat command—an exceptionally rare honor for a chaplain.

28 Prometheus

Sculptor: Paul Manship.

Dedicated: 1934.

Medium and size: Gilded bronze (approximately 10 x 18 feet), granite pedestal.

Location: Rockefeller Center (west of Fifth Avenue, between West 49th and West 50th Streets), overlooking the ice-skating rink.

Subway: B, D, F, or V to 47th–50th Streets–Rockefeller Center.

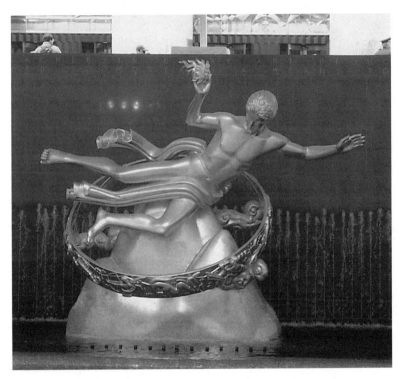

Prometheus, Manship

> **Prometheus's Gifts**
> Yea, I am he who in a fennel-stalk,
> By stealthy sleight, purveyed the fount of fire,
> The teacher, proven thus, and arch-resource
> Of every art that aideth mortal men....
> But listen now
> Unto the rede of mortals and their woes,
> And how their childish and unreasoning state
> Was changed by me to consciousness and thought.
> For, in the outset, eyes they had and saw not;
> And ears they had but heard not ...
>
> —Aeschylus, *Prometheus Bound*, ca. 456 B.C.
> (trans. E. D. A. Morehead)

About the Sculpture

We've seen that a sculpture's theme reveals what the artist considers important (*Hale*, #8). This is particularly obvious in a sculpture of a figure as multifaceted as Prometheus. According to Greek myth, Prometheus formed humans out of clay and water. He gave them sense and understanding (see Sidebar), then taught them to work wood and make bricks, to build shelters, to use the stars to tell the seasons for planting, to write, to do math, to harness beasts of burden, and to build ships. Prometheus also gave humans the gift of fire, smuggling it from Mount Olympus inside a hollow reed. Zeus, however, had forbidden anyone to give humans fire. He ordered Prometheus chained to a rock in the distant Caucasus Mountains, where each day an eagle came to rip out his liver. Each night his liver grew back so the torture could begin anew.

An artwork with Prometheus as subject could show the importance of thinking, being creative, being independent. It could show the risks of rebellion or the nobility of suffering for the sake of others. It could show sparkling intelligence or intolerable, eternal agony.

Manship chose to show Prometheus bringing fire to mortals. A torch waving in one hand, Prometheus is poised between heaven (symbolized by a cloud and a ring with signs of the zodiac) and earth (the mountains below). He is not looking warily toward an angry Zeus, but down toward the earth. No hint is given of the horrors to come: Prometheus poses insouciantly, covered with gleaming gilt. The inscription from Aeschylus across the granite behind *Prometheus* also emphasizes the positive: "Prometheus, teacher in every art, brought the fire that hath proved to mortals a means to mighty ends." For Manship, what mattered was the life-enhancing gift Prometheus brought, rather than his later suffering. (For more on the ideas implied in the artist's choice of theme, see *Shakespeare, #37*.)

Prometheus has become an icon of New York, yet when the sculpture was unveiled in 1934 a wit remarked that the figure seemed to have "just sprung from a bowl of hot soup." To persuasively represent a human figure flying under its own power is no easy task, especially if the figure doesn't have wings. In aesthetic terms (see *Lincoln, #15*), the problem with *Prometheus* is lack of clarity. He could equally well be doing a sidestroke as flying.

About the Subject

In the 1930s, the Rockefellers had made more money from business than anyone in the history of the human race. Rockefeller Center was built as a commercial center in America's most business-oriented city. Yet the center boasts not a single statue commemorating business or business executives. Why?

In the nineteenth century America was regarded as a land of opportunity where any hard-working individual could make a fortune. Entrepreneurs were heroes. By 1900, eleven Manhattan statues honored businessmen, among them *Vanderbilt, Dodge, Holley, Sims, Greeley, Ericsson*, and *Cooper* (#25, 24, 11, 47, 7, 2, 10).

Around the turn of the century, however, a notable antibusiness trend began, marked by the anti-trust laws, muckraking journalism, and Teddy Roosevelt's Progressive Party. By the 1930s, when Rockefeller Center was

under construction, the country was in the throes of the Great Depression. Many saw big government as the only hope of a desperate populace.

Sculptures erected outdoors in Manhattan changed in accordance with the prevailing views on business and politics. While only five politicians other than the Founding Fathers had been honored in the nineteenth century (including *Conkling*, #18), eleven were honored in the course of the twentieth (including *Schurz, Theodore Roosevelt, De Witt Clinton, La Guardia*, and *Eleanor Roosevelt*, #51, 42, 48, 9, 40). During the same period, only one statue of a businessman was added to Manhattan's array of public sculpture. *Rea* (#20) was commissioned by the Pennsylvania Railroad for the interior of the original Pennsylvania Station, and moved outside in the 1960s.

Because of this change in attitude, it was almost inconceivable that the art commissioned for Rockefeller Center would glorify business, even though the center was built by America's first billionaire. What, then, would the art focus on?

The Rockefellers consulted a California professor of philosophy, who suggested the theme "New Frontiers." By that he meant the challenges faced after the conquest of the physical world, including the cultivation of the mind and soul. A committee took his vague idea and mish-mashed it further, into "Intellectual and Spiritual Progress," "Historical and Mythological Background," and "The Rise of Nations." It would have taken a very great artist to concretize any of these vague ideas into a satisfying piece of visual art.

The center did not get great artists. It got the artists favored by John D. Rockefeller, Jr., wife Abby Aldrich Rockefeller, and son Nelson. Abby was a champion of the avant garde: she helped establish the Museum of Modern Art (1929) and donated to it her substantial collection of paintings by Gauguin, Picasso, and the German Expressionists. The only well-known and popular artist who worked at Rockefeller Center was Paul Manship, who was commissioned to create this fountain for the central plaza because he had a reputation for turning out attractive work on schedule.

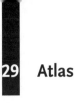

29 Atlas

Sculptor: Lee Lawrie.
Dedicated: 1937.
Medium and size: Overall 45 feet; bronze figure (15 feet) with armillary sphere (21-foot diameter), granite pedestal (9 feet).
Location: In front of the International Building of Rockefeller Center, 630 Fifth Avenue, between West 50th and West 51st Streets.
Subway: B, D, F, or V to 47th–50th Streets–Rockefeller Center.

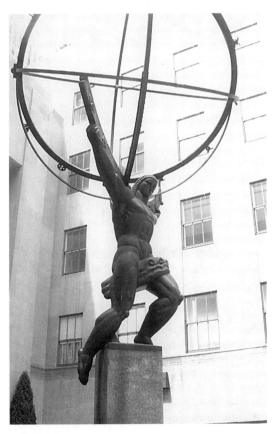

Atlas, Lawrie

> **Atlas Shrugs**
>
> "Mr. Rearden," said Francisco, his voice solemnly calm, "if you saw Atlas, the giant who holds the world on his shoulders, if you saw that he stood, blood running down his chest, his knees buckling, his arms trembling but still trying to hold the world aloft with the last of his strength, and the greater his effort the heavier the world bore down upon his shoulders—what would you tell him to do?"
>
> "I ... don't know. What ... could he do? What would *you* tell him?"
>
> "To shrug."
>
> —Ayn Rand, *Atlas Shrugged*, 1957

About the Sculpture

In Greek mythology, Atlas was condemned to carry the weight of the sky as punishment for having opposed Zeus. Instead of the usual globe, the Rockefeller Center *Atlas* supports an armillary sphere, designed to show the movements of heavenly bodies. This one is reduced to three rings bearing signs of the zodiac. In aesthetic terms such simplification makes sense: the armillary sphere allows light to fall through to the figure beneath.

For many fans of Ayn Rand's 1957 novel *Atlas Shrugged* (see Sidebar), the Rockefeller *Atlas* is a symbol of Rand's heroic view of man. That's an emotional reaction (see *Booth* and *Conkling, #17,* 18), based on the subject of the sculpture combined with the values of those readers. I, too, love *Atlas Shrugged,* but this sculpture should be critically evaluated for its philosophical message. Rand's heroes are the men of the mind, and with his bulky muscles and disproportionately small head, this *Atlas* is not at all intellectual looking. The artist implies that muscles matter more than brains, and that it's the muscle-bound laborers who bear the world on their shoulders. On the metaphysical implications of a sculpture's theme,

see *Shakespeare* (#37); on philosophical evaluations of those implications, see *Eleanor Roosevelt* and *Hamilton*, #40, 43.)

For a completely different interpretation of Atlas, walk up Fifth Avenue to 57th Street and study the *Atlas* who's been supporting the clock on Tiffany's facade since 1853. Not only does he have a much more attractive physique, he has historical associations with profitable business and glittering wealth.

About the Subject

When *Atlas* was unveiled in 1937, protesters claimed that it resembled Benito Mussolini. Far-fetched? A glass relief by Attilio Piccirilli, done at about the same time for the neighboring Italian Building (626 Fifth Avenue), had such obvious Fascist imagery and slogans that it was boarded over a week after the United States entered World War II. Nor did *Atlas* find many admirers in the following decade. In 1943 *New York Times* art critic Edward Alden Jewell and half a dozen cronies from the New York art scene jokingly deliberated which New York sculptures should be melted down to provide scrap metal for the war effort. Echoing the original protests, painter James Montgomery Flagg said *Atlas* "looks too much as Mussolini thinks he looks." Collector Chester Dale found in it "nothing worthy whatsoever." Whitney Museum director Juliana Force said it "contains much material extraneous to art." Sculptor William Zorach found it "bombastic, pretentious." As with *Prometheus* (#28), familiarity has bred fondness.

Sculptor: Isamu Noguchi.

Dedicated: 1940.

Medium and size: Stainless steel (22 x 17 feet).

Location: Associated Press Building, 50 Rockefeller Plaza, between West 50th and 51st Streets.

Subway: B, D, F, or V to 47th–50th Streets–Rockefeller Center.

News, Noguchi. © 2005 The Isamu Noguchi Foundation and Garden Museum, New York; Artists Rights Society (ARS), New York.

Mark Twain on the Associated Press
There are two forces that can carry light to all corners of the globe and only two—the sun in the heavens and The Associated Press down here.

—Address to the Associated Press annual meeting, 1906

About the Sculpture

News, with its energetic diagonals and its gleaming stainless-steel surface, is among the most dynamic of the Rockefeller Center sculptures and reliefs. Five burly men bursting out of the background convey the urgency of journalism: one takes a photo, one sets type, one speaks on the telephone, and one jots notes with pencil and paper. (The activity of the top center figure, gazing upward and to the right behind the typesetter, is unclear.) *News* was a boost to thirty-four-year-old Noguchi's reputation as well as to his bank account, which had been suffering since he decided in the early 1930s to switch from representational to abstract work.

You've probably seen Noguchi's *Red Cube* teetering in front of 140 Broadway, or his *Unidentified Object*, a pockmarked rock at Fifth Avenue and East 80th Street (near the Metropolitan Museum). Such abstract works eventually made Noguchi famous. Why, you may wonder, are they not included in this book?

They are not here because, by my standards, they are not art. The definition of art has been debated for centuries. My own study of art is based on the definition given by Ayn Rand (precise and intransigent in art, as other matters): art is "a selective re-creation of reality according to an artist's metaphysical value-judgments." Take a deep breath and keep reading: most of the elements of this definition will be familiar from earlier discussions in this book.

"Selective re-creation" means the artist chooses which details to include and starts from scratch, rather than from a mechanical reproduction such as a photograph or a laser-scanned image. (See *Shakespeare,*

#37.) From the *Statue of Liberty* and *Ericsson* onward (#1, 2), we've been studying which details each artist chose to include, and what those details signify. The details matter for the simple reason that the artist decided they would most effectively convey his message. Because a conscious decision was made to include those details, we as viewers can expect them to be significant, to convey something to us.

"Metaphysical value-judgments" are, simply put, what the artist considers important about humans and their world. (See *Hale, Booth* and *Prometheus*, #8, 17, 28.) "Metaphysical" here means "relating to existence"—broad statements such as whether it's possible to live happily on earth, rather than narrow ones such as one's preferred ice-cream flavor.

The only phrase in Ayn Rand's definition of art that we haven't discussed previously is that it's a selective re-creation "of reality." Why is that phrase necessary? Because unless a work of art shows something recognizable, there's no way the artist can communicate his or her ideas to the viewer. Discerning what Noguchi meant to convey in *Red Cube* is simply impossible.

The visual arts have been around for millennia because art conveys to us an artist's view of what's important. In so doing, art gives us guidance about what we should focus on amid the complexity of our everyday existence. (See *Hale*, #8.) A cube balanced on one corner or a rock randomly gouged doesn't convey such a message.

About the Subject

In 1932, after Mohandas K. Gandhi was escorted from prison to a remote railway station, the first person he saw was reporter Jim Mills. "I suppose when I go to the Hereafter and stand at the Golden Gate, the first person I shall meet will be a correspondent of The Associated Press," said Gandhi.

By that time the Associated Press had been sending reporters to the ends of the earth for nearly a century. In 1848, when the newspaper business was booming, six New York City newspapers (including Bennett's *New York Herald* and Greeley's *New York Tribune*, #21, 7) pooled their resources. Rather than each newspaper assigning a correspondent to a story,

they paid one reporter to relay news to all of them. As Mark Twain suggested decades later (see Sidebar), Associated Press reporters seemed to turn up everywhere.

One of the dozens of Associated Press reporters covering the Civil War preserved Lincoln's 1863 Gettysburg Address. In 1916 the AP sent the first play-by-play account of a World Series, direct from the ballpark to newspapers nationwide. Via the wirephoto service adopted in 1935, the AP distributed the Pulitzer Prize–winning photo of United States Marines raising the flag at Iwo Jima in 1945. Today the AP collects news at 143 bureaus in the United States and over 230 abroad, and distributes it to more than 10,000 news outlets. Its headquarters is still in the Associated Press Building at Rockefeller Center.

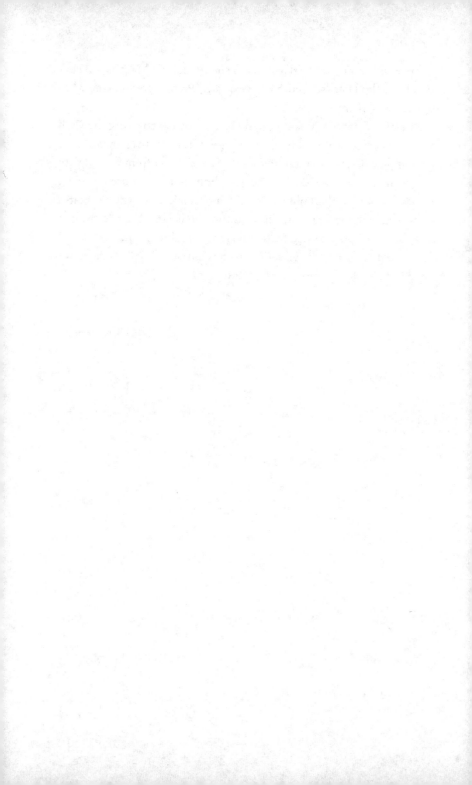

 31 **Sherman Monument**

Sculptor: Augustus Saint Gaudens. Pedestal: Charles McKim.
Dedicated: 1903.
Medium and size: Gilt bronze (15 feet), granite pedestal (about 9 feet).
Location: Grand Army Plaza, Fifth Avenue at East 59th Street.
Subway: N, R, or W to Fifth Avenue–59th Street.

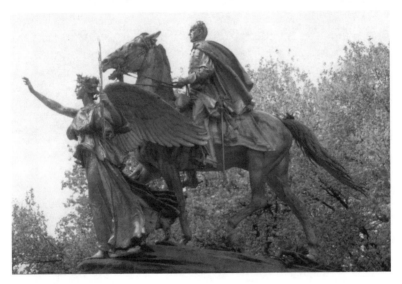

Sherman, Saint Gaudens

Sherman on Journalists

Newspaper correspondents with an army, as a rule, are mischievous. They are the world's gossips, pick up and retail the camp scandal, and gradually drift to the headquarters of some general, who finds it easier to make reputation at home than with his own corps or division. They are also tempted to prophesy events and state facts which, to an enemy, reveal a purpose in time to guard against it. Moreover, they are always bound to see facts colored by the partisan or political character of their own patrons.... Yet, so greedy are the people at large for war news, that it is doubtful whether any army commander can exclude all reporters, without bringing down on himself a clamor that may imperil his own safety. Time and moderation must bring a just solution to this modern difficulty.

—*Memoirs*, 1886

About the Sculpture

In failing health, Saint Gaudens sat supervising his assistants' work on the *Sherman*. His son reported:

"I am going to invent a machine to make you all good sculptors," [said Saint Gaudens].

The stillness promptly became uneasy.

"It will have hooks for the back of your necks, and strong springs."

The stillness grew even more uneasy.

"Every 30-seconds it will jerk you fifty feet away from your work, and hold you there for five minutes' contemplation."

Compare this equestrian statue with those of *Washington* or *Bolívar* (#13, 32), and you'll begin to realize the effect of Saint Gaudens's habit of painstakingly considering the whole as well as the parts. You'll also begin

to understand why Saint Gaudens is often considered the best sculptor America has yet produced. Like the 1880 *Farragut*, *Sherman* is represented unambiguously as a hero. Like *Farragut*, he seems to be going about his business rather than merely posing for a portrait. Unlike the *Farragut*, however, the *Sherman* is a complex composition on a monumental scale that few artists are able to achieve.

Sherman's horse trots along briskly: two of its hooves are raised, and its tail streams out behind. Rather than sitting sedately, as *Washington* at Union Square does, *Sherman* straightens his knees and leans slightly forward. His cape billows behind him. Although the association of capes with superheroes is modern, *Sherman's* cape certainly adds to the sense of vigorous movement. One of Saint Gaudens's last-minute additions was the branch of Georgia Pine beneath the horse's left rear hoof, recalling Sherman's March Through Georgia in late 1864.

Look closely at *Sherman's* face. It's calm, dignified and severe, but has a three-day stubble—rare in formal portrait sculpture. A naturalistic artist includes details simply because they're there, but Saint Gaudens was not a naturalist. The stubble has a purpose. Sherman was notoriously more concerned with getting the job done than with impeccable grooming. Mounted as he is, he looks as if he's off to do his job, rather than to ride in a parade.

In 1903, when *Sherman* was dedicated, the striding woman leading Sherman's horse was beautiful but unconventional. Proper Victorian ladies were petite, corseted, and swathed voluminously from neck to ankle. Even the Greek drapery of allegorical figures revealed little of the woman beneath. (See the *Statue of Liberty* and the *Hunt Memorial, #1, 38*.) By comparison, this woman seems an Amazon. She's tall and wears a loose dress that ripples against her body. On her chest is an aegis, the breastplate of the Greek warrior-goddess Athena, but this aegis bears an American eagle rather than the traditional head of Medusa. On her head is a crown of laurel, in her hand a palm branch—symbols of peace, fame, or victory. Saint Gaudens incorporates all three meanings: Sherman won battles, helped achieve peace, and became famous.

Victory is a wonderful figure all by herself, and Saint Gaudens sold reduced copies of her to collectors. But she is also integrated with the horse

and its rider, making this equestrian sculpture interesting from more angles than *Washington* or *Bolívar*. The lines of *Victory's* right arm, her drapery, and her wings echo the lines of *Sherman's* cape and the horse's tail. The vertical line of the palm branch echoes the line of *Sherman's* sword and the horse's weight-bearing front leg. These repeated lines emphasize the movements of the two figures and their firm connection: *Sherman* and *Victory* proceed together and belong together. Given Saint Gaudens's meticulous attitude toward his work, as shown in the *Reminiscences,* this cannot be coincidence.

Saint Gaudens proclaimed that he was tired of seeing "statues that look like stove pipes." It's a measure of the esteem in which both Sherman and Saint Gaudens were held that those who commissioned the sculpture were willing to pay for gold leaf on such a large project. Since Saint Gaudens's skills were artistic rather than prophetic, he didn't foresee that pollution would destroy the gold leaf within decades. After *Sherman* was regilded in 1989, the statue once again glowed in the sun, startling New Yorkers who had grown accustomed to its sooty hue.

About the Subject

In an unprecedented incident in 1863, a journalist was tried in a military court for a story he had submitted to a major newspaper. Blame it on nineteenth-century high technology. When the Mexican-American War began in 1846, reports from the lone newspaper correspondent at the front came east only as fast as horses or sails could move them—about a three-week lag. In contrast, reports by the hundred-odd Civil War correspondents were filed almost instantaneously via telegraph, printed in the newspapers the next day, and distributed by railroad throughout the United States.

William Tecumseh Sherman (1820–1891) had particular problems with reporters. In 1861 he had predicted to the secretary of war that at least 200,000 Union soldiers would be needed to win the war in the West. That turned out to be an underestimate, but the secretary's remark that Sherman's figure was "insane" was leaked to reporters, who began harping on Sherman's madness.

While Sherman and Grant devised plans to capture strategic Vicksburg, Mississippi, Sherman issued an order that anyone who wrote an account for publication that might give information to the enemy would be treated as a spy. In December 1862, just as Sherman attacked Vicksburg by way of Chickasaw Bayou, journalist Thomas Knox arrived at the front. Based on scattered interviews with low-ranking soldiers, he rattled off an account of the failed attack, complete with maps, and dropped it into the military sack to be sent east. A member of Sherman's staff opened Knox's suspiciously thick packet and refused to forward it. Infuriated, Knox rewrote the report and hand-carried it to a civilian telegraph station four hundred miles north. Printed in the *New York Herald* (#21) on January 18, 1863, Knox's piece praised the actions of many low-ranking officers, but slyly denounced Sherman with such statements as: "Notwithstanding his officers reported that it was impossible for even the smallest transport to ascend the bayou, he persisted in the order until his attention was directed to something else equally absurd." Knox's report, rapidly disseminated in other newspapers, was particularly damaging to Northern morale because it came a mere month after massive Union losses at Fredericksburg.

Sherman arrested Knox on charges of supplying information to the enemy, being a spy, and disobeying orders. A court-martial found Knox guilty only of having published a letter on military movements without the sanction of the general in command. Knox was ordered to leave Sherman's jurisdiction.

This particular battle wasn't yet over. In March 1863, Horace Greeley (#7) of the *New York Tribune*—the "political Bible" of the Republican Party—persuaded Lincoln that Knox's offense was "technically rather than willfully wrong." Knox presented Grant with a presidential request that Knox be allowed to continue reporting in Grant's jurisdiction. Grant deferred to Sherman.

Knox presented Lincoln's and Grant's letters to Sherman with a blandly ambiguous "regret at the want of harmony between portions of the army and the press." Sherman's reply was scathing:

After having enumerated to me the fact that newspaper correspondents were a fraternity, bound together by a common interest, that

must write down all who stand in their way, and bound to supply the public demand for news, even at the expense of truth and fact, if necessary, I cannot consent to the tacit acknowledgment of such a principle by tolerating such a correspondent. Come with a musket or sword in your hand, prepared to share with us our fate in sunshine and in storm, in success and in defeat, in plenty and in scarcity, and I will welcome you as a brother and associate. But come as you now do, expecting me to ally the honor and reputation of my country and my fellow-soldiers with you as a representative of the press,—you who, according to your own theory, will not carefully distinguish between truth and falsehood,—and my answer is, never!

In his *Memoirs* (see Sidebar) Sherman recognized the difficulty of balancing the public's desire for news with the military's need for security. By the time of the Spanish-American War in the 1890s (see *Martí* and *Maine*, #33, 34), the press and the military had hammered out a working relationship. But the battlefield is not the best place to work out such priorities. Sherman's stop-gap solution to Knox's behavior was simple: he never again allowed Knox to report from the area under his command.

Simón Bolívar

Sculptor: Sally James Farnham. Pedestal: Clarke and Rapuano.
Dedicated: 1921; relocated and rededicated 1951.
Medium and size: Bronze (13.5 feet), granite pedestal (20.3 feet).
Location: Central Park South at Avenue of the Americas.
Subway: N, R, or W to Fifth Avenue–59th Street.

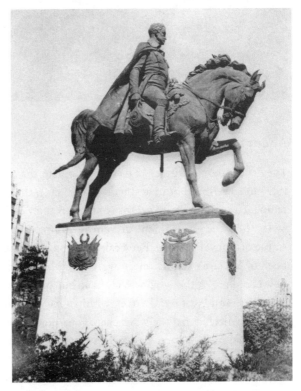

Bolívar, Farnham, with pre-1951 pedestal. Alajos L. Schuszler, New York City Parks Photo Archive.

Bolívar on the Struggle for Latin American Independence

The abuses, neglects, lack of organicity, are the result of causes it has not been in my power to correct, for many reasons: *first*, because a man in brief time and with scant general knowledge cannot do everything: not well, not even badly; *second*, because I have had to devote myself to expelling the enemy; *third*, because in our frightening chaos of patriots, traitors, egoists, white, colored, Venezuelans, Granadans, federalists, centralists, republicans, aristocrats, good and bad, and the whole caboodle of hierarchies in which every band is split, there are so many conditions to be observed that, dear friend, I have been forced many a time to be unjust in order to be politic—and when I've been just I've paid for it!

—Letter to Antonio Nariño, April 1821

About the Sculpture

The *Bolívar* monument, at 34 feet tall, is one of the city's towering sculptures in size—but not in aesthetic quality, even though it's the third attempt at a sculpture for New York of the Liberator of South America.

In 1884 the government of Venezuela presented New York with a statue of Bolívar. "An aesthetic calamity," sneered the *New York Times* of Leon de la Cuva's statue, "more aggressively bad than any [Central Park] now contains." Although it was given an out-of-the-way site near Central Park West and West 82nd Street, within a few years the statue had been so often ridiculed that the Venezuelan government volunteered to pay for a new one. In the 1890s Cuva's *Bolívar* was removed from his pedestal, probably to be melted down for use in the new statue.

Members of the National Sculpture Society "found no fault with the modeling" of the clay model for a new *Bolívar*, but asserted that the design "failed to suit the artistic taste of New York" (*New York Times*, August 27, 1897). This is an early instance of the trend toward city control of sculptures erected in public places, based on the idea that sculpture should edify and educate the public rather than simply commemorate a

certain person or event. (See *Bryant*, #22, on the City Beautiful movement.) After World War I a new *Bolívar* was finally dedicated at West 82nd Street.

At first glance, *Bolívar* looks similar to the equestrian *Washington* at Union Square (#13). Both men have severely upright, military postures. Both wear military uniforms and have hats in hand. The poses of the horses are almost identical. What's significantly different? *Bolívar* holds the reins with one hand and his hat in the other rather than reaching out to a crowd as *Washington* does.

Compared to his companions at Central Park South, *Martí* (#33) and *San Martín,* both on rearing horses, *Bolívar* looks even more static and withdrawn. If you look at these three in silhouette (which isn't difficult, given how seldom the sunlight reaches them), even the outlines of the *Martí* and *San Martín* convey great movement, energy, and excitement. *Bolívar,* in contrast, seems alone, on display. Despite competent workmanship and rigorously researched details, Farnham's *Bolívar* lacks impact because it doesn't show us the passions that drove the Liberator.

In the 1940s, New York mayor Fiorello La Guardia (#9) proposed renaming Sixth Avenue the "Avenue of the Americas" to promote and celebrate Pan-American union. He suggested that statues of prominent South Americans be erected along the avenue. *Bolívar* was moved to its current location in 1951, with the help of several hundred thousand dollars from the Venezuelan government for a new pedestal and landscaping. It was, alas, yet another bad investment. The pedestal doesn't merely elevate *Bolívar* above the common crowd, it makes him nearly disappear, and the surrounding trees complete the task of making him invisible to passersby.

About the Subject

"Those of us who have toiled for liberty in South America have but ploughed the sea," wrote Simón Bolívar (1783–1830) despairingly, near the end of his life. Strange words for a man known as the Liberator of Colombia, Venezuela, Peru, Ecuador, and Bolivia! Although he's often called "South America's George Washington," the outlines of their lives were quite different. Washington died at age sixty-seven, at his home

with family and friends, after eight years as commander in chief of the United States army and another eight years as president. Bolívar, by contrast, swore at the tender age of seventeen, "I will not rest, not in body or soul, till I have broken the chains of Spain." As a young man he visited the United States and, like Lafayette (#14), dreamed of establishing freedom and an American-style government in his homeland. But Bolívar fought for the liberation of South America for eighteen years, then died at age forty-seven, alone and impoverished, on a tiny island off the coast of Venezuela.

What went wrong? It wasn't lack of education or lack of military ability on Bolívar's part. Born to a wealthy family in Caracas, he had a tutor who tried to instill in him the principles of Rousseau, and introduced him to such intellectuals as the scientist, diplomat, and linguist Alexander von Humboldt. (See *Forgotten Delights: The Producers*, #5.) Bolívar's familiarity with John Locke and other Enlightenment thinkers is obvious in the constitutions he wrote, notably the Bolivian one of 1826.

But the situation in South America was very different from that of the thirteen American colonies. The territory Bolívar desired to liberate from Spanish dominion was vast and sparsely populated. Rain forests, deserts, and 20,000-foot peaks made transportation and communication exceedingly slow and difficult. Bogotá, the capital of Bolívar's confederation of states, was three or four weeks of hard riding from the cities of Venezuela.

Such terrain made communication and the spread of new ideas difficult. Bolívar believed that his fellow citizens had been stunted by years of colonial rule: "Bound to the triple yoke of ignorance, external tyranny and corruption, we have been able to acquire neither knowledge, power nor virtue" ("Angostura Address," 1819). As time went on, he became bitter about his compatriots' inability to share his vision for South America. The exasperated comment in the Sidebar dates to 1821.

In 1824 Bolívar's forces decisively defeated the Spanish army at Ayacucho, the last battle in Latin America's wars for independence. Four years later the countries he liberated had seceded from his union of Latin American states. By 1830, the year he died, most were under the rule of a chaotic succession of military leaders.

33 José Martí

Sculptor: Anna Hyatt Huntington.
Dedicated: 1965 (finished 1959).
Medium and size: Bronze (18.5 feet), granite pedestal (16.5 feet).
Location: Central Park South at Avenue of the Americas.
Subway: N, R, or W to Fifth Avenue–59th Street.

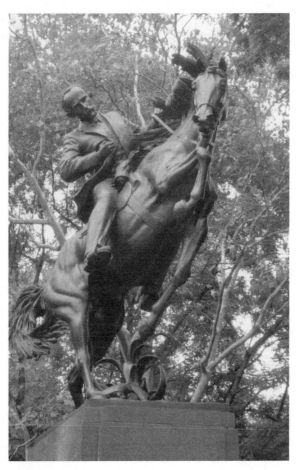

Martí, Huntington

Martí on North Americans versus Cubans

The North Americans put feeling after practicality. We put practicality after feeling. And if there is this difference in organization, in living, in being, if they were busy selling while we were weeping, if we replace their cold and calculating heads by our imaginative heads, and their hearts of cotton and ships by such a special, sensitive and new heart that it can only be called a Cuban heart, how do you want us to be governed by the laws that they use for governing themselves? Our lives are not like theirs, nor should we be so in so many matters. We feel very strongly about things.... The American laws have given the North a high degree of prosperity, and have also raised it to the highest degree of corruption. They have made money the chief good so as to create prosperity. Cursed be prosperity at such a cost!

—"Notebook 1," 1871, trans. E. Allen

About the Sculpture

Of the ten equestrian statues in Manhattan, *Martí* is by far the most dynamic. Whereas *Bolívar, Washington,* even *Joan of Arc* and the *Cid* (#32, 13, 44, 54), are satisfying from a side view, this one demands that we move around to view it from many angles.

To our right of *Martí, Bolívar's* horse walks sedately, as if on parade. To our left, *San Martín's* horse rears as its rider leads troops into battle. But *Martí's* horse is twisting like a corkscrew, eyes rolling, mane flying. *Martí* himself wears civilian clothes and carries no weapon. The lack of uniform or armor sets him apart from every other equestrian statue in the city except *Theodore Roosevelt* (#42), who's in mufti but flanked by armed guides. Further, *Martí* is leaning far to one side and has only one hand on the reins, despite his precarious situation. The other hand clutches his chest.

That gesture is the clue to the whole scene. This sculpture shows the moment just after Martí has been shot—a shot that killed Martí and terrified the horse.

We saw in *Ericsson*, *Greeley*, and *Holley* (#2, 7, 11) that a good portrait sculpture must show not only the physical appearance of the subject but a pose or action characteristic of him, one that shows the sort of man he was. To choose a man's death as the moment to represent in his portrait sculpture implies that the man's death was more important than his life. How could that be? We'll see in About the Subject.

About the Subject

No one has sculpted Washington or Jefferson on his deathbed. No one shows Nathan Hale dangling from the gallows. Why, then, was the death of José Martí (1853–1895) considered a fitting subject for his portrait sculpture?

By the late nineteenth century, Cuba's status as the lone colony of Spain in the Americas was intolerable to many Cubans. Reformists wanted Cuba to remain under Spanish dominion, but to be ruled separately. Annexationists wanted Cuba to become part of the United States. Another party favored independence.

For years journalist, orator, and poet Martí organized pro-independence Cuban exiles and rebels from his headquarters in New York. He wrote. He lectured. He arranged for warring factions to meet peacefully. Martí's wide appeal and leadership made possible the Cuban revolution that began in February 1895. By May, Martí had traveled to Cuba, where military leaders ordered him to stay away from the front lines. During a skirmish at Dos Rios, Martí rode forward anyway, and was shot. The Spanish dumped his body into a mass grave.

Martí's death was indeed as important as his life—more precisely, not the way he died, but the fact that he died when he did. True, he died too early in the revolution to enjoy the glory of victory. On the other hand, he could not be blamed for the problems that plagued Cuba in the following decades.

Beginning in the 1920s, Cubans of all factions began to appeal to Martí's eclectic writings to support their views. It's clear even from his early notebooks (see Sidebar) that Martí rejected the model of the United States. What he advocated instead is unclear. Although he wrote prolifi-

cally, his suggestions changed over time and varied according to whether he was addressing fellow revolutionaries, factory workers, Latin Americans, or citizens of the United States. Every Cuban faction could find something in Martí's writings to agree with.

By the 1950s, when Huntington created this sculpture, Martí had been transformed into a heroic martyr: the architect of Cuban independence and an inspiration to all Cubans. Dictator Fulgencio Batista's government donated $100,000 for the sculpture's pedestal. The pedestal was in place by 1959, when Batista "resigned" and Fidel Castro came to power. Fearing riots between Castro and anti-Castro forces, the State Department and the New York Police Department recommended that *Martí* temporarily be put into storage. Yet even the empty pedestal caused problems. In January 1960 there was rioting over the right to honor Martí's birthday by laying wreaths on it. "Assassins, murderers!" shouted pro-Castro forces. "Communists, godless blackguards!" responded the anti-Castro forces. Only in 1965 was the statue finally dedicated.

34 *Maine* Monument

Sculptor: Attilio Piccirilli. Architect: H. van Buren Magonigle.
Dedicated: 1913.
Medium and size: Marble pedestal (44 feet), gilded bronze group on top (16.5 feet), ten marble figures at base (over life-size).
Location: Central Park at Columbus Circle (intersection of Eighth Avenue, West 59th Street and Central Park South).
Subway: A, B, C, D, or 1 to 59th Street–Columbus Circle.

> **Her Captain Reports the Loss of the *Maine***
> *Maine* blown up in Havana harbor at nine forty tonight and destroyed. Many wounded and doubtless more killed or drowned.... Public opinion should be suspended until further report.
>
> —Capt. Charles D. Sigsbee, telegram to the Secretary of the Navy, February 15, 1898

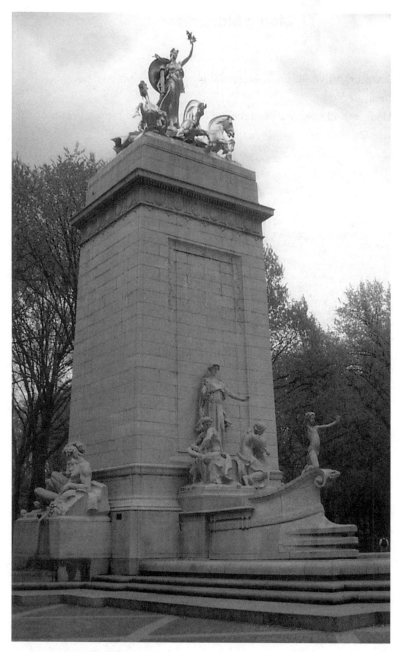

Maine Monument, Piccirilli

About the Sculpture

Lying awake grieving over a lost lover, you might wail, "Don't you know I can't sleep at night / Since you've been gone," or you might lament:

> How can I then return in happy plight,
> That am debarr'd the benefit of rest?
> When day's oppression is not eased by night,
> But day by night, and night by day, oppress'd?
> —Shakespeare, Sonnet XXVIII

Art must express an idea in a vivid image, but "vivid" does not necessarily mean ordinary and unadorned. In fact, the more unusual the images or words, the more likely you'll notice and remember them. With its eleven allegorical figures, the *Maine Monument* ranks among Manhattan's largest memorials. To understand its message requires knowledge of a specific historical event. Once you do understand it, though, this is a memorable and moving work.

Atop the *Maine Monument* gilt figures flash in the sun, catching our attention despite their position high above the sidewalk. The woman is Columbia Triumphant, that is, the United States. We know this not because of her action or anything she holds, but because the artist gave her that title. She carries a fasces, the bundle of sticks tied around an axe that symbolized government power to the Romans. (See *Washington*, #6.) Her shield gives her a martial air. Like *Sherman's* Victory (#31), she holds aloft an olive or laurel wreath, symbolizing victory or peace. A trio of seahorses draws her chariot, emphasizing that the United States is now a power at sea as well as on land. Because the Columbia group is so prominently placed on the *Monument*, and because it alone is gilded, the dominant theme of the *Monument* is the triumph of American naval power. The groups around the base, in contrast, remind us that the Spanish-American War began with a naval disaster. (See About the Subject.) On either side of the tapering pillar or pylon on which Columbia stands, a youth and an old man symbolize the Atlantic and the Pacific Oceans, the the-

aters of the war. Above them, inscriptions list those who died in the *Maine* explosion.

Kneeling against the prow of a ship at the front of the pylon is a young boy who once held two metal wreaths, again symbolizing peace and victory. They've been stolen so often that they're rarely replaced. Against the pylon's front the calm figure of Peace is flanked by a man (the strong, silent type) and a woman soothing a crying child. The artist entitled this group "The Antebellum State of Mind: Courage Awaiting the Flight of Peace and Fortitude Supporting the Feeble." I take this to mean that after the *Maine* exploded but before war was declared, Peace still reigned, Courage sat around with nothing to do (and resented it, judging from his expression), and Fortitude comforted those who grieved over the *Maine's* victims.

Moving around to the back, we see at the center Justice, her eyes closed rather than blindfolded. She probably held a pair of scales in her upraised hand (for weighing facts) and reached for a sword (to execute her decisions) from the warrior on our left. The scales and sword have also been stolen. On our right, History records the events of the war. The artist entitled this group "The Post-Bellum Idea: Justice Receiving Back the Sword Entrusted to War." Justice has triumphed, the fighters have turned in their weapons, and glorious feats are being recorded for posterity.

The message of this complex monument is that the United States fought a just war to avenge the seamen who died on the *Maine,* and emerged triumphant. Because Columbia appears in gilt on top of the *Monument,* the emphasis is on the triumph of the United States rather than the deaths of the seamen. Imagine the difference if, instead, Fortitude and the crying child, or a dead seaman, were atop the pylon. The *Monument* implies that Americans can successfully defend themselves and their values. Innocents may die, but they will not die unavenged.

What is the difference between this work, with its lengthily titled allegorical figures, and Noguchi's *Unidentified Object* (compare *News,* #30)? To understand the *Maine Monument* we must know that it relates to the Spanish-American War. Once we do, however, the various allegorical figures work together to convey a message about that war, by means of spe-

cific details included, color, composition, and so on. One cannot make a case that this *Monument* might just as well commemorate the Civil War, the Erie Canal, or *Breakfast at Tiffany's*. That said, it is an aesthetic flaw that the *Monument's* meaning isn't clear unless we know the titles given by the sculptor to the individual groups. (See *Lincoln*, #15.) The best visual art stands on its own, without verbal explanations.

About the Subject

Historians often imply that Americans, romping through the Gilded Age, were lured into the Spanish-American War by the sensationalist press's clamor about the 1898 explosion of the *Maine*. The roots of the Spanish-American War, however, extend much farther back than newspaper stories of February 1898.

By the late nineteenth century, Cuba was the only part of the Americas still under Spanish dominion. Cuban rebels had failed to win independence after a bloody ten-year war in the 1860s. For many Americans the solution was obvious: annex Cuba. Cuba would be free of Spain's oppressive monarchical rule. In turn, Cuba would supply the United States with cheap raw materials such as sugar and tobacco, and provide a new market for American goods.

José Martí's 1895 call for renewed military action against the Spanish (#33) began another brutal war. Most Americans favored the rebels. McKinley's 1896 presidential platform included support for Cuban independence. In December 1896, newspapers transformed an exchange of shots between a Spanish patrol boat and an American filibuster boat smuggling arms to Cuba into "The First Naval Battle of the Cuban War." A few months later, the press transmuted a suspected female spy searched by a matron in the privacy of a ship's cabin into a beautiful, naked girl surrounded by leering Spanish sailors.

Spain, under a new Liberal government, decreed that Cuba would be given home rule in early 1898. This pleased neither the rebels, who wanted complete independence, nor the loyalists, who feared retribution if Spanish troops were withdrawn. Violence was expected to erupt in February, when elections were scheduled. To protect American lives and

property as well as to indicate support for the new Spanish government, the United States sent the battleship *Maine* to Havana in late January.

At 9:40 on the balmy night of February 15, an explosion ripped open the *Maine's* bow, toppled its mast and smokestacks and ignited its ammunition magazines. Two hundred sixty-six sailors died, about three-quarters of the ship's complement. Americans were horrified, and speculation ran rife about the cause of the explosion. It must have been a mine planted by the Spaniards ... or by Cuban independence fighters, or by loyalists who wanted Spain to remain in Cuba. Perhaps it resulted from a short-circuited dynamo aboard the *Maine,* or spontaneous combustion within the coal bunkers (imprudently situated next to the ammunition storage), or spontaneous combustion of the gun cotton used in the ship's torpedoes, or a boiler malfunction.

Fans of television's *CSI* might expect that it would be immediately evident whether the explosion's source was internal or external. Given the state of technology and forensic science at the time, it was not. Massive damage from the initial explosion was compounded by the detonation of the ammunition and by fire and saltwater. Divers staggered about in 200-pound suits, with electric lights that barely penetrated the murky water. Underwater photography was impossible.

With evidence about the *Maine's* explosion inconclusive, New York newspapers became major players in the Cuban question. Hearst's *Journal* printed a drawing—completely fictitious—showing Spanish divers fastening a mine to the *Maine's* hull. The *Journal* devoted eight pages a day, week after week, to the *Maine* and Cuba. Pulitzer's *World,* battling the *Journal* for circulation, printed equally belligerent reports. Within a few months Americans were chanting, "Remember the *Maine!* To hell with Spain!" By June, Theodore Roosevelt (#42) and the Rough Riders sailed off to war. Two months later the war ended, and by 1899 Carl Schurz was lecturing against American imperialism in the Philippines, which the United States had taken over by the peace treaty with Spain (#51).

35 Columbus Monument

Sculptor: Gaetano Russo.

Dedicated: 1892.

Medium and size: Overall 77 feet. Marble statue of Columbus (13 feet), marble Genius on the south side (9 feet), bronze eagle on the north side (6 feet), bronze reliefs on the south and north sides (each 2 x 6 feet).

Location: Columbus Circle, intersection of Eighth Avenue, Central Park South and West 59th Street; great view from the Time Warner Building.

Subway: A, B, C, D, or 1 to 59th Street–Columbus Circle.

Columbus Monument, Russo. Detail.

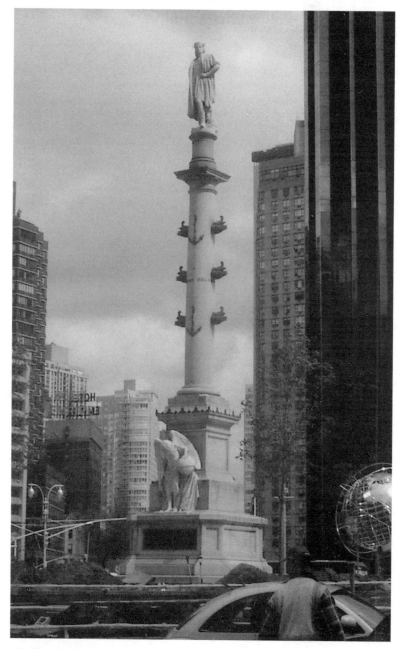

Columbus Monument, Russo

"Columbus"
Behind him lay the gray Azores,
 Behind the Gates of Hercules;
Before him not the ghost of shores,
 Before him only shoreless seas.
The good mate said: "Now must we pray,
 For lo! the very stars are gone.
Brave Adm'r'l, speak; what shall I say?"
 "Why say: 'Sail on! sail on! and on!'"...

They sailed. They sailed. Then spake the mate:
 "This mad sea shows his teeth to-night;
He curls his lips, he lies in wait,
 With lifted teeth, as if to bite:
Brave Adm'r'l, say but one good word;
 What shall we do when hope is gone?"
The words leapt like a leaping sword:
 "Sail on! sail on! sail on! and on!"

Then, pale and worn, he kept his deck,
 And peered through darkness. Ah, that night
Of all dark nights! And then a speck—
 A light! a light! a light! a light!
It grew, a starlit flag unfurled!
 It grew to be Time's burst of dawn.
He gained a world; he gave that world
 Its grandest lesson: "On! sail on!"

—Joaquin Miller, ante 1913

About the Sculpture

Like the *Maine Monument,* this is a complex ensemble. Let's see if we can work out its message. On the south side (the principal view), we first see a 9-foot-tall winged boy leaning over a globe. Before his features eroded

he gazed down at the Americas with a smile of delight, proclaiming that the discovery of the Americas was a marvelous accomplishment. Since he is the first figure the viewer sees closely, the boy sets an upbeat mood for the whole *Monument.*

He has been called the "Genius of Columbus" and the "Genius of Geography." ("Genius" in this case is a guardian deity, not a person of high intellect.) I prefer to think of him as the "Genius of Discovery," a reminder that Columbus's voyage was the impetus for hundreds of later voyages of exploration.

Aside from the Genius, two 6-foot-wide bronze reliefs form the *Monument's* most striking street-level features. On the north side, below an eagle gripping the shields of Genoa (Columbus's birthplace) and the United States, the relief shows Columbus's fleet anchored in the Caribbean. As his men crowd along the rails, a longboat ferries Columbus to shore.

They say Columbus knelt and wept for joy when he landed, but in the relief on the south side (below the Genius) he stands triumphantly, shoulders back, chin raised, gazing upward. The only kneeling figure is a youth who kisses Columbus's hand, gratefully saluting the man who brought the ships to safe harbor. Another companion respectfully touches Columbus's sleeve, as others raise the flag and haul a longboat ashore. One man anxiously draws Columbus's attention to the Indians half-hidden in the trees at the right. In the midst of this crowd Columbus dominates, and everyone acknowledges his achievement and authority.

Now step back to look above the Genius and the reliefs. The pillar supporting Columbus's statue displays five anchors, recalling a section of the coat of arms awarded to Columbus after his first voyage. Balancing the anchors are three pairs of rostra, the beaklike prows of ancient ships, designed to ram enemy vessels. The Roman emperor Augustus mounted the prows of his enemies' ships on a column after the decisive Battle of Actium in 31 B.C.; ever since, they have symbolized victory at sea. Here they represent Columbus's triumph in finding land, as well as the three ships he took on his first voyage.

Atop the column, 60 feet above the street, the colossal figure of Columbus stands proudly upright, chin level, gazing far into the distance

to his left. The left arm, set akimbo, suggests he has energy to spare: imagine the difference if his hands dangled limply, or were folded placidly in front of him. He twists to reach his right hand to the tiller behind him, so that he can steer without turning his eyes from the distant horizon. The twist gives the figure a sense of lively movement. (Compare *America* and *Lafayette*, #4, 14.)

All the elements of the *Columbus Monument* unite to present Columbus as the energetic, courageous and focused explorer who deserves full credit for the discovery of the New World. The monument's inscription, in Italian and English, makes this explicit: "To Christopher Columbus, the Italians resident in America. Scoffed at before, during the voyage menaced, after it chained, as generous as oppressed, to the world he gave a world."

About the Subject

Columbus (ca. 1451–1506) was not the first man to believe the world was round. The Greeks knew it. Many Renaissance scholars knew it. Sailors knew it, from watching ships disappear hull-first over the horizon.

Nor was Columbus the first to dream of reaching Asia by sea. For much of the fifteenth century the Portuguese had been inching their way down the west coast of Africa. By 1487, when Columbus was still seeking funding for his voyage, Bartolomeo Diaz had rounded the Cape of Good Hope, and in 1498 Vasco da Gama reached India. Columbus was not even the first European to reach America. The Vikings had landed there centuries earlier, and Europeans had been frequenting Nova Scotia's rich fishing grounds for years.

Columbus's unique and glorious achievement is that he conceived the idea of sailing west in order to reach the Far East, that he had the courage and perseverance to organize and carry out such a voyage, and that at the end of it he discovered the Americas. On his four voyages he established the transatlantic routes that continued in use until steam replaced sail in the nineteenth century. These efficient, predictable sea routes made permanent settlement in the Americas feasible.

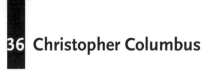

36 Christopher Columbus

Sculptor: Jeronimo Suñol. Pedestal: Napoleon Le Brun.
Dedicated: 1894.
Medium and size: Bronze (8 feet), granite pedestal (7.75 feet).
Location: Central Park, Literary Walk, north of the 65th Street Traverse.
Subway: 4, 5, or 6 to 59th Street or F to Lexington Avenue–63rd Street.

Columbus, Suñol

Washington Irving on Columbus

Certain it is that at the beginning of the fifteenth century, when the most intelligent minds were seeking in every direction for the scattered lights of geographical knowledge, a profound ignorance prevailed among the learned as to the western regions of the Atlantic; its vast waters were regarded with awe and wonder, seeming to bound the world as with a chaos, into which conjecture could not penetrate, and enterprise feared to adventure.... It is the object of the following work, to relate the deeds and fortunes of the mariner who first had the judgment to divine, and the intrepidity to brave the mysteries of this perilous deep; and who, by his hardy genius, his inflexible constancy, and his heroic courage, brought the ends of the earth into communication with each other. The narrative of his troubled life is the link which connects the history of the old world with that of the new.

—*Life and Voyages of Christopher Columbus*, 1828

About the Sculpture

What a shocking change from the *Columbus Monument* (#35)! This *Columbus* bears a wrinkled brow, bags under his eyes, deep lines at the corners of his mouth, a slight double chin, and a receding hairline. Hatless and humble, he gazes heavenward. He stands upright, facing forward rather than twisting like the *Columbus* at Columbus Circle—a static figure. This appears to be Columbus in his final years (he died in 1506), after a disastrous stint as a colonial administrator and exhausting legal battles to collect the rewards he considered due from his 1492 royal contract.

Around his neck on a heavy chain hangs a portrait of a woman, probably his patron Queen Isabella, who died while Columbus's case was plodding through the courts. *Columbus's* right hand grasps a flag bearing the arms of Spain, whose flagpole is surmounted by a cross—reminders that

Columbus made his voyage with royal authority, and for religious as well as commercial reasons. Behind him is a capstan, used on ships to wind in rope. The globe resting on the capstan provides the only reference in this sculpture to Columbus's heroic journey beyond the known ends of the earth. Why can we see all these details so easily? Because the Central Park statue's pedestal rises a mere 7 feet. This *Columbus* is literally more down-to-earth than the *Columbus Monument*, where the explorer is 60 feet above the ground.

The Central Park statue is a modified version of a marble *Columbus* by Suñol dedicated in Madrid's Plaza de Colón in 1886. The Madrid *Columbus* stands on a tall octagonal pillar with an elaborate late-gothic-style base. The base encloses reliefs of the Madonna, Queen Isabella, Columbus conferring with Father Deza, and the *Santa Maria*, plus four life-size heralds, the arms of Spain, and a list of crew members. Its message: that Columbus's achievements were committee efforts, with credit going to God, Spanish monarchs, and crew as well as Columbus. The Central Park *Columbus*, bereft of his supporting cast and with only the globe and capstan to indicate his accomplishments, looks fatigued and hopeless.

In studying the *Columbus Monument*, we saw that subsidiary details such as reliefs and ornaments can significantly affect the theme of a sculpture. In this *Columbus*, let's narrow our focus and consider the effect of one particular detail: *Columbus's* left hand. He gestures somewhat vaguely and ineffectually. Is he pointing to something? Making a request? Although the gesture is almost identical to *Vanderbilt's* (#25), we interpret them differently, in large part due to the expression and pose of each figure. The Central Park *Columbus*, old and tired, looks to heaven to solve his problems. *Vanderbilt*, with his direct gaze, stern mouth, and upright posture, seems authoritative and in control even though the portrait was sculpted when he was seventy-five years old. Given *Vanderbilt's* pose and expression, the gesture of his left hand naturally seems more decisive.

An even more significant difference between the two gestures is that *Vanderbilt's* hand turns palm down, *Columbus's* palm upward. Holding one's palm upward usually means one is begging for something. Hence we read *Columbus* as needing something, and (due to the upward glance)

as asking heaven's help to get it. We interpret *Vanderbilt*, with his palm down and finger pointed, as issuing orders.

Even so specific a detail as having a palm facing up or down, however, doesn't have an absolute and unchanging meaning that holds true regardless of the rest of the sculpture. *Roscoe Conkling* (#18) has his right arm slightly extended, palm up. Yet from the casual way he stands, his level gaze, and particularly the way he hooks his other thumb into a pocket, he seems merely casual, as if he's asking a rhetorical question while chatting with a colleague.

About the Subject

The attitude of most late-nineteenth-century Americans toward their country was reflected in a single sentence recited by the nation's schoolchildren: "I pledge allegiance to my Flag and the Republic for which it stands: one Nation, indivisible, with Liberty and Justice for all." The Pledge of Allegiance was introduced across the nation on Columbus Day, 1892, the four hundredth anniversary of Columbus's discovery of America. That's appropriate because Americans' attitudes toward Columbus, toward the United States, and toward Western civilization have always been closely linked. Washington Irving, writing in the 1820s (see Sidebar), was one of the first to make this connection. By 1892 Columbus was regarded as an American national hero, although he never set foot on what became United States soil.

The four-hundredth anniversary of Columbus's first voyage saw the dedication of monuments to the explorer throughout the United States, as well as the magnificent, six-month-long Columbian Exposition in Chicago that drew twenty million visitors. Celebrating America's centuries of progress in the intellectual, technological, and cultural arenas, the "White City's" 686-acre site was filled with the works of such eminent architects as Richard Morris Hunt (#38), McKim, Mead and White, and Louis H. Sullivan. The buildings and grounds were lavishly embellished with sculptures by Frederick MacMonnies, Daniel Chester French, Philip Martiny, and others under the direction of Augustus Saint Gaudens. In the Palace of Fine Arts, twelve hundred paintings and sculptures

formed the largest display of American art ever assembled. Other Columbian Exposition displays equated progress with material improvement, glorifying both.

A century later the National Council of Churches, in a widely publicized tirade, shrieked that Columbus's arrival in the Americas brought "an invasion and colonization with legalized occupation, genocide, economic exploitation and a deep level of institutional racism and moral decadence." Few voices rose in Columbus's defense. The five-hundredth anniversary of his first voyage passed in 1992 with only minor tributes. Yet the debate over whether Columbus's voyage to the New World deserves praise or condemnation is ultimately a debate over whether Western civilization is better than the life of the pre-Columbian "noble savage"—the exhausting, brutally short life of primitive farmers and hunters in a Stone Age culture where writing and the wheel were unknown.

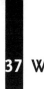 **37** William Shakespeare

Sculptor: John Quincy Adams Ward. Pedestal: Jacob Wrey Mould.
Dedicated: 1872.
Medium and size: Bronze (8 feet), granite base (8 feet).
Location: Central Park, Literary Walk, north of the 65th Street Traverse.
Subway: 6 to 59th Street or F to Lexington Avenue–63rd Street.

Shakespeare, Ward

Life Imitating Art

Paulina (draws curtain aside to show Hermione, standing like a statue).
I like your silence, it the more shows off
Your wonder: but yet speak; first, you, my liege,
Comes it not something near?
Leontes. Her natural posture!...
O, thus she stood,
Even with such life of majesty, warm life,
As now it coldly stands, when first I woo'd her!
I am ashamed; does not the stone rebuke me
For being more stone than it?...
Paulina. O, patience!
The statue is but newly fix'd, the colour's not dry.

—Shakespeare, *A Winter's Tale*, Act V, Scene 3

About the Sculpture

Near the end of *A Winter's Tale*, Queen Hermione pretends to be a statue of herself, so perfectly painted that it could pass as a living woman. Today a technician can do a laser scan of a sitter, then mechanically produce a "portrait" in foam that captures the exact shape of the sitter's eye sockets, the tendons of the neck, the size of the feet, the folds of a favorite shirt. Would such a statue, physically accurate down to the minutest detail, be a better portrait sculpture than Ward's *Washington* or Saint Gaudens's *Sherman* (#6, 31)? Would it at least be better than the awkward *Fitz-Greene Halleck* who sits just north of Shakespeare on the Literary Walk? In short, does the aesthetic quality of a portrait depend on minute fidelity to the physical characteristics of the sitter? This question is crucial, because it involves the reason for selectivity in art, the function of art, and the relationship of art to philosophy.

A laser scanner aids but also limits its technician. It will automatically record all details of the sitter, but some of those details will be purely accidental: the twitch of the eyelid, the unconscious slump of a shoulder. For the viewer, studying such a reproduction is like studying a stranger at a cafe. We don't know whether that frown is habitual, or whether she's merely upset that the man at the next table is shouting into his cell phone. By contrast, even a meticulously realistic artist constantly makes choices about which details to include, because an artist starts from scratch. This wrinkle? That one? The full volume of those bushy eyebrows? Less of them, to focus more attention on the eyes?

Based on what the artist decides is important about the sitter, he or she must make innumerable choices about expression, pose, proportions, costume, texture, composition. In *Farragut* (#19), Saint Gaudens emphasized the admiral's farsightedness and courage. In *Conkling* (#18), Ward emphasized the casual yet authoritative manner of a prominent politician. For *Shakespeare*, Ward agreed when accepting the commission to adhere as closely as possible to the few surviving early representations of the Bard. Beyond that, Ward chose to stress the pensiveness of a writer working out plot, character, and dialogue. Look at the posture: *Shakespeare's* head is bent, his feet aligned, his weight solidly on one foot. Standing that way, he can't possibly be rushing to a show at the Globe or out for a beer with friends. His expression confirms this: his eyes are downcast, his face expressionless and withdrawn, as if he's absorbed in the drama he's creating.

Switching from the artist's perspective to the viewer's: when we look at a sculpture created from scratch, we know that whatever is included is present because the artist considered it important. Because of that, a sculpture can convey not just the character of a particular individual, but the artist's view of what's important about humans and the world. An artist who shows a courageous man such as *Farragut* says, "The world is the kind of place where dangers exist but can be faced"—otherwise the very concept of courage is pointless. An artist who shows a thoughtful man such as *Shakespeare* says, "The world is a place where mental effort pays off"—otherwise thinking is a useless task. An artist who shows a man fighting evil and losing, as in the Hellenistic Greek *Laocoon Group*,

says, "The world is full of horrors that man is powerless to prevent"—so fighting fate is noble but futile.

Ayn Rand defined art as "a selective re-creation of reality according to an artist's metaphysical value-judgments." (See *News*, #30.) A statement such as "The world is the kind of place where dangers exist but can be faced" is an example of a metaphysical value-judgment. The work of art that conveys such a statement presents a vivid view of the world—the sort of world you might want to struggle toward, or fight to avoid at all costs. Such art brings philosophy, that most complex and abstract of fields, back to an image you can see and hold in your mind.

If a time-traveling laser technician scanned a "portrait" of Shakespeare, it would tell us only what Shakespeare looked like physically. Ward's statue of *Shakespeare* does much more than that. By showing the playwright deep in thought, it says that the world is a place where mental effort pays off, and implies that the process of thinking is worthwhile.

About the Subject

In 1948 Cole Porter flippantly advised men who wanted to impress society girls to quote Shakespeare: "Just declaim a few lines from *Othella*, / And they'll think you're a helluva fella." A century earlier, Shakespeare wasn't the exclusive property of the upper classes. In 1849, 20,000 working-class New Yorkers who favored American actor Edwin Forrest's interpretation of *Macbeth* mobbed the Astor Place Opera House, where New York's wealthier citizens were watching British actor William Macready in the same role. Police shot and killed twenty-two rioters, but the mob didn't disperse until cannon were dragged to the scene.

In the years after the Civil War, familiarity with and appreciation of Shakespeare became largely the province of intellectuals. Edwin Booth (d. 1893; #17) achieved national fame and popularity primarily as a Shakespearean actor, but he was one of the last Americans to do so.

When the cornerstone for *Shakespeare* was laid in April 1864 to honor the Bard's tercentenary, the *New York Times* reported "a not very large but indisputably a very elegant and intellectual audience." Judge Charles P. Daly noted that the proposed sculpture would provide Americans the

chance to demonstrate "our sympathy with, appreciation of, and common property in the works which Shakespeare has left for the delight and instruction of mankind, and which, if we omitted to do, would be a reflection upon us as an intellectual and cultivated people." In other words: hey, we're not ignorant cowboys any more!

38 Richard Morris Hunt Memorial

Sculptor: Daniel Chester French. Architect: Bruce Price.

Dedicated: 1900; allegorical figures erected 1901.

Medium and size: Overall about 30 feet wide. Two bronze allegorical bronze figures (6.25 feet), bronze bust (2.25 feet), granite exedra and colonnade.

Location: Fifth Avenue between East 70th and 71st Streets.

Subway: 6 to 68th Street–Hunter College.

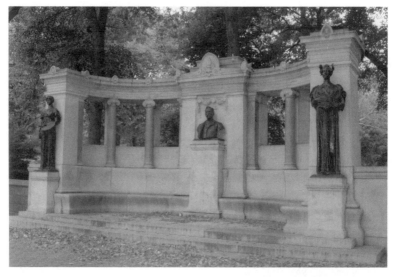

Hunt, French

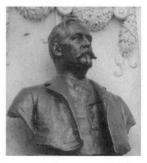

Hunt, French. Detail.

**Sculptor Bitter Describes Architect Hunt
at the Columbian Exposition**

We had come early and listened until late to speeches and odes we could not hear, and everybody was thoroughly weary and tired, in rather a bad humor, like the weather outside.... I heard Mr. Hunt exclaim, just as we reached the Court of Honor, and his tone brought us to a sudden standstill: "Look around you," he said, and he became eloquent in a manner I shall never forget. There he stood, erect with his bushy eyebrows slightly contracted, and his outstretched arm beckoning us to survey the surrounding structures. "Here we stand in the midst of what we have done, and have a cause to be proud of doing so much in so short a time! Why don't you hold up your heads in appreciation of the honor you have just received, like men, instead of crawling along in this dejected manner." ... The great enthusiasm of the speaker had kindled our own, and we cheered and cheered.

—Karl Bitter, 1892

About the Sculpture

Usually a work of art inspires you only if you agree with the artist's view of the world. (See *Booth* and the *Columbus Monument, #17, 35*.) The *Hunt Memorial* illustrates a different kind of benefit: the pleasure of seeing a top-notch mind tackle a difficult problem. Years before he executed the *Continents (#4)*, French was commissioned to design a memorial for Hunt, one of America's leading architects. Merely displaying models of Hunt's most famous buildings would have been a singularly ineffective way to commemorate Hunt's contributions to American architecture and the respect his colleagues felt for him. French resolved the problem by placing an over-life-size bust of Hunt within an architectural framework. As a reminder that one of Hunt's notable accomplishments was reintegrating sculpture into American architecture, an allegorical statue punctuates each end of the colonnade.

The figure on the left is *Painting and Sculpture.* In her right hand she holds a sculptor's mallet. In her left, she holds a palette and a statuette. The statuette reproduces the reclining *Dionysus* from the Parthenon pediment, reminding us that Hunt was thoroughly familiar with the history of art and architecture, having been the first American architect to train at the Ecole des Beaux-Arts in Paris. The *Dionysus* is also a notable example of sculpture incorporated into architecture.

On the right end of the colonnade stands *Architecture,* holding a replica of Hunt's Administration Building for the 1893 Columbian Exposition in Chicago. (See *Columbus, #36.*) The Administration Building, with its gleaming gold dome, ranked as one of Hunt's major achievements and exerted an enormous impact on fellow architects. Look closely at the model and you can see tiny replicas of the sculptural decoration by Karl Bitter, who did the *Carl Schurz Monument* (#51) and sculptures for Hunt's Metropolitan Museum of Art. For Bitter's description of sixty-five-year-old Hunt, see the Sidebar.

Consider these two allegorical figures for a moment longer. If they were in motion like Athena on the *Bell Ringers' Memorial* (# 21), they would distract attention from the portrait bust at the center. If they were larger, they'd overpower the bust, in spite of its heroic proportions. Instead, French has made them stand still, looking straight ahead, wearing drapery that falls in loose vertical folds like the fluted columns Hunt used so often in his Beaux-Arts designs.

The combination of bust, allegorical figures and colonnade that French and architect Bruce Price designed to honor Hunt almost seems inevitable. Of course, it's not: it required hard work as well as ingenuity to create such an effective combination. Even someone who doesn't admire Hunt's architecture can admire French's memorial to him.

About the Subject

Richard Morris Hunt (1827–1895) was the favored architect for the Astors, Vanderbilts, and other New York millionaires. The first American architect trained at the Ecole des Beaux-Arts in Paris, he produced mansions in neo-Renaissance and neo-Gothic styles. Among his public

commissions were such Beaux-Arts icons as the Fifth Avenue facade of the Metropolitan Museum.

Hunt should also be remembered, however, for building what was—or wasn't—one of New York's first skyscrapers. The ten-story Tribune Building stood for almost a hundred years on Nassau Street, at the western end of the Brooklyn Bridge. Begun in 1873, it was in part a monument to eccentric journalist and politician Horace Greeley, founder of the *Tribune*, who had died the previous year. In accordance with his belief that sculpture should be incorporated into architecture, Hunt commissioned Ward's *Greeley* (#7) for the Tribune Building.

The Tribune Building's facade was a motley combination of styles and colors. A heavy granite base and oversized granite window frames contrasted with deep-red brick walls. Atop the three-story mansard roof hovered a clock tower reminiscent of Florence's Palazzo Vecchio. Behind the eclectic facade, however, was a structure noteworthy for its practical elements.

Acknowledging the increasing value of real estate in lower Manhattan, Hunt made the Tribune Building twice as tall as any previous commercial building in New York. In fact, it was taller than any other structure in the city except Trinity Church's spire. Occupation of such a tall building had only recently been made feasible by Otis's safety elevator. The Tribune Building also boasted the latest technology in fireproof construction—hollow terracotta tiles over iron beams. (Compare the Cooper Union, #10.)

Many architectural historians list the Tribune Building as one of the world's earliest skyscrapers. Those who dispute the title point out that the Tribune Building had load-bearing masonry walls rather than a steel skeleton. If one accepts steel-frame construction as a requisite for classification as a skyscraper, then the Tribune Building wasn't one of the first. Yet in fairness to Hunt, one can't blame him for not using resources that were still exceedingly scarce. Mass production of steel had barely begun when the Tribune Building went up in the early 1870s. (See *Holley*, #11.)

Sculptor: Stanislaw Kazimierz Ostrowski. Pedestal: Aymar Embury II.
Dedicated: 1939.
Medium and size: Bronze (14.6 feet), granite pedestal (10 feet).
Location: Central Park, north of the 79th Street Traverse, just east of
 Belvedere Lake. From the park entrance just south of the Metropoli-
 tan Museum, walk west (uphill) and cross the East Drive, following
 the sign toward Belvedere Castle. At the fork at the top of the hill bear
 right and head downhill toward the lake; the statue is on the right.
Subway: 6 to 77th Street.

Jagiello, Ostrowski

Author of *Quo Vadis* on the Teutonic Knights, ca. 1399
The one who lives on the borders of the kingdom [near the Knights], never knows when he goes to bed in the evening, whether he will awaken in fetters, or with the blade of a sword in his throat, or with a burning ceiling over his head.... Neither the weak nor the powerful can agree with the Order, because the knights despise the weak and try to ruin the mighty. Good deeds they repay with evil ones. Is there anywhere in the world another order which has received as many benefits from other kingdoms as the knights have received from Polish princes? And how have they repaid? With threats, with devastation of our lands, with war and with treachery.... In their hearts they are always plotting means to annihilate this kingdom and the whole Polish nation.

—Henryk Sienkiewicz, *Teutonic Knights (Krzyzacy),*
trans. Samuel A. Binion, 1899

About the Sculpture

When the Nazis invaded Poland in September 1939, Hitler ordered his troops to melt down for bullets a Krakow monument to Jagiello, the hero of Grunwald. Our *Jagiello* (by a different artist) was cast for the Polish Pavilion at the 1939 New York World's Fair, and after Hitler's invasion was purchased from the Polish government in exile.

Jagiello stands in his stirrups, brandishing a pair of swords sent by enemies to taunt him. (See About the Subject.) Grim lines bracket his mouth. He wears a massive crown: he's a king as well as a warrior. Heavy armor protects and conceals his body, but the fact that he can hold two huge swords over his head makes it clear that he wields physical as well as political power.

Like *Bolívar* (#32), *Jagiello* is striking a pose, holding perfectly still. How can we tell? His cape, embroidered with the coats-of-arms of Poland and Lithuania, hangs motionless. Although *Jagiello* has dropped the reins, his horse is also perfectly still, head bowed, feet aligned. In an

equestrian statue the behavior of the horse conveys a great deal about its rider's mood and ability to command. *Jagiello's* subdued horse obviously recognizes its master.

Based on the combination of *Jagiello's* pose and expression, the theme of this work is defiance—specifically, defiance in the face of an attacking enemy rather than *Hale's* defiance of defeat and death. Advocating such defiance implies a certain view of the world: that winning is possible (else why fight?), and that one must not meekly surrender to enemies.

Given this message, it's certain that had this *Jagiello* been in Poland when Hitler invaded, it too would have been destroyed. Citizens of free countries are often blithely unaware that art makes important statements with the widest possible implications. (See *Hale* and *News*, #8, 30). Dictators cannot afford to doubt it. Hitler, Napoleon III of France (under whom the *Statue of Liberty* was conceived; #1), and absolute rulers throughout the ages have attempted to control visual arts as well as political writings and speeches, realizing that a sculpture of an allegorical figure or someone from the distant past (such as *Jagiello*) can act as a potent reminder of ideas hazardous to all-powerful despots.

About the Subject

When no crusades were under way in the Holy Land, the Teutonic Knights battled pagans in eastern Europe. In a particularly malignant example of faith used to justify brutal force, they gained territory by murdering the inhabitants and replacing them with Christian immigrants. The Knights eventually lusted after ever more land, whether or not it was occupied by pagans.

In 1377 Jagiello became Grand Duke of Lithuania, the last pagan country in Europe. Nine years later, in order to establish a defensive alliance against the Knights, he married Queen Jadwiga of Poland. Jagiello immediately converted to Christianity. Mass baptisms were performed on his subjects.

That should have made his country off limits to the Teutonic Knights, but in 1398 the Knights invaded and occupied part of Lithuania. (Sienkiewicz's novel *The Teutonic Knights* is set at this period: see Sidebar.)

A decade later, sixty-year-old Jagiello and his cousin Witowt were ready to retaliate.

Early on the morning of July 15, 1410, tens of thousands of Poles and Lithuanians faced tens of thousands of Knights and their allies near Grunwald, south of Danzig. For hours Jagiello refused to engage the enemy, forcing the Knights to stand in the sun, roasting slowly in their heavy plate armor. His own men rested in the coolness of the forest. Eventually emissaries from the impatient Grand Master of the Knights approached Jagiello and threw two swords at his feet. "Lithuanians and Poles, Dukes Witowt and Jagiello, if you are afraid to come out and fight, our Grand Master sends you these additional weapons." "I accept both your swords and your choice of battleground," replied Jagiello, "but the outcome of this day I entrust to the will of God."

At mid-morning the battle began. By sundown the Grand Master, several hundred Teutonic Knights, and thousands of foot soldiers fighting for them lay dead, after one of the decisive—and last—battles of the Middle Ages.

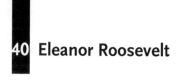

40 Eleanor Roosevelt

Sculptor: Penelope Jencks.
Dedicated: 1996.
Medium and size: Bronze (8 feet), leaning against a granite boulder.
Location: Riverside Park at West 72nd Street.
Subway: 1, 2, or 3 to 72nd Street.

Eleanor Roosevelt, Jencks. © Penelope Jencks.

The *New York Times* Summarizes Eleanor Roosevelt's Life
We shall not soon see her like again. Mrs. Franklin D. Roosevelt, niece of a President, wife of a President, a mother, a teacher, a politician, an international stateswoman, an author, a journalist, and—perhaps her greatest role—a humanitarian who cared about people with a warmth and a willingness to fight for their rights that made her whole life a mission.... She ranged far and wide as she saw and fulfilled her duty, provocative, controversial, but determined to live by her convictions.

—Obituary, November 8, 1962

About the Sculpture

Many conservatives would dislike any sculpture of Eleanor Roosevelt because she championed the idea that the government should be responsible for the social welfare of its citizens (see About the Subject). However, judging a particular *person* on philosophical grounds is not the same as judging a *portrait* of that person on philosophical grounds. The first requires looking at the person's ideas and actions across a lifetime; the second, evaluating the theme of the portrait on philosophical grounds. Jencks could have shown Eleanor Roosevelt conferring with FDR at the White House or giving handouts to Depression-era workers. Instead she shows Roosevelt deep in thought, chin on hand. The fact that *Eleanor Roosevelt* is not speaking, and that her support is a boulder rather than a podium, emphasizes the fact that she's not in public pushing an agenda.

Leave aside for the moment what you know of Eleanor Roosevelt as a person. What do you see in this statue? Simply a woman who's thinking. The fact that the artist chose to represent thinking implies that it's an important activity. (See *Shakespeare*, #37, on such metaphysical value-judgments.) In contrast, the bulky, straining muscles and disproportionately small head of *Atlas* (#29) imply a very different view of man: "Muscles matter, thoughts don't."

When evaluating a work of art in philosophical terms, you must set aside your biographical knowledge and your moral and political evaluations of the person. Instead, identify the theme and then ask: Is what the theme implies (the metaphysical value-judgment) true? Does it correspond to reality? If you lived by it, would you prosper or suffer? If you accept the definition of man as "a rational animal," then "Thinking is important" is true. By the same standard, "Muscles matter, thoughts don't" is false.

It's common for people to dismiss out of hand art whose subject isn't in accord with their philosophy. Christians condemn Harry Potter for its magical elements. Atheists disdain Michelangelo's *Pietà* for its Christian subject. In both cases, the themes actually cut across cultural, historical, and religious lines. Art is not a political or ethical textbook. In judging it philosophically, what matters isn't the literal subject, but the theme.

About the Subject

Eleanor Roosevelt (1884–1962) is described in the authoritative *American National Biography* as "perhaps the most influential American woman of the twentieth century," and was dubbed by biographer Lois Scharf the "First Lady of American Liberalism." A native New Yorker orphaned at age ten, Roosevelt wrote in her autobiography that "as with all children, the feeling that I was useful was perhaps the greatest joy I experienced." In 1905 she married her cousin, Franklin Delano Roosevelt, and over the course of his long political career worked to advance her own social and political causes, including a five-day week, prohibition of child labor, and the League of Nations. As FDR's First Lady (1933–1945), her popularity in the polls was often higher than her husband's. After his death, she served as a delegate to the United Nations and campaigned for civil rights, opportunities for women, and foreign aid. On the sidewalk around her statue is an unobtrusive quotation: "Where, after all, do universal human rights begin? In small places, close to home. Such are the places where every man, woman and child seeks equal justice, equal opportunity, equal dignity.—Eleanor Roosevelt, 1958."

41 Verdi Monument

Sculptor: Pasquale Civiletti.
Dedicated: 1906.
Medium and size: Overall 25.5 feet; marble figures (life size), granite base.
Location: Triangle between West 73rd Street, Amsterdam, and Broadway.
Subway: 1, 2, or 3 to 72nd Street.

Almost the Italian National Anthem

Va, pensiero, sull'ali dorate
Va, ti posa sui clivi, sui colli
Ove olezzano tepide e molli
L'aure dolci del suolo natal!

Go, thought, on golden wings
Go, alight on the cliffs, on the hills,
Where there are wafting the warm and gentle
Sweet breezes of our native land.

—"Chorus of the Hebrew Slaves" from *Nabucco*, lyrics by Temistocle Solera, music by Verdi, 1842

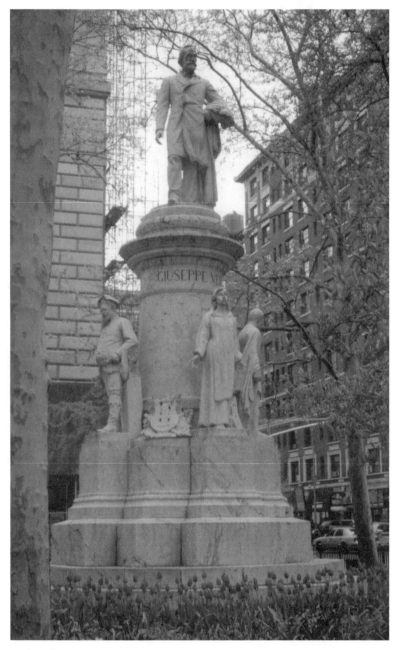

Verdi, Civiletti

About the Sculpture

Below *Verdi,* in his conventional frock coat, stand figures from four of his operas. Leonora from *La Forza del Destino,* first produced in 1862, wears a nun's habit. Aida, from the 1871 opera of the same name, seems Wonder Woman–like in a fringed sarong. Gaunt Otello, from the 1887 opera, wears a long, curved dagger tucked into his sash. Falstaff, from the 1893 opera, is cheerful and rotund.

Even when Verdi died in 1901, these four operas were not his most famous in the United States. *La Forza del Destino,* for instance, wasn't performed at the Metropolitan Opera until the 1980s. Why, then, are these four characters on the *Monument,* rather than characters from *La Traviata* or *Rigoletto?*

The obvious place to seek the answer would be *Il Progresso Italo-Americano,* whose editor Carlo Barsotti conceived and sponsored the drive for the *Verdi Monument. Il Progresso* devoted page after page in issue after issue to woodcut engravings illustrating the five figures and the complete *Monument.* Not once, however, did an article appear explaining why these particular figures were chosen.

So let's speculate. Perhaps Civiletti chose those operas to show Verdi's international sources and reputation: *La Forza del Destino* debuted in St. Petersburg, *Aida* in Cairo; *Otello* and *Falstaff* derive from Shakespeare. The characters might also have been chosen to show the breadth of Verdi's work: *Falstaff* was a successful comedy, *Aida* a profound tragedy. Then again, perhaps Civiletti chose these figures for their visual contrast: brooding Otello and cheerful Falstaff, prim Leonora and exotic Aida.

A sculpture whose message is unclear is aesthetically flawed (see *Lincoln,* #15). On the other hand, the choice of figures here might be deliberately thought provoking. For Verdi fans, the *Monument* offers an opportunity to consider which of Verdi's works are most innovative, most emotionally charged, and most appealing. If you were creating a monument to Verdi, which characters would you include?

About the Subject

On a bleak, rainy day in January 1901, Giuseppe Verdi (b. 1813) was laid to rest. Although he had asked that no music be performed at his funeral, five thousand mourners spontaneously burst into "Va, pensiero" from his 1842 opera *Nabucco*. (See Sidebar.) When the bodies of Verdi and his wife were moved to the grounds of the musicians' retirement home that Verdi had founded, Toscanini led eight hundred singers performing "Va, pensiero." Why was this piece so beloved that it became virtually the Italian national anthem?

Nabucco (or *Nabucodonosor*) is played out against the conquest of Jerusalem by Nebuchadnezzar II and the Babylonian captivity of the Israelites. In Act 3 the Chorus of Hebrew slaves sings "Va, pensiero," whose lyrics are based on Psalm 137: "By the rivers of Babylon we sat mourning and weeping when we remembered Zion." The psalm ends with a gruesome imprecation: "Fair Babylon, you destroyer, happy those who pay you back the evil you have done us! Happy those who seize your children and smash them against a rock." Solera, the librettist, wrote a kinder, gentler ending:

> Rekindle the memories in our hearts,
> Remind us of times gone by!
> Remembering the fate of Jerusalem
> Play us a sad lament,
> Or may the Lord inspire you
> So that we can endure our suffering!

According to one account, Verdi, reluctantly scanning the libretto after he had resolved to terminate his short, unsuccessful career, found the lyrics of "Va, pensiero" so moving that he decided to return to composing.

In the early 1840s, the Italian peninsula comprised a patchwork of provinces under foreign rule. A Hapsburg duke held Tuscany, the French held southern Italy and Sicily, the Austrians Lombardy and the Veneto. The Austrians were inclined to deny permission for *Nabucco's* performance at La Scala, fearing it would encourage antimonarchical sentiments.

They ultimately granted permission with the proviso that no encores be performed. The opening-night audience, however, demanded a repetition of "Va, pensiero." Ever since, it has been traditional to sing an immediate encore at every performance.

In a country 80 percent illiterate, "Va, pensiero" became a rallying cry. Like the image of Jagiello (#39), it made no explicit statement about the prevailing political situation, yet had a theme that roused strong patriotic feelings. Verdi's name even became an anagram for those seeking the re-unification of Italy under the king of the Piedmont. "Viva Verdi" stood for "Viva Victor Emanuel, Rei d'Italia." When Verdi died forty years after Italy was unified, "Va, pensiero" still held profound emotional resonance for those who had struggled to create the Italian nation.

Sculptor: James Earle Fraser. Architect: John Russell Pope.
Dedicated: 1940.
Medium and size: Bronze equestrian group (10 feet), granite pedestal
(8.6 feet), friezes on either side, life-size figures on cornice.
Location: American Museum of Natural History, Central Park West and
West 79th Street.
Subway: B or C to 81st Street–Museum of Natural History.

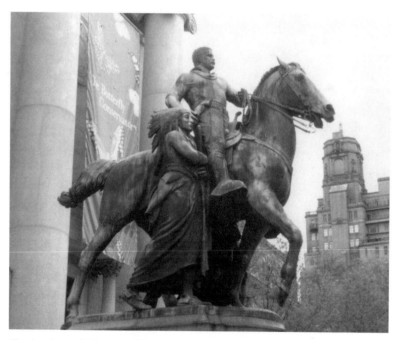

Theodore Roosevelt, Fraser. With permission of the artist's heirs.

Roosevelt on Critics versus Doers

It is not the critic who counts: not the man who points out how the strong man stumbles or where the doer of deeds could have done better. The credit belongs to the man who is actually in the arena, whose face is marred by dust and sweat and blood, who strives valiantly, who errs and comes up short again and again, because there is no effort without error or shortcoming, but who knows the great enthusiasms, the great devotions, who spends himself for a worthy cause; who, at the best, knows, in the end, the triumph of high achievement, and who, at the worst, if he fails, at least he fails while daring greatly, so that his place shall never be with those cold and timid souls who knew neither victory nor defeat.

—"Citizenship in a Republic," 1910

About the Sculpture

Roosevelt was a Rough Rider, governor of New York State, and president of the United States, but in front of the Museum of Natural History he's commemorated as an explorer and naturalist. On one side a Native American guide wearing a war bonnet carries a rifle. On the other, an African guide bears a rifle and a nail-studded shield. In low relief along the terrace behind this trio are wild animals: moose, buffalo, deer, bears, and other American fauna on the southern end; on the northern end, lions, a zebra, and several African animals with horns of alarming size. High above *Roosevelt* are four life-size sculptures (also by Fraser) representing notable American explorers and naturalists: Daniel Boone, who in 1775 blazed the principal route westward from Virginia; ornithologist John James Audubon; and Meriwether Lewis and William Clark. (See *Jefferson*, #50.)

In this book we've often focused on small telling details, but it's also important to pull back from the details to look at the wider context of a sculpture. This monument to Roosevelt included not only the equestrian

sculpture, but a whole section of the American Museum of Natural History's facade, with *Roosevelt* framed in the center of three arches. As originally conceived, it would also have included a 350-foot-wide plaza extending into Central Park, with a path leading east to the Metropolitan Museum. Although the Central Park Association vetoed that plan on grounds that it would have disrupted the park, the grandiose conception indicates how highly his hometown esteemed Teddy Roosevelt.

About the Subject

Because of his military experience and political activities, it's odd to think of Theodore Roosevelt (1858–1919) as a man passionately interested in art. Yet he wrote a fascinating critique of the famous 1913 Armory Show, which introduced European Modernism to America. During his presidency (1901–1909) he actively promoted art, asking advice of such notables as architects Charles McKim and Daniel Burnham and painter Frank Millet. He even enlisted, for a government project, the services of the foremost American sculptor of the time: Augustus Saint Gaudens. (See #10, 19, 31.)

Roosevelt asserted that American coinage, designed since Revolutionary times by employees of the United States Mint, was in a state of "artistically atrocious hideousness." In 1905 he asked Augustus Saint Gaudens to redesign several coins. Saint Gaudens (d. 1907) finished only the exquisite "Double Eagle," a twenty-dollar gold piece. On one side Liberty strides forward, much like the Victory on the *Sherman Monument* (#31). On the other, an eagle soars.

"It is simply splendid," said Roosevelt when he saw the final design. "I suppose I shall be impeached for it in Congress but I shall regard that as a very cheap payment." Impeachment for a coin design? Ah, yes: Saint Gaudens had recommended that to reduce clutter on the coin, the words "In God We Trust" be omitted. That motto had first appeared on coins during the Civil War, after a Pennsylvania minister campaigned to have God mentioned on American coinage because otherwise, if the Union ceased to exist, "Antiquaries of succeeding centuries [might] rightly reason ... that we were a heathen nation." In 1864 Congress authorized use

of the motto "In God We Trust," but (as Roosevelt discovered) didn't require its inclusion.

To an outcry from clergymen and women's groups about the new Double Eagles, Roosevelt responded with the argument that invoking God's name on a coin often led to sacrilegious mockery. He finally caved in to pressure from Congress, agreeing that "In God We Trust" would appear on Double Eagles issued after July 1, 1908. He probably would have said (per the Sidebar) that at least he'd tried.

43 Alexander Hamilton

Sculptor: Carl Conrads.
Dedicated: 1880.
Medium and size: Granite (10 feet), granite pedestal (9.5 feet).
Location: Central Park, near the East Drive, just west of the Metropolitan
 Museum of Art (at about the level of East 83rd Street).
Subway: 4, 5, or 6 to 86th Street.

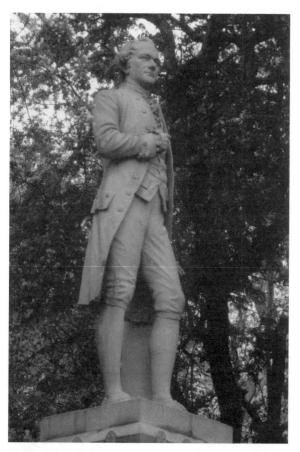

Hamilton, Conrads

Hamilton on the Proper Function of Government

The principal purposes to be answered by Union are these—The common defence of the members—the preservation of the public peace as well against internal convulsions as external attacks—the regulation of commerce with other nations and between the States—the superintendence of our intercourse, political & commercial, with foreign countries.

—*The Federalist* No. 23, December 18, 1787

About the Sculpture

Few public figures have more than one monument in Manhattan. Hamilton has four. Why? Noted orator Chauncey M. Depew explained at the dedication of the Conrads statue:

> Hamilton's reputation as a statesman is beyond the reach of detraction, his service to his country is hardly capable of overestimation, and the placing of his statue at this late day in the chief popular resort of the American Metropolis is a tardy and inadequate recognition of the debt which all generations in the United States will owe him.

Conrads's *Hamilton* was Manhattan's first outdoor sculpture of Hamilton, but not the first in the city. Half a century after the Revolutionary War, when New Yorkers finally had the leisure and wherewithal to erect monuments, the first larger-than-life-size sculpture was produced: a 15-foot *Hamilton* that stood in the Merchants' Exchange. It was destroyed later the same year in the Great Fire of 1835. Conrads's 1880 sculpture was followed by the 1892 statue now at Hamilton Grange (#53), a 1908 statue at Columbia University (compare *Jefferson*, #50), and one created around 1940 for the façade of the Museum of the City of New York (compare *Clinton*, #48).

If you have a camera with a zoom lens, take a photo of this *Hamilton's* face and compare it with the bronze face of the Grange *Hamilton*. You'll be surprised at the difference the medium and color make in rendering such details as eyelids, cheekbones, and hair. Conrads's *Hamilton* is of granite. Its flecked color makes it more difficult to distinguish details, and its hardness makes rendering nuances of texture impossible. On the other hand, granite is exceedingly durable. Many Manhattan pedestals carved of it show little deterioration as compared to, say, the soft white marble of the Genius on the *Columbus Monument* (#35).

In discussing *Eleanor Roosevelt* (#40), I said that evaluating a sculpture philosophically includes judging whether the statement implied in the theme (in her case, "Thinking is important") was true or false. The other aspect of philosophical evaluation is judging the scope of the theme. Many sculptures of animals are purely decorative arrangements of line and texture. Unless they refer somehow to human experience (a family group, a playful young creature), such sculptures have a more limited scope than representations of humans. But there are also sculptures of humans that are narrow in scope, particularly those that record the subject's physical appearance but fail to capture any of his distinctive characteristics. This sculpture of Hamilton shows a late eighteenth century gentleman about to speak in public, without implying any particular emotion or virtue. Compare it to the *Hamilton* at Hamilton Grange (#53), which shows him not just performing one of his habitual actions (giving a speech) but bursting with energy, one of Hamilton's notable traits.

About the Subject

Hamilton is a fascinating figure: a highly intelligent businessman and lawyer, an excellent orator, an efficient and accomplished writer. Theodore Roosevelt (#42) praised him as "the most brilliant American statesman who ever lived, possessing the loftiest and keenest intellect of his time." As Washington's first secretary of the Treasury (see #53), his actions and arguments had an enduring effect on American government.

Like Roosevelt, Hamilton was known as an advocate of "big government." Roosevelt thought government should paternally protect the wel-

fare of Americans. In his opinion the biggest threat to Americans was big business: large corporations were by nature mendacious and corrupt.

Hamilton advocated a strong central government for a completely different reason. Under the Articles of Confederation, the thirteen states were semi-independent and correspondingly weak. Hamilton wanted a federal government capable of defending the United States and conducting foreign affairs.

Hamilton also advocated government regulation of internal and external trade (see Sidebar). Although he favored business, he was not a laissez-faire capitalist. In 1782 he wrote:

> There are some who maintain that trade will regulate itself, and is not to be benefited by the encouragements, or restraints of government. This is one of those wild speculative paradoxes, which have grown into credit among us, contrary to the uniform practice and sense of the most enlightened nations.

Hamilton's economic ideas were based on study of the policies of such "enlightened nations"—European governments. European monarchs espoused mercantilism, which held that a country could prosper only if it kept cash within its borders by promoting production and maintaining a favorable balance of trade. An individual's right to trade for the best or cheapest products was subordinate to the wealth of the country as a whole.

Hamilton advocated mercantilism, rather than an economic policy based on the concept of individual rights stated in the Declaration of Independence and the Constitution. This idea threw the door open (to an extent that Hamilton himself could probably not have imagined) for business regulation of all sorts. Nevertheless, Hamilton deserves credit for setting the new United States government on its financial feet and promoting business to the best of his ability, because in his opinion, doing so would promote the prosperity of all Americans.

44 Joan of Arc

Sculptor: Anna Hyatt Huntington. Pedestal: John V. Van Pelt.
Dedicated: 1915.
Medium and size: Bronze (11 feet), granite pedestal (13.5 feet).
Location: Riverside Drive and West 93rd Street.
Subway: 1, 2, or 3 to 96th Street.

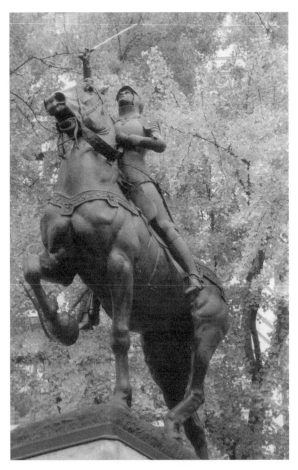

Joan of Arc, Huntington

From Schiller's *Maid of Orleans*, 1802
Deluded mortal! to destruction doomed!
Thou'rt fallen in the Maiden's hand, from which
Redemption or deliverance there is none.
But to encounter me is certain death.

From Twain's *Personal Recollections of Joan of Arc*, 1896
I love my banner best—oh, forty times more than the sword!
Sometimes I carried it myself when I charged the enemy, to avoid
killing any one.

From Shaw's *Saint Joan*, 1923
You think that life is nothing but not being stone dead.... But to
shut me from the light of the sky and the sight of the fields and
flowers; to chain my feet so that I can never again ride with the sol-
diers nor climb the hills; to make me breathe foul damp darkness,
and keep from me everything that brings me back to the love of
God when your wickedness and foolishness tempt me to hate
Him: all this is worse than the furnace in the Bible that was heated
seven times.

About the Sculpture

The fact that visual art should communicate by visual means (#27, 34)
doesn't mean we must look at a sculpture as though we'd never cracked
open a book. The themes available to artists would be severely limited if
they couldn't draw on shared knowledge of millennia of history and liter-
ature. Imagine Michelangelo's *David* empty-handed. He'd still be of
heroic size with fearless posture, but he'd no longer be a boy who was
brave enough to fight a giant. The slingshot identifies him as David and
reminds the viewer of his story and character.

In the same way, the armor identifies this figure as Joan: no other
young woman in history wore a man's armor into battle. We know that
Joan heard voices as a teenager, decided to fight with the French army,
defeated the English several times, was captured, tried as a heretic, and

burned at the stake. Within that story, an artist could choose many different themes, as Schiller, Twain, and Shaw did when telling Joan's story (see Sidebar). Which aspect did Huntington choose to illustrate? In Appendix A, §2, I've explained in detail how I determined the theme of this sculpture. The raised sword and uplifted glance, the figure's posture and plate armor, and many other details combine to show a young girl passionately dedicated to her religion and her country, and capable of inspiring battle-hardened soldiers to follow her.

About the Subject

Due to the sort of convoluted dynastic marriages that make European history so confusing for us plebeians, fifteenth-century English monarchs had a legal claim to much of present-day France. Henry V of England invaded France, winning the decisive battle of Agincourt in 1415 with "we few, we happy few, we band of brothers." By 1422 France had two kings: Charles VII (1403–1461) was crowned at Poitiers, while Henry VI of England was proclaimed king at Paris. In 1428 Henry's armies were besieging Orleans, on their way to capture the Loire Valley and the south of France.

Enter Joan, an uneducated peasant girl who for years had been hearing voices telling her she would help drive the English out of France. Joan persuaded Charles to allow her to ride to Orleans at the head of several thousand troops. She dressed in chain mail, bore an embroidered pennant of her own design, and carried a sword that she claimed had been Charlemagne's. Even those skeptical of Joan's voices agreed that her courage and leadership roused the French to repel the English from Orleans. The English were eventually pushed north of Reims, where the coronations of French monarchs were traditionally held. When Charles VII was crowned there, twenty-year-old Joan of Arc stood by his side.

45 Firemen's Memorial

Sculptor: Attilio Piccirilli. **Architect**: H. van Buren Magonigle.
Dedicated: 1913.
Medium and size: Overall approximately 24 x 35 feet, not including the
 flight of steps from Riverside Drive. Bronze relief (8 x 19 feet); two
 groups in marble (approximately 8 feet).
Location: Riverside Drive and West 100th Street.
Subway: 1 to 103rd Street.

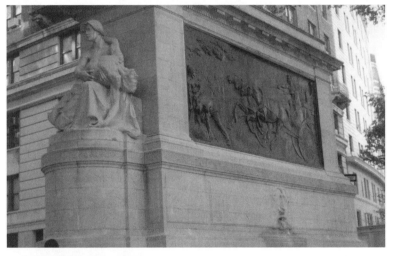

Firemen's Memorial, Piccirilli

Firemen's Memorial, Piccirilli. Detail.

"Into the Fire"
You can tremble, you can fear it
But keep your fighting spirit
Alive, boys!
Let the shiver of it sting you!
Fling into battle! Spring to
Your feet, boys!
Never hold back your step for a moment!
Never doubt that your courage will grow!
Hold your head even higher
And into the fire we go!

—Nan Knighton and Frank Wildhorn, *The Scarlet Pimpernel*, 1998

About the Sculpture

Mounting the grand sweep of steps from Riverside Drive, we first see a huge, gleaming bronze relief in which three wild-eyed horses hurtle along, hauling a fire engine. On the left, two men struggle to shift debris. Behind them in low relief lurk the ubiquitous New York rubberneckers.

The urgent summons, the adrenalin rush, the fight to save lives and property: those are the rewarding and exciting parts of the firefighter's job, and it's fitting that they are the dominant feature of the *Firemen's Memorial*. But firefighting is also perilous, as shown in the marble groups on either side of the relief. On the left, a woman holds the limp body of her husband, killed in the line of duty and still wearing pants and thigh-high boots. The pose of these two figures evokes a *pietà*, a representation of the grieving Madonna supporting Christ's body. (Michelangelo's version is the most famous.) The resemblance to the *pietà* introduces two ideas: that the firefighter who dies in the line of duty makes the ultimate sacrifice for others, and that those who survive feel both devastating grief and pride for the firefighter's courage. (On "quoting" other sculpture, see *Cooper* and *Washington*, #10, 13.)

In the group on the right, a young child looks up questioningly at the woman whose arm encircles him. Since she holds a firefighter's helmet and coat and sits next to a fire hydrant, this must be the fireman's widow, about to explain to the child why his father won't be coming home. I find this pair more wrenching than the woman holding her husband's dead body, because the child leans against the woman so trustingly, and she will soon have to emerge from the numbness of shock to explain what happened.

Why is the message of the *Firemen's Memorial* so easy to grasp after almost a hundred years? When this statue was dedicated in 1912, motorized fire engines were already coming into use, but it's impossible to show an emotionally charged machine. Using a horse-drawn engine allowed the artist to convey the drama and the urgency of the situation via the wild-eyed horses.

The *Memorial* also appears timeless because the women wear classical drapery rather than period costume. Women's fashions of a century ago, with their pin-tucks, ruffles, and lace, were so visually complex that they would inevitably drawn attention to themselves, and soon would have been distractingly anachronistic. The simple drapery used here modestly covers the women's bodies without adding extraneous details.

Imagine for a moment that instead of the relief and two groups of statuary, the *Firemen's Memorial* consisted of a tablet inscribed with the names of firemen who died in the line of duty. It would specifically honor each individual who died, but it would not be as effective at evoking the values and emotions that drove them, and the feelings of those they left behind. It takes living figures—usually human—to evoke human values and emotions. The *Maine Monument* (also by Piccirilli and Magonigle, #34) bereft of all but its list of names of dead sailors would be much less moving. So would the *East Coast Memorial* in Battery Park, if it consisted of eight huge slabs listing the dead but no ferocious, swooping eagle.

Now think of Maya Lin's *Vietnam War Memorial* and all its descendants, from Oklahoma City to those proposed for 9/11. Ask yourself: Are we saying all we could to remember and honor the dead, if we restrict ourselves to lists of the dead and landscape architecture?

About the Subject

In September 1776, mere weeks after George Washington abandoned New York to the British, a fire of suspicious origin reduced 493 of the city's buildings to ashes. In the ensuing sweep for suspects, anyone arrested with matches (a relatively new invention) was executed, and Nathan Hale, captured with incriminating documents in his shoe, was hanged as a spy (#8).

That wasn't the last major fire in Manhattan, or even the most destructive. In December 1835 the "Great Fire" destroyed twenty square blocks of lower Manhattan. One of the 674 buildings destroyed was the "fireproof" Merchants' Exchange, with its 15-foot-tall marble statue of Alexander Hamilton (#43). In the subzero temperatures, water froze in the firefighters' hoses. That blaze was extinguished only by the use of explosives hastily rowed in from Governor's Island.

The late nineteenth and early twentieth centuries saw dramatic improvements in prevention, equipment, and techniques. Sprinkler systems and rooftop water tanks were installed. Motorized fire engines were introduced in 1907. Still, firefighting remained one of the city's most dangerous professions.

On Valentine's Day 1908, firefighters rushed yet again to Canal Street, a neighborhood notoriously fire prone due to crowded tenements and furniture-manufacturing companies that stored large quantities of flammable liquid. That night Deputy Fire Chief Charles W. Kruger, a thirty-six-year veteran, drowned in an 8-foot-deep flooded sub-basement. As the city mourned, Bishop Potter suggested that a memorial be erected to firefighters who had died in the line of duty. The inscription on the east side dedicates the *Memorial* to firefighters "who died at the call of duty, soldiers in a war that never ends."

46 Straus Memorial

Sculptor: Augustus Lukeman. Architect: Evarts Tracy.
Dedicated: 1915.
Medium and size: Bronze (3 x 7 feet); granite fountain and exedra (approximately 15 feet wide).
Location: West 106th Street between Broadway and West End Avenue.
Subway: 1 to 103rd Street.

Straus, Lukeman

Shakespeare on True Love
It is an ever-fixed mark
That looks on tempests, and is never shaken;
It is the star to every wandering bark [=ship],
Whose worth's unknown, although his height be taken.
Love's not Time's fool, though rosy lips and cheeks
Within his bending sickle's compass come;
Love alters not with his brief hours and weeks,
But bears it out even to the edge of doom.
If this be error and upon me proved,
I never writ, nor no man ever loved.

—Sonnet CXVI

About the Sculpture

Who is this woman? Her features are so classically well proportioned that she doesn't seem to be a portrait; besides, portraits usually wear period costume to help the viewer identify them. Is she a mythological figure? Probably not, since she has no helmet, aegis, bow and arrow, or other identifying feature. By elimination, then, she must be an allegorical or symbolic figure—but of what? Let's gather clues from the details.

Based on her body language, she is meditative, rather than (for example) distraught with grief or struggling to solve an algebra problem. She's reclining, relaxed, one foot dangling. Her eyelids are lowered, her head rests on one hand and the other hand is at her chin. She looks down into a reflecting pool, rather than at a busy street or the pages of a book. She seems, then, to be thinking of someone or something she remembers, not about what she can see right now.

Simple as it is, that's the identity of this figure: she is Memory. The gilt inscription on the curved bench (exedra) behind the figure confirms this: "In memory of Isidor and Ida Straus, who were lost at sea in the Titanic disaster April 15, 1912. Lovely and pleasant were they in their lives and in

their death they were not divided. II Samuel 1:23." The inscription tells us whom the monument honors, but the sculpture's dominant idea—that calm remembrance is a good and important activity—would be clear without the inscription.

One of the great pleasures of searching for the theme in a work such as this one is that it allows you to spend more time with the sculpture. To spend even more time with Memory, take a few minutes to study details such as the way the drapery flows along her figure. The folds of the thin fabric outline her hips and legs, emphasizing the body beneath the fabric. Many of the sculptures in this book have been portraits of nineteenth-century gentlemen in business attire. For such models of decorum, it would be inappropriate to reveal too much of the figure beneath the clothing. This sculpture is a reminder of how beautiful an inanimate figure can be.

About the Subject

Just before midnight on April 14, 1912, under clear skies and on a sea smooth as glass, the largest ship afloat was racing to set a speed record on her maiden voyage. Four hours later, after striking an iceberg, the luxury liner *Titanic* was at the bottom of the Atlantic Ocean and 1,522 of her passengers and crew were dead.

Among those who perished were Isidor and Ida Straus, two of New York's wealthiest and most beloved philanthropists. With a conviction that recalls Shakespeare (see Sidebar), Ida refused to board a lifeboat without her husband of forty-one years. Isidor refused to board until the last of the women and children had been taken off. Survivors reported seeing the pair on deck, arms around each others' waists, in the hours before the *Titanic* went down. Isidor's body was recovered and buried at Woodlawn Cemetery in the Bronx. Ida's remained lost at sea.

Isidor Straus was a classic example of a poor immigrant succeeding spectacularly, through intelligence and sheer hard work. In 1902 he and brother Nathan moved the department store they had recently purchased from Union Square up to Sixth Avenue and Thirty-Fourth Street, next door to the new home of Bennett's *Herald* (#21). At first they had to offer

customers free transportation to persuade them to venture into such an unfashionable neighborhood. A few years later, when Pennsylvania Station opened at Seventh Avenue and West 33rd Street (#20), thousands of commuters and visitors suddenly found shopping there marvelously convenient. Isidor's most spectacular and enduring monument is seventy-two blocks south of the *Straus Memorial:* Macy's Herald Square, "the largest department store in the world."

Dr. James Marion Sims

Sculptor: Ferdinand von Miller II. Pedestal: Aymar Embury II.
Dedicated: 1892.
Medium and size: Overall 12.5 feet. Bronze (8.75 feet), granite pedestal (approximately 9 feet).
Location: Central Park at Fifth Avenue and East 103rd Street, across from the Academy of Medicine.
Subway: 6 to 103rd Street.

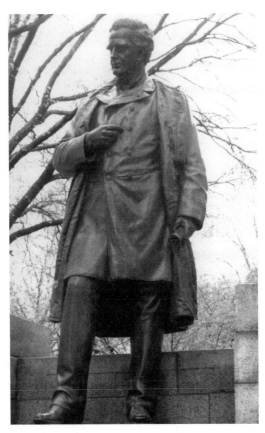

Sims, Miller

Man's Proper Heroes

Toward the higher civilization, the progress of man is slow. As yet the shadows of barbarism linger about him. His heroes are the destroyers, the Caesars, the Napoleons, who covered the earth with ruin and buried beneath it countless lives, sacrificed upon the altar of personal ambition. But the time must come when those whose genius and works give life and health and happiness to the world will be first in the heart of man. In this purer temple of fame, along with those of Jenner, Ephraim McDowell, Morton, Lister, Pasteur and others, generations yet unborn shall read the name of Marion Sims.

—John Allan Wyeth, surgeon and Sims's son-in-law, ante 1922

About the Sculpture

With his bowed head, shadowed eyes, and solemn mouth, Dr. Sims seems to be pondering a diagnosis or deciding how to deliver unpleasant news. Perhaps he has just finished one of the surgeries that made him famous. The overcoat and double-breasted coat beneath it would not have been out of place in an operating room in the 1870s, when sterilization and disinfection were still radically new ideas.

Sims's pedestal and site are rare examples of a replacement being better than the original. When *Sims* was dedicated in Bryant Park in 1892, he stood on a tall pedestal similar to the one that now supports *Vanderbilt* (#25). In 1928, to make room for a reconstruction of Federal Hall erected as part of the bicentennial celebration of George Washington's birth, *Sims* was tucked away beneath the Williamsburg Bridge. Following a campaign by influential New York physicians, *Sims* was rededicated in 1934, with a new pedestal whose inscription describing Sims's accomplishments is more informative and easier to read than the original one. Although the new site at Central Park and East 103rd Street is less frequented than Bryant Park, the statue's position opposite the New York Academy of Medicine is fitting for a monument to a notable physician.

About the Subject

In a painting created around the time of the American Revolution, a well-dressed physician comfortably seated in an armchair checks the pulse of a limp white arm. The bed's velvet curtains modestly conceal the rest of the woman. When J. Marion Sims began practicing medicine half a century later, intransigent prudery still precluded male physicians (and all physicians were male) from examining unclothed female patients. Asking a physician to deal with the female reproductive tract was like asking a blindfolded toddler to repair a computer. Women routinely suffered and died from mysterious ailments vaguely referred to as "female complaints."

Sims (1813–1883) began to change that. At a small hospital for women in his home in Montgomery, Alabama, he methodically strove to correct the lack of bladder control that often occurred after prolonged and obstructed childbirth. In an era before adult disposable diapers or even indoor toilets, such incontinence could cause a woman to be a social outcast or an invalid.

Sims's first contribution to women's health was the invention of an instrument that allowed him to see what he was doing: a silver spoon with its handle bent at a right angle that allowed him to look into the vagina. He later developed this into that indispensable tool of gynecologists, the vaginal speculum. To see better during examinations and operations, he asked the patient to lie on her left side curled into a ball, which is still known as the "Sims position."

With these aids, Sims determined the cause of the incontinence: a tear in the wall between the vagina and the bladder, now known as a vesico-vaginal fistula. Then he set out to repair the fistula by stitching the edges together. After numerous failures, Sims discovered that the silk sutures used by contemporary surgeons encouraged infection, so he developed the use of silver wire for sutures—a major innovation in surgical procedure. Sims has been virulently criticized for performing early operations on slaves whose consent is not recorded anywhere except in Sims's autobiography. On the other hand, recent studies in Africa of vesico-vaginal fistulas indicate that the condition is much more common when a

woman is malnourished or bears children very young, both of which were appallingly common among slaves in the antebellum South. Sims's efforts improved the lives of some of these unfortunate women in an immediate, concrete way.

Sims moved from Alabama to New York City, there establishing in 1855 the city's first hospital for women. A women's philanthropic association backed him: the medical establishment had pooh-poohed the need for such a hospital. Self-exiled to Europe during the Civil War because his sympathies lay with his native South, Sims became famous as physician to such prominent women as the wife of Napoleon III. His brilliant (although unsystematic) *Clinical Notes on Uterine Surgery* (1866) helped gynecology gain recognition as a separate field of medicine and led to surgeons actively intervening in problems of the female reproductive tract, rather than letting nature take its course.

Although most of us are more familiar with the careers of Napoleon and Julius Caesar than with those of Jenner, Pasteur, and the other scientists and physicians mentioned by Sims's son-in-law (see Sidebar), it's proper that we also pay tribute to men like Dr. Sims, whose efforts made the lives of countless women longer and healthier.

48 De Witt Clinton

Sculptor: Adolph A. Weinman.

Dedicated: 1941.

Medium and size: Nickel silver (8 feet).

Location: Museum of the City of New York, Fifth Avenue at East 103rd Street.

Subway: 6 to 103rd Street.

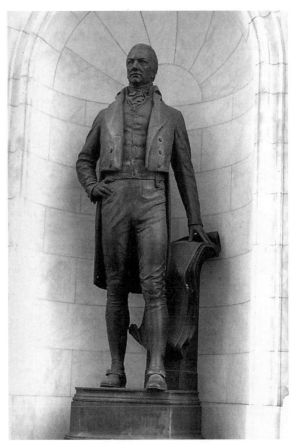

Clinton, Weinman. With permission of the Weinman family.

"Song of the Canal"
We are digging the Ditch through the mire;
Through the mud and the slime and the mire, by heck!
And the mud is our principal hire [= pay];
Up our pants, in our shirts, down our neck, by heck!
We are digging the Ditch through the gravel,
So the people and freight can travel.

—Folk song, ca. 1817–1825

About the Sculpture

In 1885, Abram Hewitt noted at the dedication of William Earl Dodge's portrait statue (#24) that New York still had no statue of De Witt Clinton. In fact, a neoclassical one already stood in Green-Wood Cemetery in Brooklyn. In 1908 Manhattan got one, the third figure from the left on the fifth-floor cornice of the Surrogate's Court at Chambers Street. In 1941 this third *Clinton* was dedicated.

It's the liveliest of the three. Why? It shows Clinton standing with one arm akimbo, which suggests more energy than a hand hanging limply at the side. He holds an unrolled map of the Erie Canal, but his eyes look into the distance as if he's seeing the work in progress. One foot is forward, as if he's about to stride off to the canal site. The niche at the other end of the museum's facade is occupied by a statue of Alexander Hamilton, who promoted New York's financial and commercial rebirth after the devastating British occupation, and as Washington's secretary of the Treasury organized the finances of the United States (#43, 53). Together *Hamilton* and *Clinton* emphasize the importance of business and trade in New York City's history.

About the Subject

"Talk of making a canal three hundred and fifty miles through a wilderness is little short of madness," said Thomas Jefferson, who had doubled the size of the United States by the 1803 Louisiana Purchase (#50). Unfortunately, the Appalachian Mountains isolated Jefferson's purchase from the original thirteen colonies. Shipping goods down the Mississippi River, around Florida and up the Atlantic coast not only took weeks, but often cost more than the goods themselves.

The best alternative route lay through upstate New York, where a series of river valleys and a pass through the Appalachians at water level gave access to the Great Lakes, and hence the whole Midwest. The water-level route connected Buffalo (on Lake Erie) to Albany, and from Albany the Hudson River flowed south to New York City. A canal along this route had been suggested in the eighteenth century, but the idea languished for lack of funds. In the early years of the nineteenth century it found a fervent advocate in De Witt Clinton (1769–1828), who was either mayor of New York City or governor of New York State for most of the quarter century from 1803 to 1828. For support of the canal project, Clinton appealed to city merchants, who could expect to benefit from increased trade and lower shipping costs. Eventually 100,000 New Yorkers signed a petition demanding the state legislature take action. In 1817 Clinton dug the first shovelful of dirt. Irish immigrants by the hundreds carried on the work, "Through the mud and the slime and the mire, by heck!" (see Sidebar). It was the early nineteenth century's greatest engineering achievement.

Forty feet wide at the surface and a mere four feet deep, set with eighty-three locks, the canal stretched 323 miles—twice as long as any European canal. A contemporary proclaimed that its builders "have built the longest canal, in the least time, with the least experience, for the least money, and to the greatest public benefit." In 1825, eight years after work began, Governor Clinton and a party of celebrities floated along "Clinton's Ditch" from Buffalo to New York City in the astoundingly short time of ten days. With the canal in operation, the cost of shipping a barrel of flour from Ohio to New York dropped from $12 to $1. In a decade,

the canal's revenue repaid its eight-million-dollar cost. Over its first half century it carried Midwestern produce to the Atlantic coast and untold numbers of immigrants to the Midwest. Most of all, it made New York City the commercial hub of the nation, far outstripping Philadelphia and Boston.

Until just after the Civil War, the canal remained a vital part of the American economy: it's no accident that from 1869 to 1880, Clinton's face appeared on the thousand-dollar bill. The canal was finally superseded by the expansion of the railroads, which carried passengers more comfortably and freight more quickly, and did it even when temperatures dropped below freezing. Ironically—and not coincidentally—the first segment of what became Vanderbilt's New York Central Railroad (#25) was laid in 1825, right next to the Erie Canal.

49 Alma Mater

Sculptor: Daniel Chester French. Pedestal: McKim, Mead and White.
Dedicated: 1903.
Medium and size: Bronze (8.5 feet), granite pedestal (approximately 5.5 feet at front).
Location: Columbia University, on the steps of the Low Memorial Library. Enter the campus on Broadway near West 116th Street, walk half a block east and then look north.
Subway: 1 to 116th Street–Columbia University.

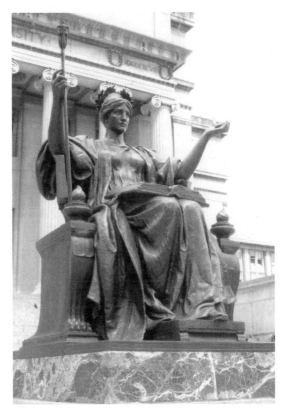

Alma Mater, French

Learning and Experience

[Studies] perfect nature, and are perfected by experience: for natural abilities are like natural plants, that need proyning [pruning], by study; and studies themselves do give forth directions too much at large, except they be bounded by experience. Crafty men contemn studies, simple men admire them, and wise men use them; for they teach not their own use; but that [i.e., proper use] is a wisdom without [i.e., outside] them, and above them, won by observation. Read not to contradict and confute; nor to believe and take for granted; nor to find talk and discourse; but to weigh and consider.

—Francis Bacon, "Of Studies,"
in *Essays of Counsels Civil and Moral*, 1597–1625

About the Sculpture

Alma Mater is Education personified: the serene focal point of the central quadrangle of New York City's oldest institution of higher learning. Over her classical drapery she wears an academic gown—see the tiny pleats on the shoulders? She sits regally, her scepter topped by the crown that has appeared on Columbia's seal ever since King George II chartered it in 1754. With her other arm also raised, she seems cordially to greet those entering the university's gates.

On the arms of *Alma Mater*'s chair are torches, once again symbols of enlightenment (as in the *Statue of Liberty* and *Verrazzano*, #1, 3). The torches are labeled *Doctrina* and *Sapientia,* Learning and Wisdom. As Francis Bacon recognized (see Sidebar), it's essential not only to know the facts, but to have the proper means of interpreting them.

The laurel wreath on *Alma Mater*'s head symbolizes fame or victory. (Compare *Sherman*, #31.) The huge book on her lap represents knowledge transmitted from generation to generation. Tucked into the folds of the gown near her left leg (it took me three visits to find it) is Athena's owl, another symbol of wisdom.

Alma Mater is a brilliant adaptation of the central figure on Columbia's seal, which is sculpted in low relief on the back of *Alma Mater*'s chair. A decade after the statue's unveiling, French explained that he had aimed to create "a figure that should be gracious in the impression that it should make, with an attitude of welcome to the youths who should choose Columbia as their College."

About the Subject

It's shocking that anyone would throw a bomb at a figure of such serene grace and beauty as *Alma Mater*, yet it did happen in 1970. In the context of that turbulent time, the event had a grim symbolic significance.

In 1968 the Tet Offensive in Vietnam proved an overwhelming victory by any standards except those of the American media. Dr. Martin Luther King Jr. was assassinated in April, Robert Kennedy in June. That summer massive riots erupted at the Democratic National Convention, resulting in the trial of the Chicago Seven in 1969.

At Columbia, students occupied five buildings and held an administrator hostage to protest the university's defense contracts and the construction of a gymnasium with separate entrances for university and community users. Separate entrances, they stubbornly asserted, would lead to segregation. After several days the students were evicted by New York City police.

In November 1969 the media broke the story of the My Lai massacre. In December came the first military draft lottery in the United States since the end of World War II. Late 1969 and early 1970 brought a rash of bombings in New York: at a high school, a movie theater, a federal office building, banks, department stores, Midtown office buildings. The Weather Underground accidentally blew up the Greenwich Village townhouse where they were manufacturing bombs. Twenty-one Black Panthers came to trial in April 1970 for plotting to assassinate police officers and blow up buildings.

At Columbia, students demanded that the university calculate reparations due to the Hispanics and African Americans in neighboring Morningside Heights, and use the money to bail out the Panthers. The *New*

York Times carried a picture of Abbie Hoffman (one of the Chicago Seven) haranguing students from *Alma Mater*'s pedestal. He joked that recent bombings were examples of "better living through chemistry," and gave weather forecasts for American cities: "Seattle, boom! Chicago, boom! New York, boom, boom, boom!"

In late April 1970, President Nixon announced that the United States was invading Cambodia in order to destroy Viet Cong bases. Student riots erupted across the country, with the National Guard called to many campuses. Students and the police or the Guard usually battled using rocks and tear gas, but at Kent State on May 4, Guardsmen shot four students dead. The ensuing riots closed down at least 450 campuses for weeks. A hundred thousand antiwar activists marched in Washington.

Eleven days after Kent State, someone threw a bomb at *Alma Mater*. No one claimed responsibility. But why would anyone waste an incendiary device on a sixty-seven-year-old sculpture, when all those Midtown bastions of commerce were so close at hand? Or, if a work of art had to be the target, why not the nearby sculptures *Jefferson* (#50), *Hamilton*, Rodin's *Thinker*, or the *Great God Pan*?

In the context of the times, the bombing of *Alma Mater* would seem to have been a flat-out rejection of what the statue and Columbia stood for: Learning and Wisdom, and the fabric of advanced civilization that was built on them. One can muster sympathy for the Cid (#54), in whose medieval world life was nasty, brutish, and short. He had little choice but to use physical force as well as his wits to survive. But what excuse can be made for intelligent American students in the late twentieth century who chose detonation over deliberation?

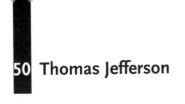

50 Thomas Jefferson

Sculptor: William Ordway Partridge.
Dedicated: 1914.
Medium and size: Bronze (8.75 feet), granite pedestal (5.5 feet).
Location: Columbia University, in front of the Graduate School of Journalism. Enter on Broadway at West 116th Street, turn right at the end of the first building, then right again.
Subway: 1 to 116th Street–Columbia University.

Jefferson, Partridge

Jefferson on the Dangers of New Orleans

There is on the globe one single spot the possessor of which is our natural and habitual enemy. It is New Orleans, through which the produce of three-eighths of our territory must pass to market, and from its fertility it will ere long yield more than half of our whole produce and contain more than half of our inhabitants.... The impetuosity of [France's] temper, the energy and restlessness of her character placed in a point of eternal friction with us and our character, which, though quiet, and loving peace and the pursuit of wealth, is high-minded, despising wealth in competition with insult or injury, enterprising and energetic as any nation on earth; these circumstances render it impossible that France and the United States can continue long friends when they meet in so irritable a position.

—Letter to Robert Livingston, April 18, 1802

About the Sculpture

Partridge's *Jefferson* stands relaxed, holding a sheaf of papers and a cape in his left hand, lightly grasping his vest with the other. He bows his head slightly. As a specimen of a person deep in thought, he's quite a contrast to the Rodin's contorted *Thinker,* a copy of which sits near St. Paul's Chapel across the Columbia campus.

Yet Rodin's style undeniably influenced Partridge's. Starting in the 1870s, Rodin introduced two innovations with far-reaching effects on contemporary and later sculptors. First, he broke the surface into shimmering, flickering strokes, rather than polished surfaces. (Contrast Brown's *Lincoln,* #15.) Second, Rodin introduced the use of fragments of the human form as complete sculptures, claiming it was more important for a viewer to see the artist's process of creation than to see a completed sculpture. This is the equivalent of saying it's more important to see a first draft of a novel than the finished product. It's the beginning of the

trend to emphasize style over subject (method over content), which eventually helps creators of abstract pieces justify their works.

Rodin, with a lifelong government-funded position, could afford to create radical art long before he had buyers for it. American portrait sculptors working to earn a living couldn't adopt Rodin's fragmentary style, but many adopted his change in surface texture. MacMonnies's 1893 *Nathan Hale* (#8) and Partridge's *Jefferson* show Rodin's influence in the texture of the costume, although the faces are highly polished. Whitney, heavily influenced by Rodin, reduced the entire surface of *Stuyvesant* (#16) to one boring texture. As decades passed, textures became ever more broken and irregular: see the *Immigrants*, 1973 (Battery Park) and the *Garment Worker*, 1984 (Broadway at West 39th Street). *Jefferson* stands not far west of Partridge's statue of Alexander Hamilton (compare #43, 53), Jefferson's arch enemy.

About the Subject

Jefferson's most important action as president (1801–1809) was the 1803 Louisiana Purchase, which contradicted several of the principles he had advocated so vehemently in debates with Alexander Hamilton. Although Jefferson favored a strict construction of the Constitution, he admitted that he had no constitutional authority to make the purchase. Although he abhorred a strong and active central government, he contracted a $15 million debt for Louisiana that only such a government could finance and repay. And he bought the territory because he distrusted the French (see Sidebar), whom he had fervently supported during the bloody French Revolution. What consideration was significant enough to make Jefferson disregard so many of his convictions?

Commerce. To transport goods to market, American farmers west of the Appalachians relied on shipment down the Mississippi and through New Orleans. La Salle had claimed the Mississippi River, its tributaries, and all the lands drained by them for Louis XIV (*L'état, c'est moi!*) in 1682. The whole unexplored, ill-defined territory—from the Gulf of Mexico to Canada, from the Rockies to the Mississippi—was signed over to the

Spanish in 1763, at the end of the French and Indian War. In 1800 it was secretly transferred back to Napoleon's France.

After a New Orleans official abruptly closed the port to American goods in 1802, Jefferson attempted to purchase New Orleans. Napoleon responded by offering to sell the whole 828,000-square-mile Louisiana Territory to the United States. The treaty was signed in Paris in April 1803.

Jefferson admitted he had exceeded his executive authority in negotiating the treaty: "The general government has no powers but such as the constitution has given it; and it has not given it a power of holding foreign territory, and still less of incorporating it into the Union." Rather than risk having Napoleon change his mind, however, Jefferson presented the sale to Congress for approval in October 1803 as a golden opportunity that would give "important aids to our treasury, an ample provision for our posterity, and a wide-spread field for the blessings of freedom and equal laws." Congress approved the treaty three days later.

Jefferson promptly offered the governorship of the new territory to his dear friend from Revolutionary War days, the Marquis de Lafayette (#14). Lafayette, living circumspectly under Napoleon's imperial rule, regretfully declined: "Here [the cause of humanity] is deemed irrevocably lost, but for me to pronounce this sentence and to do so through expatriation goes against my hopeful character. I cannot see how, unless some force place me in physical constraints, I could abandon even the smallest hope."

Even before negotiations to purchase Louisiana began, Jefferson had proposed an expedition to explore the Missouri River and seek a water route across the Rockies to the Pacific. Congress approved funds in February 1803, and Jefferson signed instructions for the expedition four months later. Lewis and Clark, who now survey the disciplined wilderness of Central Park from their vantage point high above *Theodore Roosevelt* (#42), set forth on their journey of exploration in spring 1804.

Although it contradicted Jefferson's principles, the Louisiana Purchase doubled the area of the United States: thirteen states were formed from it. Its acquisition was a major impetus for the building of the Erie Canal, completed in 1825 (#48).

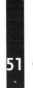

51 Carl Schurz Monument

Sculptor: Karl Bitter. Exedra: Henry Bacon.
Dedicated: 1913.
Medium and size: Overall about 50 feet wide. Bronze figure (9 feet), granite reliefs below figure (4 by 3 feet) and at ends of exedra (each 4 by 9 feet).
Location: Upper Morningside Drive at West 116th Street.
Subway: 1 to 116th Street–Columbia University.

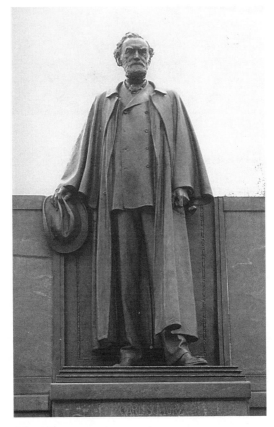

Schurz, Bitter

"My Country, Right or Wrong ..."

I confidently trust that the American people will prove themselves too clear-headed not to appreciate the vital difference between the expansion of the republic and its free institutions over contiguous territory and kindred populations, which we all gladly welcome if accomplished peaceably and honorably—and imperialism which reaches out for distant lands to be ruled as subject provinces ... too wise not to detect the false pride or the dangerous ambitions, or the selfish schemes which so often hide themselves under that deceptive cry of mock patriotism: "Our country, right or wrong!" They will not fail to recognize that our dignity, our free institutions, and the peace and welfare of this and coming generations of Americans will be secure only as we cling to the watchword of true patriotism: "Our country—when right to be kept right; when wrong to be put right."

—Schurz, "The Policy of Imperialism," October 17, 1899

About the Sculpture

The *Schurz Monument* is another ensemble whose sum is greater than its parts. At the center stands *Schurz* himself, larger than life size and magnificently displayed against a panoramic view. His enveloping greatcoat is very different from *Lincoln's* cape (#15): by 1913, there was no attempt to transform its voluminous folds to a neoclassical, toga-like effect. In fact, *Schurz's* coat and jacket fall in such elegant, simple folds that our attention naturally rises to *Schurz's* face, which has far more interesting contrasts of light and dark. Based on the posture, expression, and costume, Schurz's most notable qualities were dignity, maturity, and severity.

Schurz is bracketed by reliefs at either end of long, curving benches. At the far left, Athena, the warrior goddess, breaks a set of shackles as she turns to look back at an African American couple. Behind them sits a woman in vaguely Egyptian dress, and behind her a much younger female figure in Greek drapery eagerly draws a Native American forward.

On the relief at the far right, a winged woman with a torch (Liberty?) leads a man by the hand. Behind him, another man turns to speak to a woman guiding a child. The flat, stylized zigzags of the drapery show the influence of Archaic Greek sculpture, which had only recently become known through archeological excavations.

The significance of the two large reliefs is explained by the smaller relief directly beneath *Schurz*. It shows a man holding a sword and a woman holding out her hand (in friendship?), flanking an inscription that describes Schurz as "a friend of liberty and a defender of human rights." He was widely respected for his actions on behalf of emancipated slaves during Reconstruction and on behalf of Native Americans during his tenure as secretary of the Interior (1877–1881). The combination of allegory, mythology, and symbolism in the *Memorial*'s reliefs reminds the viewer of Schurz's achievements in a way that a portrait sculpture alone could not.

About the Subject

As the United States stood poised to enter the twentieth century, fresh from victory in a "splendid little war" (see the *Maine Monument*, #34), a debate raged over whether it should be acquiring new territory. In 1803 Jefferson had doubled size of the United States with the Louisiana Purchase (#50). In 1845, a year before the Mexican-American War began, journalist John O'Sullivan wrote of America's "manifest destiny to overspread and to possess the whole of the continent which Providence has given us for the development of the great experiment of liberty and federated self-government." The East and West Coasts were linked in 1869 by a transcontinental railroad. By 1890 Frederick Jackson Turner announced the "closing of the American frontier." In 1900, all the territory from New York to California had been granted statehood except Oklahoma, New Mexico, and Arizona.

What next? Not Cuba. Congress amended its 1898 declaration of war against Spain to note that the people of Cuba "are, and of right ought to be, free and independent." Cuban independence was recognized as soon as the war was over. Like Cubans, Filipinos had been

struggling for independence from Spain for years. In 1898 they fought side by side with Americans, and expected that their independence would also be recognized. Instead, the United States agreed to pay Spain $20 million for possession of the Philippines, Guam, and Puerto Rico. When McKinley imposed American military rule there in late 1898, the Filipinos rebelled.

Andrew Carnegie, Mark Twain, Samuel Gompers, and other prominent Americans formed the American Anti-Imperialist League in June 1898. One of its most rousing speakers was Carl Schurz. His speeches infuriated fellow New Yorker and former friend Theodore Roosevelt (#42): "If we ever come to nothing as a nation, it will be because the teaching of Carl Schurz, President Eliot, the *Evening Post,* and the futile sentimentalists of the international arbitration type bears its legitimate fruit in producing a flabby, timid type of character, which eats away the great fighting features of our race."

In 1899 Schurz wrote "The Policy of Imperialism," a brilliant 13,000-word exposition that opened with a definition of "imperialism" as "the policy of annexing to this republic distant countries and alien populations that will not fit into our democratic system of government"—territories that would be ruled indefinitely as subject provinces rather than admitted as equals into the United States. Schurz set the historical context, refuted arguments for American military control of the Philippines, and offered specific recommendations about what the United States ought to do. He delved into such issues as executive versus congressional authorization for war, the deleterious effect of precedent, and the commercial and military consequences of a free Philippines. The most thought-provoking and memorable line, and the one still relevant today, came at the very end of the speech (see Sidebar): "Our country—when right to be kept right; when wrong to be put right."

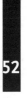

52 Daniel Butterfield

Sculptor: Gutzon Borglum (John Gutzon de la Mothe Borglum). Pedestal: Ludlow & Peabody.

Erected: 1917 (never dedicated).

Medium and size: Bronze (10.9 feet), granite pedestal (7.5 feet).

Location: Sakura Park, northwest corner of Claremont Avenue and West 122nd Street.

Subway: 1 to 125th Street.

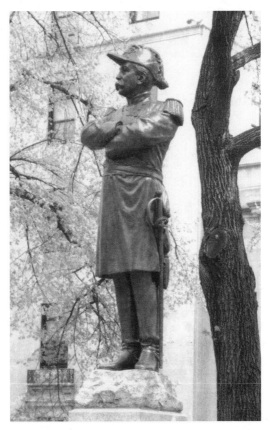

Butterfield, Borglum

Borglum's Advice to Artists
This story is told to lend an encouraging, believing hand to all lonely, creative souls who are wandering into the uncharted, untraveled wilderness of God's greater universe, finding through their own understanding new and undreamed worlds; and to those who continue alone to pour into unpeopled space their cry—unafraid, expecting no answer. Courage to stand alone; courage to master, to know, to do alone. Courage to spurn the tradesman's reward and popularity. Courage to be without great approval, in spite of government, in spite of today's laws, tomorrow's threat—every threat—in spite of Heaven.

—Quoted in Robert J. Casey and Mary Borglum,
Give the Man Room, 1952

About the Sculpture

The sculptor of Mount Rushmore once worked on a much smaller scale in New York. General Daniel Butterfield's widow having bequeathed funds for a statue of her husband, her executors hired Gutzon Borglum, who even in the 1910s was, according to his biographer Casey, "a bit unused to doing things the way other people did them."

> There was only one of him, and there were so many of the rest of the population that maybe one shouldn't be disturbed by this technique. He had a genius's variety of talent; so it probably isn't remarkable that his art studio should have been filled with frightening projects for roads, transportation, parks, breakwaters, engineering, airplane models, philosophy, abstract science, and the saving of the world. He believed he could do anything—so he did it.

He conceived the 120-foot-high, quarter-mile-long granite monument to Confederate heroes at Stone Mountain in 1916, but when his relief of

Lee was criticized, Gutzon Borglum destroyed the models. In the 1920s he began Mount Rushmore, which was completed in the 1940s, soon after his death.

Gutzon Borglum produced a model for *Butterfield* that was approved by three of the four executors, but after those three died, the fourth insisted that the whole sculpture be redone. Gutzon Borglum refused. The executor in turn refused to pay the foundry for the statue's casting, and the case spent two years in the judicial system before a jury viewed the statue and forced the Butterfield estate to disburse $32,000.

An oft-quoted anecdote whose source I've been unable to trace recounts that Borglum inscribed his signature on top of *Butterfield's* hat, claiming it was the only part of the sculpture the executors hadn't insisted he modify. It's a charming story, but the statue is, in fact, signed on the figure's left boot. The behavior of the Butterfield executors undoubtedly rankled, though: when *Butterfield* was moved to allow the construction of Riverside Church, Gutzon Borglum said he wouldn't mind if they dropped it into the Hudson River.

About the Subject

Daniel Butterfield (1831–1901) used his political and family connections to arrange a high-ranking position for himself during the Civil War. After blunders at Second Manassas and Fredericksburg in 1862 resulted in thousands of casualties, Butterfield's superiors wisely relegated him to desk duties. From then on, his most significant contributions to the war effort were the inglorious but essential administrative tasks for which his experience in the family business (American Express) had prepared him.

A few years later, as director of the United States Sub-Treasury in New York, Butterfield again displayed notable lack of judgment—perhaps even outright dishonesty. He notified Jay Gould when President Grant telegraphed orders to sell millions of dollars worth of gold. Gould and his partners had been attempting to corner the gold market; Butterfield's warning gave Gould time to sell his holdings before the price plummeted on September 24, 1869. (See *Bennett*, #21, for coverage in New York papers.) In the congressional investigation that followed Wall Street's first

"Black Friday," Butterfield was removed from office but not prosecuted. Small wonder that Mrs. Butterfield required her husband's statue to honor him as a soldier rather than a bureaucrat.

A century later, the only achievement of Butterfield's that's still remembered is not financial or military but musical. He modified a decades-old bugle call into the melody we know as "Taps." Despite his mediocrity as a major general and his machinations on Wall Street, Butterfield was buried honorably at West Point, to the somber accompaniment of "Taps."

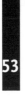

53 Alexander Hamilton

Sculptor: William Ordway Partridge.
Dedicated: 1892.
Medium and size: Bronze (8 feet), granite pedestal (approximately 8 feet).
Location: Hamilton Grange, 287 Convent Avenue, between West 141st and 142nd Streets.
Subway: 1 to 137th Street–City College.

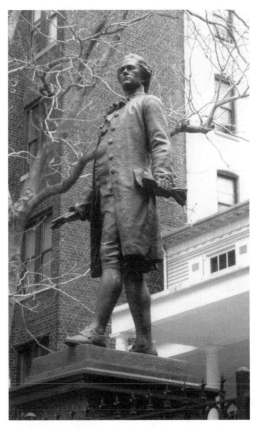

Hamilton, Partridge

First Secretary of the Treasury on the Need for a Sound Financial Basis for the United States

To attempt to enumerate the complicated variety of mischiefs, in the whole system of the social economy, which proceed from a neglect of the maxims that uphold public credit, and justify the solicitude manifested by the House on this point, would be an improper intrusion on their time and patience.

In so strong a light, nevertheless, do they appear to the Secretary, that, on their due observance, at the present critical juncture, materially depends, in his judgment, the individual and aggregate prosperity of the citizens of the United States; their relief from the embarrassments they now experience; their character as a people; the cause of good government.

—Hamilton, "First Report on Public Credit," January 1790

About the Sculpture

Of the four sculptures of Hamilton in Manhattan—all of which represent him as an orator—this is the liveliest. Why? The *Hamilton* behind the Metropolitan Museum (#43) holds a document in his left hand and grasps his lapel with the other. From the position of his feet it's clear that he's not moving. The *Hamilton* at the Museum of the City of New York (next to *Clinton,* #48) is also self-contained and motionless; a hand with a scroll rests on a pillar, the other hangs by his side.

The Grange *Hamilton* and Partridge's other *Hamilton* (on the Columbia campus near *Jefferson,* #50) both stride forward with notes for a speech in one hand. With his right hand, however, the Columbia *Hamilton* genteelly grasps his lapel, while the Grange *Hamilton* gestures. That slight change makes the Grange *Hamilton* much more dynamic.

Study the texture of the Grange *Hamilton's* coat. What sort of fabric does the texture suggest? What does that imply about Hamilton's taste in clothing and his income? How is this coat different from those of *Nathan*

Hale or *George Washington* (#8, 6), which date to the same period? Why is this texture appropriate for a statue of Hamilton but not for one of Hale, or of Washington on Inauguration Day?

About the Subject

Picture the new United States, with its radically innovative Constitution guaranteeing individual rights and limited government, as a brilliant but bankrupt young inventor: great potential but massive debts, and no income. If the country can't be put on a sound financial basis, the Constitution won't even get a trial run.

Enter thirty-four-year-old Hamilton, the nation's first secretary of the Treasury. Despite his age, he was by far the best candidate for the post. As Washington's aide during the Revolutionary War, he had proved himself a great administrator and an able fiscal manager. As coauthor of the *Federalist Papers,* he had displayed such a profound grasp of the Constitution's principles that Jefferson hailed the *Papers* as "the best commentary on principles of government ever written."

When Washington appointed him secretary in 1790, Hamilton knew he was facing financial chaos (see Sidebar). American debt from the Revolutionary War was approximately $79 million, twenty times the amount of money in circulation. The government had no funds to pay off this debt. It could not even meet current expenses: the Constitution didn't specify how the federal government should raise revenue. Since not even the interest on its debt was being paid, no one was willing to make loans to the United States.

Over the next five years, Hamilton set up a workable financial program for the United States. To provide government income, Hamilton chose to tax imports. This remained the primary source of government income until 1913, when the Sixteenth Amendment was passed to permit an income tax. (Hence the elaborate 1907 Customs House at Bowling Green; see #4.) Hamilton's plan for debt repayment was so successful that just over a decade later, in 1803, Jefferson was able to sell $15 million dollars in government bonds for the purchase of the Louisiana Territory

(#50). By the time Hamilton was killed in a duel with Aaron Burr in 1804, the United States was financially stable.

I admire Hamilton's financial abilities, but to me his most endearing quality is that he was one of those nonnative New Yorkers who whole-heartedly adopted the city as his home. Born in the Caribbean, he arrived here as a teenager in 1775. Over the course of the next three decades he lived away from New York for only a few years, while serving as Washington's aide-de-camp and later as secretary of the Treasury.

Walk through Midtown and you'll still see reminders of Hamilton, no-tably branches of the Bank of New York, which he cofounded at age twenty-nine, and copies of the *New York Post,* which he founded at age forty-four (#22). His greater memorial is the skyline of Manhattan. Jef-ferson would have hated our hustle and bustle. Washington and Adams would have preferred to return to their farms. But from the time he ar-rived, Hamilton never expressed a desire to live anywhere but New York, and he did his considerable best to help it grow and prosper.

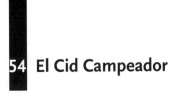

Sculptor: Anna Hyatt Huntington.

Dedicated: 1927.

Medium and size: Bronze (16 feet), granite pedestal (approximately 16 feet) with four bronzes of soldiers (approximately 7 feet) at the corners.

Location: Hispanic Society of America courtyard, off Broadway between West 155th and 156th Streets.

Subway: 1 to 157th Street.

Cid, Huntington

The Cid Leads His Men into Battle
The Cid was in his armor mounted at their head;
He spoke aloud amongst them; you shall hear the words he said:
"We must all sally forth! There cannot a man be spared,
Two footmen only at the gates to close them and keep guard;
If we are slain in battle, they will bury us here in peace,
If we survive and conquer, our riches will increase.
And you, Pero Bermuez, the standard you must bear;
Advance it like a valiant man, evenly and fair."

—From 12th-century *Poem of the Cid*, anonymous
trans. in Southey's *Chronicle of the Cid*, 1808

About the Sculpture

Approaching the *Cid*, the first thing you notice is its heroic size: about 16 feet tall, on a pedestal of the same height. At its base are four over-life-size sculptures of primitive warriors. It's the dominant element in a sculptural ensemble that includes reliefs of two figures from Spanish history (Boabdil and Don Quixote), and six groups of Spanish animals. This context affects how we interpret the *Cid*, even before we study the details: we assume that he's an important figure and that he's heroic.

What part of the sculpture catches the eye first? The triangle formed by the *Cid's* arm and lance, which frame his head. That puts the emphasis on his expression, his right arm, and one of his weapons.

Is he riding in a parade, like *Washington* at Union Square (#13)? Surely not; like *Joan of Arc* (#44), he's standing in his stirrups and brandishing a weapon. He scowls with intensity as he twists to look behind him, encouraging his men to follow as he rushes into battle. The pennant on his lance marks him as the leader, making him a target, yet he shows no fear. Chain-mail armor falls back to reveal the bulging muscles of his right arm: he's physically strong as well as courageous. What's missing from his medieval warrior's garb? A helmet. In the eleventh century, Spanish hel-

mets were conical, with a nose piece. But if Huntington had included one, for the sake of historical accuracy, we wouldn't be able to see the Cid's expression. His ferocity in battle would have been literally obscured. Sometimes historical accuracy in a sculpture is less important than getting the message across.

The behavior of a soldier's horse increases our knowledge of its rider. The *Cid's* horse is not merely strong (we can see its powerful muscles, and even the veins that feed them), but very spirited. It twists its head to one side and swishes its tail. From the way it leans forward on its right foreleg, it's clearly impatient to move. The fact that the *Cid* can control such a horse with one hand, while his mind is clearly on rousing his followers, emphasizes the fact that the *Cid* is both physically strong and commanding.

The theme of the *Cid* is: "A strong, courageous warrior encourages his troops to rush after him into battle." If the adrenalin rush of charging into battle or into a new project matters most to you, the *Cid* may be an inspiration. If, on the other hand, you value the sense of triumph after a job well done, you may prefer *Washington* at Union Square.

Most Manhattan sculptures are subject to the whim of city officials for their site (*Sims*, #47), to the growth of surrounding trees (*Joan*, #44), or to the construction of nearby buildings (*Commerce*, #26). The *Cid* is singularly fortunate: it sits in a privately owned, treeless courtyard where it's set against a blank wall. Today, on its high pedestal in the sunken courtyard, it still looks precisely as the sculptor planned it eighty years ago.

About the Subject

In 1094 at the Battle of Poblet, near Valencia, a small force led by Rodrigo Diaz, known as El Cid Campeador (d. 1099), bested the previously undefeated Almoravids. Nine centuries later we recognize this as an important step in the Christian reconquest of Spain from the Moors. But looking backwards tends to make history exceedingly dull. Personal choices seem predetermined. Fortuitous events seem inevitable. (See *Washington*, #6.)

Try for a moment to imagine instead what your situation would be if you lived in the Iberian Peninsula in the 1090s.

A millennium earlier the Peninsula was one of the most civilized and prosperous provinces of the Roman Empire. Unfortunately, its prosperity and its position at the empire's westernmost edge made it an irresistible target once the empire began to disintegrate. By the fifth century A.D., Spain was overrun by the Vandals and Visigoths. In the eighth century came the Moors. By the late eleventh century the Peninsula was the scene of constant battles among a dozen or more Christian and Moorish rulers, linked or polarized by constantly shifting alliances.

If you were a military leader in eleventh-century Iberia, your first and most difficult goal was to stay alive. Your second was to get enough power to keep yourself and your followers safe. Death in battle was glorious. So were victory, riches, and fame.

> If we are slain in battle, they will bury us here in peace,
> If we survive and conquer, our riches will increase. (See Sidebar)

Later, it mattered whether your allies were Christians or Moors. Later, the expulsion of the Moors was proclaimed to be the goal of all good Christians. Later, Moors and Jews were forced to convert, face the Inquisition, or flee Spain. But in the eleventh century, a warrior's and leader's alliances were determined by political and military expediency rather than religion. You formed alliances with anyone who could help you without becoming an immediate threat.

This is the context of the historical Cid, of whom the *Encyclopaedia Britannica* (1910) says:

> Whatever were his qualities as a fighter, the Cid was but indifferent material out of which to make a saint,—a man who battled against Christian and against Moslem with equal zeal, who burnt churches and mosques with equal zest, who ravaged, plundered and slew as much for a livelihood as for any patriotic or religious purpose.... The Cid of romance, the Cid of a thousand battles, legends and dramas, the Cid as apotheosized in literature, the Cid in-

voked by good Spaniards in every national crisis, whose name is a perpetual and ever-present inspiration to Spanish patriotism, is a very different character from the historical Rodrigo Diaz.

Should we judge the Cid by the standards of his time, or by those of the twenty-first century? Was he an amoral traitor or merely a man of his times? An objective historian would judge him both ways—while being quite explicit about what he or she was doing at a given time.

It doesn't matter which of the historical or romanticized versions of the Cid Huntington had in mind when she sculpted this statue. That would only matter if she were an illustrator, paid to present someone else's ideas. Huntington chose to show the importance of courage and leadership. In the end—and at the beginning, and in the middle—that's what a work of art should do: convey a message to the viewer about what's important about the world and those living in it.

Afterword

Although I was hooked on art history after my first reading of Janson (see Introduction), I didn't understand why art and history were so closely related until I read Ayn Rand's works on aesthetics years later.[1] Rand's work raised fascinating questions. What's the purpose of art? Why has it endured for millennia, long before history or even the written word? Is there an objective way to interpret art? Why do some people react so strongly to a work that bores others? What is the definition of art?

When I finally attended an illustrated lecture on Ayn Rand's aesthetics, I was elated. The lecturer had done a marvelous job of integrating art, emotions, and philosophy. She made it crystal clear that art was neither mere decoration nor the province of inexplicable gut feelings.

The elation lasted until my next trip to a museum, when I realized that I couldn't make the sort of integrations that the lecturer had made. I didn't know where to begin. I didn't even know where to begin to learn. Were thinking and talking intelligibly about art, after all, the province of professionals? Did I have to hire an art critic to talk me around the museum?

Being an independent type, I determined to teach myself how to study and analyze art. The questions in "How to Read a Sculpture" (Appendix A) are condensed from the list I developed over the years to jump-start my study of sculpture—to help me notice details, identify themes, and evaluate it.

Why, though, should *you* walk around with such a list of questions? Why not smile or scowl at sculptures as you walk by, and move right along to your favorite coffee shop? I can suggest three excellent reasons.

Seeing and Thinking

You can train your nose and taste buds to isolate cumin, lemongrass, or tannin. You can train your ears to identify a cello's sound as opposed to a viola's, or your car alarm rather than your neighbor's. If you practice closely observing details of sculptures, you'll find you also start to "see" more of the world around you. It may be the details of a deliriously happy child's face, or the size and shape of tail lights as you sit in traffic, or subtle differences in the colors of business suits.

Not only will you notice more, you'll do more with that information. If you're a fan of crime dramas, you probably perk up every time the detective bags a shard of plastic. You start wondering where the plastic came from and what its forensic significance is. Why? A scriptwriter can't show the detective collecting hundreds of pieces of evidence: he has to choose those most significant for the plot. Once you've realized that, you assume that each detail shown is significant.

Sculptors must also be selective. They must meticulously choose which shapes, colors, textures, and so on will convey a particular message, then arrange those details so the sculpture conveys that theme.

When you look carefully at the details a sculptor has chosen, you are in effect learning from the sculptor how to perceive in essentials. That, in turn, gives you a model and a method by which to bring order into the jumble of items you see in the world around you, and by extension the jumble of ideas you hear and read. You're learning how to organize data by bringing it under your conscious control, rather than just letting it bombard you. You're learning how to determine what's essential in a given context and what can be ignored.

Ayn Rand called this "stylizing" your consciousness.[2] Learn to be methodical about observing and considering data when studying sculpture and you'll find yourself being more methodical when you consider Say's Law, your teenager's seemingly erratic behavior, or your laptop's latest system failure. Such habits of thought don't stop when you exit a museum.

Admiration

Looking closely at art occasionally brings another benefit—the sheer pleasure of seeing a top-notch mind at work. You can enjoy watching a sushi chef's swift slicing without experiencing the least desire to eat raw tuna. Likewise, once you understand the mental discipline it takes to select a theme and present it in an integrated, crystal-clear manner, you will often be awestruck at a sculptor's ability, even if you dislike his or her subject and theme. You needn't believe in Greek mythology to admire the curves and complexities of Cellini's *Perseus with the Head of Medusa.*

Among Manhattan's outdoor sculptures, works by Saint Gaudens and French are consistently of this caliber. Walk into the Metropolitan Museum, the Louvre, or Athens' National Museum and you'll find many other examples of sculptures you can admire for their method at least as much as their content.

Enjoyment

Learning to see and think more efficiently and finding artists whose work is technically and aesthetically admirable are both wonderful, but think of them as side dishes. The entrée—the most important reason to work through "How to Read a Sculpture"—applies only to sculptures you love.

Art's purpose is to give a viewer emotional fuel: "a moment, an hour or some period of time in which he can experience the sense of his completed task, the sense of living in a universe where his values have been successfully achieved. It is like a moment of rest, a moment to gain fuel to move farther."[3] Learning to look at a sculpture thoughtfully and systematically means you'll be able to spend more time with such favorite works.

Think of the movie you love so much that you've watched it ten times. Every time, you spot a detail that you missed before and which gives you even greater pleasure in the film. The same is true of sculpture. When you develop the habit of looking at your favorite sculpture systematically, you observe more and more details and find layer after layer of significance.

In turn, spending time with your favorite works helps you achieve and maintain a focus on the world as you believe it can and ought to be.

Detailed analysis also helps you identify what appeals to you in a given work. If you realize that you like the *Straus Memorial* (#46) because it shows a beautiful woman, you can look for other sculptures of beautiful women. If the calm, meditative mood appeals to you, you can look for works of art that have a similar mood. Knowing explicitly what you like in art (as in food, cars, or romantic partners) makes it much more likely that you'll find it.

I'm often asked whether looking closely at a sculpture might not reduce the viewer's enjoyment of it. Just the opposite: you react more strongly when you know something about a sculpture than when you're not-so-blissfully ignorant. You notice more details, see their significance, and realize how the work relates to your own values. With that knowledge, the work inevitably has a greater emotional impact.

All you have to do is stop, look, and think.

NOTES

1. See especially *The Romantic Manifesto: A Philosophy of Literature* (New York: New American Library/Signet, 1975); and Chapter 12 in Leonard Peikoff, *Objectivism: The Philosophy of Ayn Rand* (New York: Penguin, 1993).

2. "Art and Cognition," in *The Romantic Manifesto*, p. 47.

3. Ayn Rand, "Art and Sense of Life," in *The Romantic Manifesto*, p. 38.

Appendix A: How to Read a Sculpture

If you adore a certain sculpture but can't say what it means or why you like it, this section is for you. By demonstrating how to examine details and state their effects, the questions in Section 1 will help you identify the theme of the sculpture (the message the artist is conveying), and then evaluate the work. Consider the questions a guide rather than a straightjacket. You need not answer every question for every sculpture, nor answer in the exact order given below. Numbers following each question refer to essays in which the question is discussed in detail.

In Section 2, I've worked through the process of identifying a sculpture's theme for *Joan of Arc* (#44). Section 3 gives a detailed evaluation of the *Cid* (#54). Section 4 is a series of questions (without answers) to jump-start your study of *Butterfield* (#52).

§1: Questions for Looking at Sculpture

Step 1. Orientation

- Where does your eye go first, or what strikes you first about the sculpture? #27, 34, 35, 45.
- Size: life size, heroic, under life size? #23, 35, 52.

Step 2. Subject or Story: The Person or Event Shown

- Subject versus theme, #5, 28, 40, 44, 52.
- Perils and pleasures of allegorical sculptures, #34.

Step 3. Objects Shown
- Human figures: #7, 15, 36, 44, and many others. When working through these questions, *always* state the detail and its effect, that is, what the detail suggests about the figure represented (#14).
 - Proportions: tall or short, slender or sturdy, well fed or gaunt, etc.
 - Pose: weight on one or both feet, moving or still, arm positions, position of chin and head. Is the body facing in one direction or turning? Is the spine ramrod straight, relaxed, twisted?
 - Face: direction of gaze, position of eyelids, expression of mouth, wrinkles (lines from laughing, frowning, worrying?).
 - Hair: wild or controlled, low or high maintenance.
 - Overall: what characteristics and emotions do the face and figure project?
- Drapery or costume: Does it date the figure, indicate a profession or activity, emphasize certain parts of the body? Discussed in most essays. Costume versus drapery, #45.
- Props (objects the figure is holding, or that are near the figure): What are they and what are they for? Discussed in most essays.
- Pedestal: What do its shape, decoration, and inscription add? #2, 3, 10, 12, 14, 19, 22, 27, 28, 32, 34, 35, 36, 38, 40, 44, 51. Why should the sculpture be intelligible without its inscription? #45, 46.
- Setting: Where was the sculpture designed to be seen? #25, 42; also 10, 20, 22, 32, 48, 49, 51, 54.
- Tentative theme: Consider the concretes you've seen and the effects you've stated. Are some of them repeated or related, and thus emphasized? So far, what message do you think the artist is trying to convey? For a portrait, state the sitter's character as revealed so far. #44, 52.

Step 4. Attributes of the Objects
- Medium and color: What feature(s) do they emphasize? #5, 19, 27, 28, 30, 31, 34, 43.
- Texture and play of light: Does a contrast between light and dark or plain surfaces and complex detail draw your eye to a particular area? #16, 43; also 5, 27, 53.

- Forms beneath the surface: Are you aware of the body beneath the drapery or costume? How does it affect your interpretation of the sculpture? #46, 54.

Tentative theme (see end of Step 3), revised based on which feature(s) the attributes emphasize.

Step 5. Overview

- Composition (arrangement of the figures): Is the outline simple or complex? Are the figures compact or sprawling? Does the composition emphasize any particular parts of the statue? Can you explain why your eye went to a certain part of the sculpture first, based on composition or on an aspect such as color or texture? #5, 19, 21, 27, 31, 33, 38.
- Contrasting sculpture: Compare the objects, attributes, and composition of another sculpture on the same subject, by the same sculptor, or in a similar pose. How does this sculpture differ? #1, 4, 7, 15, 22, 27, 29, 32, 35, 36, 39, 44, 45. "Quoting" other sculptures, #10, 13, 45.
- Summary and review
 - Subject: Most essays.
 - Mood: Does the sculptor approve or disapprove, like or dislike his subject? #26.
 - What's emphasized? Most essays.
 - Final statement of theme, double-checked against earlier observations and tentative themes from Steps 3 and 4. Does this theme involve what you first noticed about this sculpture, which is presumably what the artist chose to emphasize?

Step 6. Historical Information

- Biographical facts about the subject of a portrait, the artist's comments about this work, the occasion for which it was commissioned, etc. Why this comes last in studying a sculpture: Introduction, #18, 46.

Step 7. Evaluation

After you identify the theme, you can spend even more time with your favorite sculpture, puzzling out exactly what you like about it and evaluating in what respects it's good or bad. See "Evaluating the *Cid*" below (§3).

- Emotional: #17, 18; also 29, 35.
- Aesthetic: #15; also 7, 28, 32, 35, 41.
- Philosophical: #40, 43.
- Art historical, based on whether the work is innovative and influential: #19, 31.

§2: Identifying the Theme of *Joan of Arc* (#44)

This is a rough transcript of my thoughts as I worked to identify the theme of Huntington's *Joan of Arc*, using the "Questions for Looking at Sculpture" on the preceding pages.

Step 1. Orientation

The area of the sculpture that catches my eye first is *Joan's* upturned face and raised sword. The theme I propose must include whatever these two elements imply, since they're emphasized. The over-life-size proportions—often termed "heroic"—suggest that this woman is literally meant to be looked up to. (Compare *Stein*, #23.)

Step 2. Subject or Story

The subject of the sculpture is Joan of Arc. If I'd seen this work without knowing its title, I could identify it as Joan because it shows a young woman (small size relative to the horse, delicate facial features) wearing medieval armor. I can't think of another woman who would appear thus.

 The armor identifies this figure as Joan and also recalls her story: the voices she heard as a teenager, her determination to fight with the French army, her military triumphs against the English, her capture, trial, and death at the stake. Within that story, an artist could choose many different themes, as Schiller, Twain, and Shaw did when telling Joan's story (see Sidebar to #44). Which aspect did sculptor Huntington choose to illustrate? To find out, I'll study the details.

Step 3. Objects

Joan is looking toward heaven, which suggests a religious theme: piety, perhaps. H'mmm, but no overtly religious symbols appear on the sculpture, although it would have been easy enough to include one. The *Cid* (#54), for example, wears a cross on his tunic. I've seen a sword held hilt-upwards to represent a cross, but Joan doesn't do that.

Let me look at *Joan's* face again. Her expression is calm, as opposed to *Jagiello* (#39), who's scowling with defiance, or the *Cid*, who's shouting to his troops. From the expression on her face and the direction of her glance, I'll tentatively say *Joan* is intensely focused on something, concentrating on it—"dedicated" is the word I want. It doesn't look as if a cloud has caught her attention—it looks as if she's offering a vow or a prayer. Yet, as I already noted, no other religious symbolism is included in the statue. Besides, she's wearing armor, raising a naked sword, and riding a war horse, so this sculpture can't be wholly about religion. If it were, the sculptor could have shown her kneeling in prayer, as some statues of Joan do.

What other clues can I spot? Joan is standing up in her stirrups. I know this because her legs are straight and the stirrups are pulled taut. (Compare the comfortably seated *Washington*, #13.) The lower half of her body leans slightly forward, as if to set the horse in motion, so she's not relaxing in the saddle. Aha: she's riding into battle; otherwise the bared sword doesn't make sense. In fact, the way she holds the sword and the way she stands in the stirrups might suggest that she's a leader, and that there are men behind her who will follow her into battle.

No, wait, perhaps that's reading in too much. What makes me think of followers? She's not twisting around like the *Cid*. She's not posing, as *Jagiello* does. Oh, I know: it's the position of the sword. The sword seems to suggest that someone's observing her, and it's the gesture of a leader rather than a follower. ("Here I am, follow me!") Can I add anything to my knowledge of *Joan* from her outfit? As opposed to the *Cid's* chain mail (a series of metal rings linked together), the plate armor *Joan* wears completely hides her young girl's body, except for that delicate face. The contrast of the face with the armor is particularly effective, reminding me that part of the novelty of Joan's story is that as a young girl, she led bat-

tle-hardened soldiers. Show her with the same pose, same expression, same sword, but wearing a gown rather than armor, and she'd look bizarre. The fact that she's dressed for battle is crucial to telling me what aspect of Joan's story is presented here.

The sword Joan holds was legendary. Her voices told her where to find it, and it was said to have been carried by Charlemagne himself. That gives it both patriotic and religious significance: Charlemagne was one of France's most famous early kings, and in A.D. 800 the pope crowned him first Holy Roman Emperor.

As I said when describing *Jagiello* (#39), the behavior of a horse reveals a good deal about the character of its rider. *Joan* rides a powerful steed: I can clearly see the muscles and veins bulging beneath its skin, because (unlike *Jagiello*'s mount) the horse isn't covered with trappings. It's also stepping forward briskly, like *Sherman*'s mount (#31), and the turn of its head and flare of its nostrils show that it's energetic and spirited. Yet *Joan* holds it in check with one hand, while the other raises the sword. She may not be huge and muscular, but she has authority.

And look, there's another clue to what's important to Joan on her horse's harness. It's stamped with the fleur-de-lis, symbol of the French monarchy. Since she's shown with that symbol as well as the raised eyes, she must be dedicated to her country as well as God.

Dedicated to God, dedicated to country … Can I combine these two somehow? The common element is dedication to values, in this case both religious and patriotic. I'd say the religious values are more important, since they're implied by Joan's gaze, while the patriotic emblem appears only on her horse's trappings. As a tentative theme, I'll say she has strong convictions and is willing to fight for them: more succinctly, she's eager to fight for what she believes in.

What else can I figure out from observing *Joan of Arc* closely? There's the pedestal. Although the gothic arches on the pedestal aren't Christian symbols, they have strong religious associations because they were key elements in medieval cathedrals. The arches remind us of Joan's religion and the nature of the period she lived in. In researching the sculpture I learned that a scrap of stone from the Cathedral of Reims is embedded in

the pedestal (see #44, About the Subject), as well as a piece of stone from Joan's prison at Rouen. That's not part of the visual effect of the sculpture, but it's an interesting historical sidelight.

Step 4. Attributes

One of the wonderful characteristics of bronze is that it can be modeled with extraordinary detail. I know the horse is strong and the armor is hard because of the way the artist has rendered their textures. If I mentally morph the surface of this sculpture into an all-over rough texture like Whitney's *Stuyvesant* (#16), it immediately loses much of its urgency and appeal.

I could also visualize this sculpture carved of marble, like the figures at the base of the *Maine Monument* (#34). The sword would have had to be added in metal, since marble would crack if carved into such a slender shape and left unsupported. A metal sword held by a marble figure, though, would be much more noticeable than a sword that's the same color as the figure. That would put the emphasis on *Joan's* weapon, rather than on what she's thinking. That in turn would change the theme of the sculpture. As it is, *Joan's* upraised face and the sword have about equal emphasis. (I wish the Parks Department would trim the trees around *Joan,* so the sword could be seen more easily. Presently it's almost invisible, which certainly wasn't the sculptor's intention.)

Step 5. Overview

In Step 1, I noted that the elements that catch the eye first in this sculpture—the ones that are emphasized—are *Joan's* face and sword. My current tentative theme is that she's eager to fight for what she believes in: God and country. That theme suits the emphasis on the face and sword. So far, so good.

Now I'll pull my focus way back and look at the entire sculpture in its setting. *Joan of Arc* is over-life-size and, in addition, is set on a pedestal and on a hill, so that I have no choice but to look up to her. That has metaphorical as well as literal significance: she's presented as a hero, not Everyman. (Compare the *Garment Worker* on its almost-pavement-level base at Broadway and West 39th Street.)

At this point I like to look at contrasting sculptures, which sometimes jog me to notice points I've missed. I've already compared various details to other equestrian sculptures in this book (*Jagiello, Sherman, Washington*), which helped me see that *Joan* is riding into battle rather than returning triumphant, that she's a leader, and that her attitude is dedicated, calm, and confident rather than aggressive.

Looking back over my earlier comments, I see that in my tentative theme, "Joan is eager to fight for what she believes in: God and country," I didn't capture the idea that Joan is not only willing to fight for her own convictions, but capable of inspiring men to fight with her. Is that important enough to include in a statement of the theme? Yes, because the point of Joan's story is not simply that she fought for what she believed in—otherwise a sculpture of her kneeling in prayer with a sword would have been adequate. Joan is famous because she inspired her compatriots and led them to victory. How do I work that into my statement of the theme? "This young girl fought passionately for her God and her country, and inspired others to fight for them as well."

All that would have been needed to give this *Joan of Arc* a negative spin would be a reminder of the deaths Joan caused in battle, or of the scorching end that awaited her. Huntington includes neither. She implies that humans can have values, that values are worth fighting for, and that men can work together to achieve them. (See *Shakespeare*, #37, on metaphysical value-judgments.)

After I'd gone through the lengthy process of identifying the theme of *Joan* and the metaphysical value-judgments it implies, I finally realized why I like it. Although I'm not French, Christian, or a soldier, I have values and I fight for them: and that's what this *Joan* is about. (For more on identifying one's emotional reaction to a sculpture, see Section 3 below.)

§3: Evaluating the *Cid* (#54)

Aesthetic Evaluation

The questions to ask when evaluating a work aesthetically are: Is the theme presented clearly? Are all the details of the work integrated to present that theme? (See *Lincoln*, #15.) The *Cid* excels in both respects. What's

happening is immediately obvious, and no inexplicable details confuse the message. To grasp this more clearly, imagine the *Cid* on *Jagiello's* horse (#39). The energy of the man compared to the stillness of the horse would be disconcerting. You would stop thinking about the sculpture and start trying to imagine why the artist presented horse and rider in such disparate moods. Wondering about the artist's motivation when you first look at a sculpture is often a sign that a sculpture lacks clarity, integration, or both.

Philosophical Evaluation

The first question to ask when evaluating a sculpture philosophically is: Does it have an identifiable theme, and does that theme imply something fundamental about the nature of humans and the world they live in? All the sculptures in this book do, but consider, for contrast, an animal sculpture that is a purely decorative combination of line and texture. It may well have no fundamental message. A sculpture whose subject is very obscure, or that's very incompetently executed, might also convey no theme, and hence have no philosophical message.

If a sculpture does have an identifiable theme, the second question for philosophical evaluation is: Are the metaphysical value-judgments implied by that theme true? If you believed in them and acted accordingly, would you survive and be happy or die miserably? The *Cid's* theme is, "A courageous warrior encourages his troops to follow him into battle." That implies (like Huntington's *Joan of Arc*) that values exist, can be fought for, and can (at least sometimes) be achieved through cooperation. The difference between the two is not in the implications as much as the emotional tone. The *Cid*, scowling ferociously as he rushes into battle, is focused on his soldiers and the coming battle. *Joan* is instead pausing for a final quiet moment to rededicate herself to her values.

Emotional Evaluation

Your emotional evaluation depends on your values as well as the content of the sculpture: what you consider important as well as what the artist chose to say (*Booth, #17*). If charging into battle or into a new project seems most important to you, the *Cid* may be an inspiration. If you love

the theater, the connection between the *Cid* and Corneille's *Cid* may attract you. If, on the other hand, you value the sense of triumph after a job well done, rather than the adrenalin rush before battle, you may prefer the *Washington* at Union Square (#13) to the *Cid.* If you know the ethical and political principles of Washington and the Cid, respectively, and you prefer the former, that will affect your reaction to both works. Remember that an emotional reaction never springs solely from the sculpture's content. Don't expect others to share or even understand your response to a sculpture, if they don't understand and share your values.

Art-Historical Evaluation

Art-historical evaluation of a sculpture requires specialized knowledge and a multitude of illustrations, which is why little of it appears in this volume. To evaluate the *Cid's* importance in the history of art, we'd have to compare equestrian sculptures from ancient times to the present. Does the *Cid* offer any major innovations? Is it similar to other works produced during the twentieth century? Is it merely a copy of another sculptor's work, with minor revisions?

Huntington is one of America's best sculptors of animals. Her human figures are competent, but her horses (including the *Cid's*) are magnificent. Although she did not introduce radically new subjects or style, in equestrian sculptures such as the *Cid, Joan of Arc,* and *Martí* (#33, 44), she contrived to make the behavior of the horses contribute substantially to our understanding of their riders. Huntington's *Cid* didn't change the course of sculpture to the degree that Saint Gaudens's *Farragut* did (#19), but Huntington's contributions to sculpture were distinctive and respectable.

Overall Evaluation

How can we combine all these apples and oranges into one overall evaluation of the *Cid?* Summarizing a restaurant, you might say the food is excellent, the service mediocre, the décor ugly. Summarizing a sculpture, you might say, "The *Cid* is well done, inspiring, and I like it"—or simply, "I like it." Anyone who's intrigued will ask for further details.

§4: Questions Regarding the Theme and Evaluation of *Butterfield* (#52)

For *Joan of Arc* I gave you a play-by-play account of how I worked out the theme, and for the *Cid*, how I evaluated it in various ways. Here's your chance to do the same for *Butterfield*. Visit the sculpture—you really do need to look at the work itself, not a tiny photograph—and see what you can make of it. Here are some questions to get you started, based on the "Questions for Looking at Sculpture" in Section 1 but specific to this work of art.

Orientation

Where on the sculpture does your eye go first, or what strikes you first? This can be specific (the toe of the right boot) or general (the head and torso, hands, etc.). It often helps to back up and block out parts of the statue with one hand. Which part do you miss most when it's covered up? That's what the artist emphasized. If your final theme isn't directly related to this, your theme's probably wrong.

Is the statue life size, of heroic size, or smaller than life-size? What's the effect of that: Do you look up to him (as you do to *Joan*), look down on him (as *Stein*, #23), or look him in the eye as an equal?

Subject

The green Parks Department sign will give you a biography of *Butterfield*, but for the moment resist reading it. Biographical facts and the opinions of others will affect your judgment of the man (just as they did in *Conkling*, #18), and it's better to try to look at the sculpture first without preconceptions. For starters, is this soldier an officer or a grunt? How do you know? Can you tell from his costume what period he dates to? You may want to compare this figure to other Manhattan sculptures of soldiers. Try *Farragut* (#19), *Webb* (Convent Avenue at West 138th Street), *Sheridan* (Seventh Avenue at West 4th Street), *Duffy* (#27), and the *Flanders Field Memorial* (Eleventh Avenue at West 52nd Street). I suggest taking photographs of these with you to *Butterfield*.

Objects: Human Figure

Pose: If you came home to find your Significant Other waiting for you in this pose (arms crossed, chest thrust out), how would you think he or she was feeling? Is it a protective pose, a keep-your-distance pose, a giving-orders pose? Look at *Butterfield's* feet. Is his weight on one foot or both, forward or back? Is he standing still or about to move?

Proportions: Does he look like a soldier who's been suffering on a difficult campaign, or one who's well fed and healthy? How do you know?

Start working on a tentative theme. What adjectives would you use to describe this man?

Head: Is his chin down, level or up? What's the effect, especially combined with the position of his arms and his posture? What do you think he might be doing: giving orders in battle, inspecting his troops, or something else?

Hair: Is he scruffy, like *Sherman*, or dapper? High maintenance or low maintenance? (Finally, a chance to show off your knowledge of mustache grooming!) How does that combine with what you've seen of his posture?

Eyes: Are they wide open, half-open, nearly closed? What's the effect, combined with his posture and the position of his chin?

Mouth: What's its expression? How does that fit with his posture and gaze?

Continue work on the theme. Can you add any further adjectives to describe him? Do the details of the face and hair that you've just observed emphasize anything that's suggested by his pose? If so, assume the artist wants to emphasize that point, and give it prominence in your tentative theme.

By the way, why is his face so easy to see compared to *Webb's* or *Sheridan's?*

Objects: Costume

What's noticeably different about *Butterfield's* uniform jacket, compared to those of *Webb, Sheridan,* or *Sherman?* Based on the way he stands and his expression, why do you suppose he has so many medals pinned on his jacket? Is he proud of his accomplishments, ar-

rogant, pompous, authoritarian? Is he dressed for a formal occasion, or for a battle?

Note: *Butterfield* wears a hat called a chapeau-de-bra, which we have also seen on *Bolívar* (#32). By the end of the nineteenth century this hat was used only when an officer expected to be ceremonially tucking his hat under his arm. What's implied by *Butterfield* wearing this hat?

Weapons: Does he carry any? What's he doing with it or them? (Compare *Webb.*) Based on a study of this man's costume, what can you add to your tentative theme? Does the costume emphasize any points you noticed when studying the pose and face?

Objects: Pedestal and Setting

How high is the pedestal compared to your eye level? If it were a mere 6 inches or a full 15 feet, how would that change your perception of the figure?

Is there an inscription or a relief on the pedestal? Does it affect your reaction to the figure represented?

Attributes

Medium and color: What would be the effect of this sculpture if it were bright white marble? Very dark bronze? Gilt?

Texture and play of light: Study the concentration of textures. Which parts of the sculpture draw your eye by their greater detail?

Modify your tentative theme again. Do the attributes help emphasize anything you noted when studying the posture, face, and costume?

Overview

Composition: Where did your eye go first? Does that agree with the part that has the greatest detail (see Attributes)? Given that, what aspect of the sitter do you think the sculptor decided to emphasize: his physical strength, his mood, his rank, his attitude toward the world and his subordinates, or something else?

If the man were in exactly the same outfit, but posed like Memory in the *Straus Memorial* (#46) ... Well, perhaps that's too silly to be useful. All right, picture him in the same pose but with a flag unfurling behind him,

as in the *Abingdon War Memorial* (Eighth Avenue at West 12th and Hudson Streets). Would that change your perception of him? In what way? Without such an explicit appeal to patriotism, what effect does *Butterfield* have?

Contrasting sculpture: Go step by step through a sculpture of a different military figure, for example *Webb*. Look at his posture, face, costume, and so on. Make notes of how *Butterfield* is different, and the effect those differences have.

Summary: Re the subject, is this an officer or a grunt, and to what period does he belong? What is emphasized about him, by the objects presented and their attributes? What is your final statement of the theme, that is, of this man's character? Double-check this with one final look at the sculpture, to be certain nothing is inexplicable given your theme.

Evaluation

Note that it's useless to attempt most of these types of evaluation unless you've taken the time to work out the theme. In the case of portraits, the theme is the person's dominant characteristics as shown by the sculptor.

AESTHETIC EVALUATION

Is the sculpture clear: do you get an immediate, vivid sense of what type of man this is, even if it takes you some time to put it into words? Is the sculpture integrated, that is, do all the details "fit," or are there elements that make you wonder why the artist included them?

PHILOSOPHICAL EVALUATION

Remember that philosophical evaluation of *Butterfield* the sculpture is not the same as judging the actions and ideas of Butterfield the man. Can you identify the most important characteristics of the figure shown here, or is this sculpture merely a record of his physical appearance? If you can identify such characteristics, what broader statements do they imply about man and the world? If you took those statements as true and lived by them, what would the consequences be?

EMOTIONAL EVALUATION

How do you, personally, feel about Butterfield? Do you approve of the characteristics with which he's shown here? Do you admire his life and his career?

ART-HISTORICAL EVALUATION

This sort of evaluation requires some knowledge of other sculptures: other portraits of military men, other American portrait sculptures, other sculptures of Civil War heroes. If you don't have that background, whet your skills by comparing *Butterfield* with the sculptures mentioned above: *Webb, Sheridan, Duffy, Flanders Field.* Do you see elements in *Butterfield* that don't appear in any of them? Do you find *Butterfield* distinctive or unique?

OVERALL EVALUATION

If you had to summarize this sculpture in five words or less, how would you describe it? If you could use twenty words or so, what qualifications would you add? Are you glad that you saw and studied it? Would you recommend that people go out of their way to see it?

Appendix B: Statues in Chronological Order by Date of Dedication

1856: *George Washington*, by Henry Kirke Brown (#13)

1869: *Cornelius Vanderbilt*, by Ernst Plassmann (#25)

1870: *Abraham Lincoln*, by Henry Kirke Brown (#15)

1872: *William Shakespeare*, by John Quincy Adams Ward (#37)

1873: *Marquis de Lafayette*, by Frédéric-Auguste Bartholdi (#14)

1880: *Farragut Monument*, by Augustus Saint Gaudens (#19)

1880: *Alexander Hamilton*, by Carl Conrads (#43)

1883: *George Washington*, by John Quincy Adams Ward (#6)

1885: *William Earl Dodge*, by John Quincy Adams Ward (#24)

1886: *Statue of Liberty*, by Frédéric-Auguste Bartholdi (#1)

1890: *Horace Greeley*, by John Quincy Adams Ward (#7)

1890: *Nathan Hale*, by Frederick MacMonnies (#8)

1890: *Alexander Lyman Holley*, by John Quincy Adams Ward (#11)

1892: *Columbus Monument*, by Gaetano Russo (#35)

1892: *Dr. James Marion Sims*, by Ferdinand von Miller II (#47)

1892: *Alexander Hamilton*, by William Ordway Partridge (#53)

1893: *Roscoe Conkling*, by John Quincy Adams Ward (#18)

1894: *Peter Cooper*, by Augustus Saint Gaudens (#10)

1894: *Christopher Columbus*, by Jeronimo Suñol (#36)

1895: *Bell Ringers' Monument (James Gordon Bennett Memorial)*,
 by Antonin Jean Paul Carles (#21)

1900: *Richard Morris Hunt Memorial*, by Daniel Chester French (#38)

1903: *John Ericsson*, by Jonathan Scott Hartley (#2)

1903: *Sherman Monument*, by Augustus Saint Gaudens (#31)

1903: *Alma Mater*, by Daniel Chester French (#49)

1906: *Verdi Monument*, by Pasquale Civiletti (#41)

1907: *Four Continents*, by Daniel Chester French (#4)

1909: *Giovanni da Verrazzano,* by Ettore Ximenes (#3)

1911: *William Cullen Bryant Memorial,* by Herbert Adams (#22)

1913: *Maine Monument,* by Attilio Piccirilli (#34)

1913: *Firemen's Memorial,* by Attilio Piccirilli (#45)

1913: *Carl Schurz Monument,* by Karl Bitter (#51)

1914: *Glory of Commerce (Progress with Mental and Physical Force),*
by Jules-Felix Coutan (#26)

1914: *Thomas Jefferson,* by William Ordway Partridge (#50)

1915: *Joan of Arc,* by Anna Hyatt Huntington (#44)

1915: *Straus Memorial,* by Augustus Lukeman (#46)

1916 and 1918: *Washington Arch,* by Hermon MacNeil and Alexander Calder (#12)

1917: *Edwin Booth as Hamlet,* by Edmond T. Quinn (#17)

1917: *Daniel Butterfield,* by Gutzon Borglum (John Gutzon de la Mothe Borglum) (#52)

1921: *Simón Bolívar,* by Sally Jane Farnham (#32)

1923 (cast of 1992): *Gertrude Stein,* by Jo Davidson (#23)

1927: *El Cid Campeador,* by Anna Hyatt Huntington (#54)

1930: *Samuel Rea,* by Adolph A. Weinman (#20)

1934: *Prometheus,* by Paul Manship (#28)

1936: *Peter Stuyvesant,* by Gertrude Vanderbilt Whitney (#16)

1937: *Father Francis P. Duffy,* by Charles Keck (#27)

1937: *Atlas,* by Lee Lawrie (#29)

1939: *King Jagiello,* by Stanislaw Kazimierz Ostrowski (#39)

1940: *News,* by Isamu Noguchi (#30)

1940: *Theodore Roosevelt,* by James Earle Fraser (#42)

1941: *De Witt Clinton,* by Adolph A. Weinman (#48)

1965 (finished 1959): *José Martí,* by Anna Hyatt Huntington (#33)

1989: *Charging Bull,* by Arturo Di Modica (#5)

1994: *Fiorello La Guardia,* by Neil Estern (#9)

1996: *Eleanor Roosevelt,* by Penelope Jencks (#40)

Appendix C: Brief Biographies of Artists

Adams, Herbert. 1858–1945, b. West Concord, Vt.; studied in Paris, then taught at the Pratt Institute, Brooklyn. He was known for superb portrait reliefs. Manhattan has *Solon* on the Appellate Court, ca. 1900 (Madison Avenue at East 25th Street), the sculptures on the north portal of St. Bartholomew's Church, 1904 (Park Avenue at East 50th Street), and *Bryant*, 1911 (#22).

Bartholdi, Frédéric-Auguste. 1834–1904, b. Colmar, Alsace. In his native France he was famous for the *Lion of Belfort*, 1875–1880. Manhattan has *Marquis de Lafayette*, 1873 (#14), *Statue of Liberty*, 1886 (#1), and *Lafayette and Washington*, 1890 (West 114th Street and Manhattan Avenue, at Morningside Avenue).

Bitter, Karl. 1867–1915, b. Vienna (where he studied sculpture), moved to the United States in 1887. He often collaborated with Richard Morris Hunt, producing the sculptures for Hunt's Administration Building at the 1893 Columbian Exposition in Chicago (see #36) and the sculptural ornament for Biltmore, the Vanderbilt estate in North Carolina. Manhattan has the reliefs on the doors of Trinity Church, 1893 (Broadway at Wall Street); the facade sculptures on the Metropolitan Museum of Art, 1899 (Fifth Avenue at East 82nd Street); the three-figure group of Peace on the Madison Avenue side of the Appellate Court, 1900 (at East 25th Street); a cartouche on the Customs House cornice representing the Great Seal of the United States, flanked by Peace and Strength, ca. 1907 (see #4); *Franz Sigel*, 1907 (Riverside Drive at West 106th Street), and the *Pulitzer Fountain*, 1913–1916 (Fifth Avenue at East 58th Street). The Bronx has *Henry Hudson*, 1909–1939 (Spuyten Duyvil), and Brooklyn *Confucius*, ca. 1900 (Brooklyn Museum).

Borglum, Gutzon (John Gutzon de la Mothe Borglum). 1867–1941, b. Idaho of Danish immigrants (brother Solon was also a well-known sculptor); trained as a painter in San Francisco and Paris. Beginning in 1905 he produced dozens of sculptures for the Cathedral of St. John the Divine (Amsterdam Avenue at West 112th Street), but is most famous for Mount Rushmore, 1927–1941. Manhattan has *Four Periods of Publicity*, ca. 1906 (Garrison Building, 20 Vesey Street), and *Butterfield*, 1917 (#52). Brooklyn has *Henry Ward Beecher*, 1914 (Orange Street between Hicks and Henry).

Brown, Henry Kirke. 1814–1886, b. Leyden, Mass. Among his most notable works are *General Nathanael Greene*, 1867, and *General Winfield Scott*, 1871 (both in Washington, D.C.). Manhattan has *Washington* and *Lincoln* at Union Square, 1856 and 1868 (#13, 15). Brooklyn has *DeWitt Clinton*, ca. 1850 (Green-Wood Cemetery), and *Lincoln*, 1866 (Prospect Park).

Calder, Alexander Stirling. 1870–1945, b. Philadelphia, son of Scottish sculptor Alexander Milne Calder; studied with Thomas Eakins at the Pennsylvania Academy of Fine Arts, then in Paris. He designed huge groups for the 1915 Panama-Pacific Exposition, then turned to garden and fountain sculptures. Manhattan has Washington as president on the *Washington Arch*, 1918 (#12), and four actresses on the Miller Building, ca. 1927–1929 (1552 Broadway). He was the father of that very mobile sculptor Alexander Calder, whose *Guichet*, 1963, stands at Lincoln Center.

Carles, Antonin Jean Paul. 1851–1919, French, trained at the Ecole des Beaux-Arts. He designed the *Bell Ringers' Monument* (*Bennett Memorial*), 1895 (#21).

Civiletti, Pasquale. 1858–1952, Italian. Manhattan has *Verdi*, 1906 (#41).

Conrads, Carl. 1839–1920. The National Statuary Hall in the United States Capitol has *John Stark* and *Daniel Webster* (after Thomas Ball), both 1894. Manhattan has *Alexander Hamilton*, 1880 (#43).

Coutan, Jules-Felix. 1840–1931, French Beaux-Arts sculptor, best known for *Armed France* on the Alexandre III Bridge in Paris. He designed the *Glory of Commerce* for Grand Central Terminal, 1914 (#26).

Davidson, Jo. 1883–1952, b. New York; studied with Hermon A. MacNeil and in Paris. One of America's leading twentieth-century portraitists, he created likenesses of John D. Rockefeller, George Bernard Shaw, Mohandas Gandhi, James Joyce, Franklin Delano Roosevelt, and many others. Manhattan has *Gertrude Stein*, 1923 (#23), and *La Guardia*, 1934 (near Madison Street, between Clinton and Jefferson Streets). Bear Mountain has *Walt Whitman*.

Di Modica, Arturo. Italian, sometimes works in New York. He did *Charging Bull*, 1989 (#5).

Estern, Neil. B. 1926, New York. His portraits include those of J. Robert Taft, J. Edgar Hoover, Jimmy Carter, and Princess Diana. Manhattan has *La Guardia*, 1994 (#9). Brooklyn has *John F. Kennedy*, 1965 (Grand Army Plaza).

Farnham, Sally Jane. 1876–1943, b. Ogdensburg, N.Y. Although she had no formal training, her work was critiqued by Frederic Remington, Augustus Lukeman, and Frederick Roth. She produced sculptures of Native Americans and a series of reliefs for the Pan American Union in Washington. Manhattan has *Bolívar*, 1921 (#32). The Bronx has a charming sculpture of a fatigued dancer from Isidora Duncan's troupe: *End of the Day*, 1922 (Woodlawn Cemetery).

Fraser, James Earle. 1876–1953, b. Winona, Minnesota; studied in Chicago and Paris, and assisted Saint Gaudens while the *Sherman* was in progress (#31). Major works include the groups of explorers and pioneers on the Michigan Avenue Bridge in Chicago and the pediments for the National Archives Building and Supreme Court in Washington. He designed the 1913 nickel with the Indian head and buffalo. Manhattan has *Roosevelt*, 1940 (#42).

French, Daniel Chester. 1850–1931, b. Exeter, N.H.; one of America's most notable sculptors. He studied with John Quincy Adams Ward and with Thomas Ball in Florence. Among his most notable works are the *Minuteman*, 1875 (Concord, Mass.); the *Milmore Memorial*, 1893 (copy at the Metropolitan Museum); the enormous *Republic* for the 1893 Columbian Exposition (smaller reproduction still standing in Chicago); the doors of the Boston Public Library, 1904; the *Melvin Memorial* (*Mourning Victory*, 1908; copy in the Metropolitan Museum), and the *Lincoln* in the Lincoln Memorial, 1922 (Washington). Manhattan has the *Hunt Memorial*, 1900 (#38), *Alma Mater*, 1903 (#49), and *Continents*, 1907 (#4). Brooklyn has allegorical figures of *Brooklyn* and *Manhattan*, ca. 1900 (in front of the Brooklyn Museum), and a lovely relief of *Lafayette*, 1917 (9th Street entrance to Prospect Park).

Hartley, Jonathan Scott. 1845–1912, b. Albany, N.Y.; trained with Erastus Dow Palmer and in London, Paris, Berlin, and Rome. He was famous for his busts, including *Edwin Booth, Susan B. Anthony*, and *William Cullen Bryant*. His series of eminent American writers appears on the Library of Congress's facade (Washington). Manhattan has *Ericsson*, 1903 (#2), and *Alfred the Great* on the Appellate Court, ca. 1900 (Madison Avenue at East 25th Street). The Bronx has the *Algernon Sydney Sullivan Memorial*, 1906 (Van Cortlandt Park).

Huntington, Anna Hyatt. 1876–1973, b. Cambridge, Mass. Her specialty was animal sculpture. *Joan of Arc*, 1915 (#44), was her first major commission. In 1923 she married railroad heir Archer Huntington and came to share his passion for Spain, producing an ensemble for the Hispanic Society of America courtyard that includes the *Cid*, 1936 (#54), reliefs of Don Quixote and Boabdil, and numerous animals native to Spain. Many of her works are on view at Brookgreen Gardens (Pawley's Island, S.C.), which she and her husband founded in 1931 as a showplace for American figurative sculpture. Manhattan also has her *Martí*, 1959 (#33). The Bronx has the *Arabella Huntington Memorial* (Woodlawn Cemetery.)

Jencks, Penelope. B. 1936. Manhattan has her *Eleanor Roosevelt*, 1996 (#40).

Keck, Charles. 1875–1951, b. New York, student of Saint Gaudens and Philip Martiny; studied in Greece, Florence, and Paris. His notable works include *Stonewall Jackson* and *Lewis and Clark* in Charlottesville, Virginia, and *Booker T. Washington* in Tuskegee, Alabama. Manhattan has *Letters* and *Science* flanking the entrance to Columbia University, 1915 and 1925 (West 116th Street and Broadway), *Father Duffy*, 1937 (#27), *Governor Alfred E. Smith* with an accompanying relief, 1946 (Catherine Street between Monroe and Cherry), and *Abraham Lincoln*, 1948 (Madison Avenue near East 133rd Street). Brooklyn has the the *Genius of Islam*, 1900 (Brooklyn Museum), the *61st District War Memorial*, 1922 (Greenwood Playground), and the *Brooklyn War Memorial*, 1951 (Cadman Plaza).

Lawrie, Lee. 1877–1963, b. Germany, came to the United States as an infant. He worked on the 1893 Columbian Exposition, and later in New York with Philip Martiny and Saint Gaudens. He is best known for the sculptures on the Nebraska State Capitol in Lincoln. For Rockefeller Center he designed fourteen works, including *Wisdom, Light, Sound*, 1933 (over the entrance to 30 Rockefeller Plaza), *Atlas*, 1937 (#29), and numerous reliefs. He also did sculptures behind the altar of St. Thomas Church (Fifth Avenue at West 53rd Street).

Lukeman, Augustus. 1872–1935, b. Richmond, Va.; trained at the Cooper Union and the National Academy of Design, assisted Daniel Chester French. Manhattan has *Manu* (Indian law) at the Appellate Court, ca. 1900 (Madison Avenue at East 25th Street), *Genoa* on the Customs House cornice, 1907 (see #4), and the lovely *Straus Memorial*, 1915 (#46). Brooklyn has the *Hebrew Apostle*, 1907 (Brooklyn Museum), and a rather chilling World War I memorial, 1920 (near the Wollman Rink in Prospect Park).

MacMonnies, Frederick. 1863–1937, b. Brooklyn, N.Y.; trained with Saint Gaudens and in Paris. His big break was the commission for the enormous *Ship of State* for the Columbian Exposition in Chicago, 1893. *Bacchante with Infant Faun,* 1893 (banned in Boston, now in the Metropolitan Museum's American Wing), earned him nationwide notoriety. Manhattan has *Nathan Hale,* 1890 (#8), the sculptures of the Bowery Savings Bank, 1894 (130 Bowery), and the angels on the *Washington Arch,* 1894 (#12). Brooklyn's Grand Army Plaza has *Stranahan* (1891), *Slocum* (1902), and the chariot plus the reliefs of Army and Navy (1898, 1901) on the *Soldiers' and Sailors' Arch.* Prospect Park has the *Horse Tamers,* 1898 (Park Circle entrance). Later works lack his earlier exuberance and skill. Manhattan has *Truth* and *Beauty,* 1914–1920 (flanking the Fifth Avenue steps of the New York Public Library at West 42nd Street). Queens has *Civic Virtue,* 1922 (Queens Borough Hall, banished from Manhattan's City Hall Park after an outcry by suffragists).

MacNeil, Hermon. 1866–1947, b. College Point, Queens; studied in Rome and Paris, worked under Philip Martiny for the Columbian Exposition of 1893. His favorite subject was Native Americans (the Metropolitan Museum has a copy of his *Sun Vow*), but among his best known works are the 1907 *McKinley Memorial* in Columbus, Ohio, and the pediment of the Supreme Court in Washington, D.C. Manhattan has his figure of Washington as commander in chief on the *Washington Arch,* 1916 (#12). Queens has the *Flushing War Memorial,* 1920, and the Bronx has four busts in the Hall of Frame of Great Americans (Bronx Community College). MacNeil also designed the "Standing Liberty" quarter, minted from 1916 to 1930.

Manship, Paul. 1885–1966, b. St. Paul, Minn.; trained with Solon Borglum and in Rome. On a 1912 trip to Greece he was inspired by Archaic Greek art (then relatively unknown), whose style he adapted for mythological subjects with crisp details and glossy surfaces. In the 1930s he was the most famous living sculptor in the United States. Manhattan has the *Four Elements* on the former AT&T Building, 1917 (195 Broadway), *Prometheus,* 1934 (#28), the *Group of Bears,* 1932 (Fifth Avenue at East

81st Street, just inside Central Park), the *Governor Alfred E. Smith Flagpole* with charming New York State fauna, 1946 (Catherine and Cherry Streets), and the gates at the entrance to the Central Park Children's Zoo, 1961 (near East 66th Street). Queens has an armillary sphere in Flushing Meadows, and the Bronx has the *Rainey Gates* at the north entrance to the Bronx Zoo, 1934.

Miller, Ferdinand von (II). 1842–1929, German. He sculpted several Confederate memorials in North and South Carolina, and *Sims* for Manhattan, 1892 (#47).

Noguchi, Isamu. 1904–1988, born in Los Angeles of Japanese parents; studied with Gutzon Borglum, later with abstract sculptor Constantin Brancusi in Paris. *News* at Rockefeller Center, 1940 (#30), is Noguchi's only representational sculpture in New York. He is famous for such abstract works and installations as the ceiling and waterfall for 666 Fifth Avenue, 1957, the sunken garden at Chase Manhattan Bank Plaza, 1964 (1 Chase Manhattan Plaza), *Red Cube*, 1967 (140 Broadway), and *Unidentified Object*, 1979 (Fifth Avenue at East 80th Street).

Ostrowski, Stanislaw Kazimierz. 1879–1947, Polish. Manhattan has *Jagiello*, 1939 (#39).

Partridge, William Ordway. 1861–1930, b. in Paris of American parents, studied in Europe, taught at Stanford University and George Washington University. Manhattan has the *Hamilton* now at Hamilton Grange, 1892 (#53), *Hamilton* and *Jefferson* at Columbia University, 1908 and 1914 (#50), a bust of Dean van Amringe, 1922 (also at Columbia), and *Samuel J. Tilden*, 1926 (Riverside Drive at West 112th Street). Brooklyn has *Ulysses S. Grant*, 1896 (Bedford Avenue at Bergen Street), and the Bronx his *Pulitzer Memorial*, after 1911 (Woodlawn Cemetery).

Piccirilli, Attilio. 1866–1945, member of a family of Tuscan stonecutters whose studio was in the Bronx. The Piccirillis carved for Daniel Chester French (including the *Continents* at the Customs House, #4, and the *Lin-*

coln in the Lincoln Memorial in Washington), and for John Quincy Adams Ward (including the New York Stock Exchange pediment), plus works such as the lions outside the New York Public Library, 1911 (Fifth Avenue at West 42nd Street), parts of the *Washington Arch,* ca. 1895–1918 (#12), and the *Pulitzer Fountain,* 1916 (Fifth Avenue at West 58th Street). Of Attilio's own design are the sculptures on the *Maine Monument* and the *Firemen's Memorial,* both 1913 (#34, 45), as well as *Youth Leading Industry* and the *Joy of Life* at Rockefeller Center, ca. 1936 and 1937 (636 Fifth Avenue and 15 West 48th Street, respectively), the pediments of the Frick Art Reference Library (East 71st Street at Fifth Avenue), and the doors of the Riverside Church (Riverside Drive at West 122nd Street). Brooklyn has *Indian Literature* and *Indian Law Giver,* ca. 1900 (Brooklyn Museum). The Bronx has *Columbus* (East 183rd Street, Crescent Avenue, and Adams Street), and *Outcast,* 1908 (Woodlawn Cemetery).

Plassmann, Ernst. 1823–1877, b. Sondern, Westphalia; trained in Germany and Paris. Manhattan has *Vanderbilt,* 1869 (#25), and *Benjamin Franklin,* ca. 1872 (Park Row at Nassau Street).

Quinn, Edmond T. 1868–1929, American; trained with Thomas Eakins. Notable works include busts of Edgar Allen Poe and Eugene O'Neill, and a portrait of Dr. J. Marion Sims in Columbia, S.C. (compare #47). Manhattan has *Booth,* 1917 (#17), and *Victor Herbert,* 1927 (Central Park Mall). Brooklyn has *Zoroaster,* 1909 (Brooklyn Museum).

Russo, Gaetano. Italian. He did the *Columbus Monument,* 1892 (#35).

Saint Gaudens, Augustus. 1848–1907, born in Dublin, brought to New York City as an infant; studied art at the Cooper Union, then in Paris. He is arguably the greatest sculptor America has produced. *Farragut,* 1881 (#19), was his first major commission. Other significant works include the *Puritan,* 1886 (Springfield, Mass.); the *Standing Lincoln,* 1887 (Chicago; see #15); the *Adams Memorial,* 1891 (Washington, D.C.); and the *Shaw Memorial,* 1897 (Boston). Manhattan has *Cooper,* 1894, and

Sherman, 1903 (#10, 31). The Metropolitan Museum's American Wing has several of his works, including *Diana,* 1894 (weathervane from Madison Square Tower). Staten Island has *Richard Randall,* 1884, at Snug Harbor, and Brooklyn has the *David Stewart Memorial,* 1883, in the Green-Wood Cemetery. At Theodore Roosevelt's invitation, Saint Gaudens designed the famous "Walking Liberty" ten-dollar gold piece in 1906 (see #42).

Suñol, Jeronimo. 1839–1902, Spanish. The bronze *Columbus* in Central Park, 1894 (#36), was adapted by the artist from his marble *Columbus* in Madrid.

Ward, John Quincy Adams. 1830–1910, b. Urbana, Ohio; worked with Henry Kirke Brown on *Washington,* 1856 (#13). Far earlier than his contemporaries, Ward believed American sculptors should present American ideas and be trained in America: he never studied abroad. He was the leading American sculptor for fifty-odd years, known as the "Dean of American Sculpture." *Indian Hunter,* 1869 (Central Park, near the Mall), established his reputation. Manhattan has *Washington, Greeley, Holley, Conkling, Dodge* and *Shakespeare* (#6, 7, 11, 18, 24, 37), as well as the *Seventh Regiment Memorial,* 1869 (Central Park, West Drive at West 67th Street), and the *Pilgrim,* 1885 (Central Park, east end of the 72nd Street Traverse). The original sculptures of the New York Stock Exchange pediment were Ward's, but they've been replaced with copies. Brooklyn has *Henry Ward Beecher,* 1891 (Columbus Park).

Weinman, Adolph A. 1870–1952, German, moved to the United States at age ten; studied at the Cooper Union, trained with Philip Martiny, Saint Gaudens, and French. One of his most notable works is *General Alexander Macomb,* in Detroit. Manhattan has *Rea, Hamilton,* and *Clinton* (#20, 48), as well as the gilded *Civic Fame* atop the Municipal Building, 1914 (Chambers and Centre Streets), and the *John Purroy Mitchel Memorial,* ca. 1926 (Fifth Avenue at East 90th Street). Brooklyn has the *Prison Ship Martyrs' Monument,* 1909 (Fort Greene Park), and *Mayor William Jay*

Gaynor, 1926 (Cadman Plaza). Weinman designed the Walking Liberty half-dollar (minted 1916–1947) and the Winged Liberty (Mercury) dime, minted 1916–1945.

Whitney, Gertrude Vanderbilt. 1875–1942, b. New York City of a prominent family, trained with James Earle Fraser and others. Her first major commission was the *Titanic Memorial* in Washington, D.C., 1914. During and immediately after World War I, she designed a number of memorials, including the *Washington Heights–Inwood War Memorial,* 1922 (Broadway and St. Nicholas Avenue, between West 167th and 168th Streets). A leading promoter of progressive American art, she was the founder of the Whitney Museum of American Art (1931), whose core collection of five hundred pieces the Metropolitan Museum had refused to accept as a gift. The Whitney Biennial remains one of the most prestigious contemporary art exhibitions. Manhattan also has *Stuyvesant,* 1936 (#16). The Bronx has the *Untermeyer Memorial* (Woodlawn Cemetery).

Ximenes, Ettore. 1855–1926, Italian. Manhattan has *Verrazzano,* 1909 (#3), and *Dante Alighieri,* 1921 (Dante Square, Broadway at West 64th Street).

Permissions

2. *John Ericsson*, by Jonathan Scott Hartley. Newspaper image from the *New York Times*, April 15, 1893.

3. *Giovanni da Verrazzano*, by Ettore Ximenes. New York City Parks Photo Archive (cropped).

9. *Fiorello La Guardia*, by Neil Estern. © Neil Estern, Sculptor.

15. *Abraham Lincoln*, by Henry Kirke Brown. Saint Gaudens, *Lincoln*, photograph by David Finn.

16. *Peter Stuyvesant*, by Gertrude Vanderbilt Whitney. Used with permission of the artist's descendant.

20. *Samuel Rea*, by Adolph A. Weinman. Photo used with permission of the Weinman family. Excerpt from Berton Braley's "The Thinker" used with permission of the heirs of Berton Braley, www.BertonBraley.com.

23. *Gertrude Stein*, by Jo Davidson. © 2005 Artists Rights Society (ARS), New York / VI$COPY, Australia.

27. Sculpture © Charles Keck.

30. *News*, Noguchi © 2005 The Isamu Noguchi Foundation and Garden Museum, New York; Artists Rights Society (ARS), New York.

32. *Simón Bolívar*, by Sally James Farnham. Alajos L. Schuszler, New York City Parks Photo Archive (cropped).

40. *Eleanor Roosevelt*, Jencks. © Penelope Jencks.

42. *Theodore Roosevelt*, Fraser. With permission of the artist's heirs.

45. "Into the Fire" (from *The Scarlet Pimpernel*). Words by Nan Knighton and Frank Wildhorn. Music by Frank Wildhorn. © 1992 WB Music Corp., Knight Errant Music, Scaramanga Music, and Bronx Flash Music, Inc. All Rights on behalf of itself, Knight Errant Music and Scaramanga Music administered by WB Music Corp. Used with Permission.

48. *Clinton*, Weinman. With permission of the Weinman family.

Index

About the Author

Dianne L. Durante is a freelance writer, lecturer, and researcher living in Brooklyn, New York. She is author of *Forgotten Delights: The Producers, A Selection of Manhattan's Outdoor Sculpture.*